"I simply follow the light, where it comes from, where it goes to."

FRANK W. BENSON

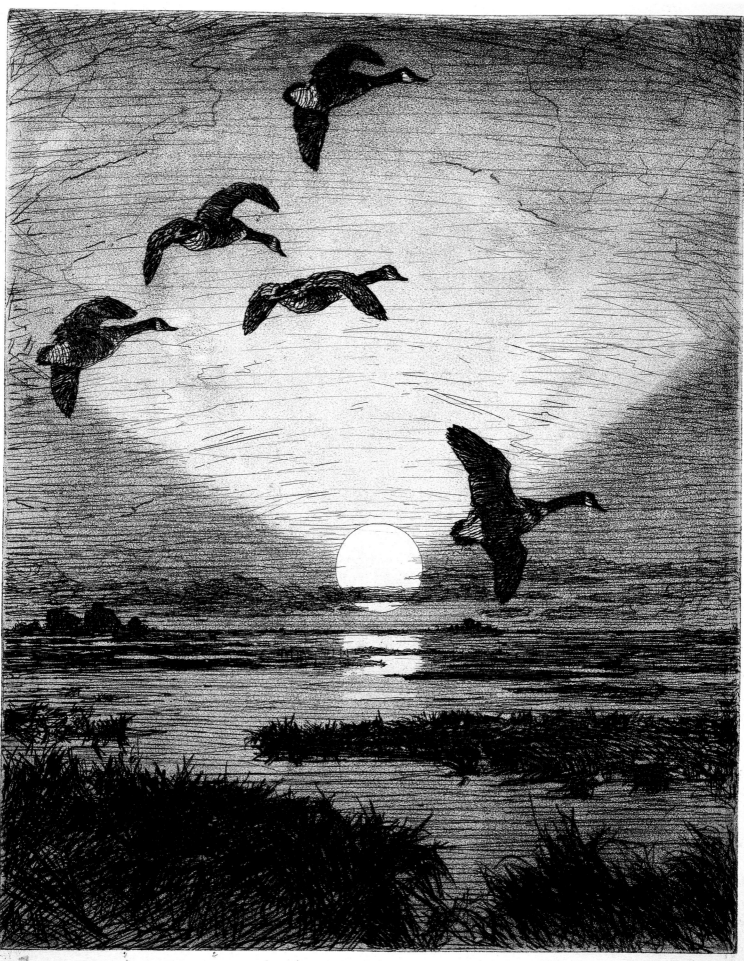

The Art of Frank W. Benson

AMERICAN IMPRESSIONIST

Exhibition Catalogue and Essays
by Faith Andrews Bedford, Laurene Buckley,
Dean T. Lahikainen, and Jane M. Winchell

PEABODY ESSEX MUSEUM
East India Square, Salem, Massachusetts

The front cover image is *Study for Young Girl with a Veil* (CAT. 20), a painting of Benson's eldest daughter, Eleanor. *Great White Herons* (CAT. 51) is displayed on the back cover. The frontispiece is the etching *November Moon* (CAT. 48).

The Benson quotations associated with the sections of the gallery portion of the catalogue are all from "Advice to an Artist: Notes Taken after Criticism after Painting" (see note 1, page 54).

Peabody Essex Museum Collections for 1999
Volume 135
ISSN 1074-0457
ISBN 0-88389-116-6

The *Peabody Essex Museum Collections* is an annual monographic series published in Salem, Massachusetts. All correspondence concerning this publication should be addressed to the Editor, *Peabody Essex Museum Collections,* East India Square, Salem, Massachusetts 01970. Previous books are available upon request. This volume was copyrighted in 2000 by the Peabody Essex Museum.

Unless otherwise noted, all photographs are from the collections of the Peabody Essex Museum.

Contents

List of Lenders to the Exhibition

Art Institute of Chicago

Boston Public Library

Butler Institute of American Art, Youngstown, Ohio

Carnegie Museum of Art, Pittsburgh

A descendant

Mr. and Mrs. Roy E. Demmon

Detroit Institute of Arts

Natalie Fielding

Georgia Museum of Art, University of Georgia

Marie and Hugh Halff

Museum of Fine Arts, Boston

National Academy of Design, New York

Grant and Carol Nelson

New Britain (Conn.) Museum of American Art

Pennsylvania Academy of the Fine Arts, Philadelphia

Mrs. Richard D. Reitz

Mr. and Mrs. Thomas A. Rosse

Stephen Phillips Memorial Trust House, Salem, Mass.

Charles Sterling

Peter Strong

Mr. and Mrs. Abbot W. Vose

Robert C. Vose III

Foreword and Acknowledgments

In keeping with its 1992 creation through the consolidation of two predecessor institutions, the Peabody Essex Museum has two founding traditions. One, derived from the Peabody Museum of Salem, is a commitment to the acquisition and presentation of works of art and culture from Asia, the Pacific Islands, Native America, and Africa. This legacy originated in 1799 with the vision of several of America's first global entrepreneurs. The other component of the museum's mission dates from 1821, when the Essex Institute was formed to preserve art, architecture, and cultural history related to Boston's North Shore. This dual heritage reflects the region's long history as a center for global trade, finance, industry, and higher education.

During the nineteenth and twentieth centuries, dedicated staff and patrons continued what is now a two-hundred-year tradition of collecting that has resulted in a unique, diverse, and exceptionally important set of collections that embrace New England and much of the rest of the world. All of these collections are nationally and internationally important, and most rank among the finest of their kind.

The consolidation of the Peabody Museum of Salem and the Essex Institute has provided a singular opportunity to create a new kind of museum—one that uniquely interconnects art, culture, and architecture—and to bring to light one of the nation's greatest hidden assets. The museum is now among the largest cultural institutions in New England. It stands poised, upon completion of a substantial new expansion of its facilities, to take its place on the national and international stage as a major American museum.

As the Peabody Essex Museum celebrates its bicentennial year, it is fitting that we present the work of an outstanding American artist, one whose life and work was rooted in Salem and New England, but who drew upon international artistic and cultural trends and traditions. Benson, for example, frequently chose to incorporate Chinese and Japanese art and artifacts into his classic interior scenes, reflecting their significant presence in New England's evolution. As one of America's greatest impressionists, we believe that his work, with its exquisite representation of light and color in landscapes and interiors, merits rediscovery by a new generation. We hope that the exhibition entitled *Frank W. Benson: American Impressionist* and this companion publication will foster an expanded appreciation of Benson's work and the richly complex cultural environment that made it possible.

The museum would like to express its gratitude to the many individuals who in one way or another have made this exhibition and publication possible. Valuable information for the project

8

was provided by Lorna Condon, Society for the Preservation of New England Antiquities; Jeffrey Filmore; the staff at the Frick Art Reference Library; Sherry Goodhue, Pickering Foundation of Salem; Sinclair Hitchings and Karen Shafts, Boston Public Library; Mr. and Mrs. Timothy Ingraham; Selina F. Little; Maureen O'Brien, Rhode Island School of Design; Zachary Ross, Hirschl and Adler Galleries; Peter Strong; and Mr. and Mrs. Richard Wheatland II. The staff of the Vose Galleries of Boston, who are preparing a catalogue raisonné of Benson's work, have also been most supportive, especially Robin Dabney, Nancy Jarzombek, Abbot Vose, and Robert C. Vose III. Many members of the Benson family have also been of enormous help in tracking down material relating to Benson's long career, especially Nancy Brown, Edward Lawson, Ann B. Reece, and Gail Reitz.

Various members of the staff at the museum contributed to the success of this project. William La Moy and Louise Sullivan copyedited the manuscript and oversaw production of the catalogue. Kristen Weiss, collections manager of the American Decorative Arts Department, coordinated many other aspects of the project, such as the complex tracking and handling of the multitude of images associated with the publication. Harvard University intern Tracey deJong ably assisted Kristen in this. The photography department, represented by Jeffrey Dykes, Carolle Morini, Markham Sexton, and Heather Shanks, provided many of the superb illustrations. Natural History curator Janey Winchell wrote an insightful article for the catalogue. Fred Johnson and his staff were responsible for the outstanding exhibition design. Lucy Butler and Elizabeth Heide were instrumental in the organization of loans and the installation of the exhibition. Media coordinators Christy Sorenson and Mark Keene produced the special video highlighting Benson's career.

This publication would not have been possible without the work of several key people from outside the museum. We want to express our appreciation to Dr. Laurene Buckley, director of the Queens Museum of Art, for her fine essay for the project and Anthony McCall for his superb design of the catalogue. It would have been impossible to mount the exhibition were it not for the generosity of the many individuals and institutions willing to loan works. To each lender, we extend our heartfelt thanks and deepest appreciation. Finally, we are most indebted to our two cocurators, Faith Andrews Bedford and Dean Lahikainen (the museum's curator of American Decorative Arts), for their excellent essays for the catalogue and for their relentlessly hard work during every stage of the planning and implementation process. Their skilled guidance and knowledge were key to the project's success. This impressive collaboration of so many individuals has culminated in an exhibition and publication that have significantly increased our understanding and appreciation of this important American artist.

DAN L. MONROE
Executive Director and Chief Executive Officer
Peabody Essex Museum

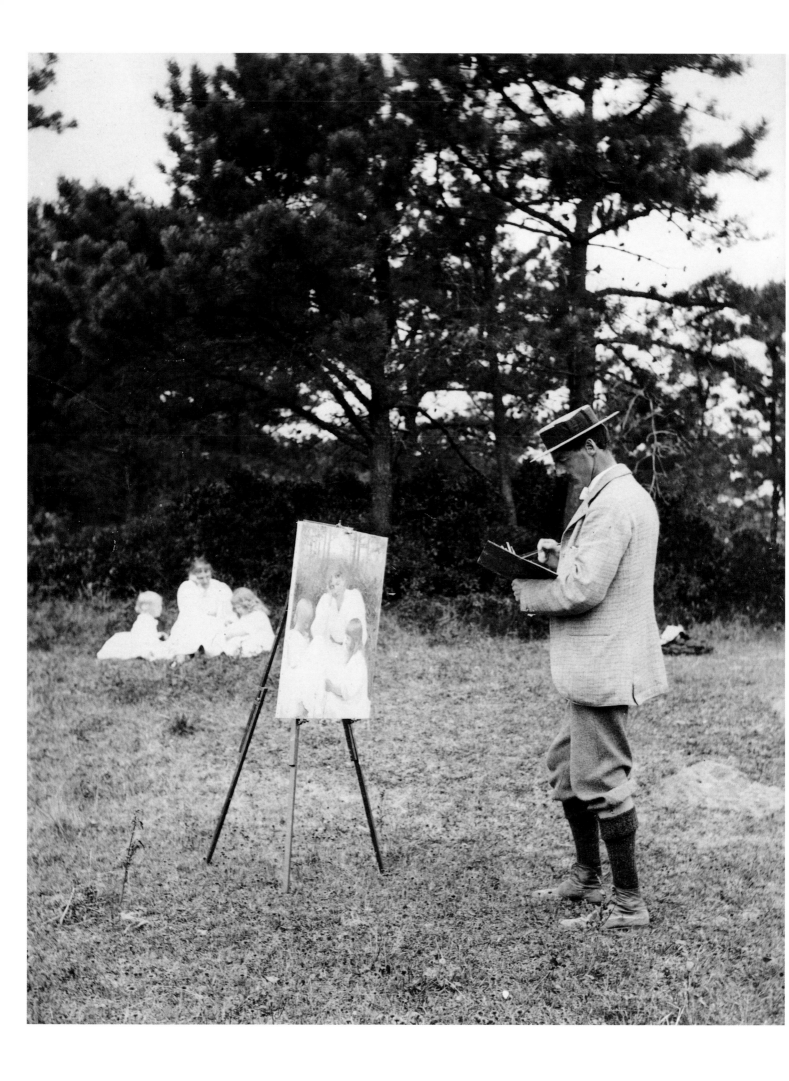

Frank W. Benson: Master of Light

BY FAITH ANDREWS BEDFORD

The childhood world of Frank W. Benson that began in 1862 was defined by the light and water that surrounded him. Light danced off the waves as he sailed his dinghy in the waters of Salem Harbor and played on the beaches of nearby Marblehead. It glanced off the white sails of the ships tied up at the Crowninshield and Derby Wharves. Light filtered through the curtains of his Washington Square home and shone on the Chinese porcelains that Benson's sea captain forebears brought home from their voyages to the Orient.

A child of the out-of-doors, Benson began tramping the marshes of Essex County with brothers and cousins when he was ten. He spent hours hunting in the dappled light of the forest and the lowering, gray light of a winter's day on a marsh. He watched sunlight shatter in the droplets of water cast off by a leaping trout and saw many a dawn slowly form its intricate colors as he sat in a duck blind waiting for the birds to rise from their watery resting places. Be it river or lake, marsh or sea, Benson's whole life was spent by the water. When it came time for him to become a painter, Benson (FIG. 1) distilled those memories and placed them on canvas and paper, recreating for others his own perceptions of a world defined by light. As he once told his daughter Eleanor, what he felt was most important in art was to "follow the light, where it comes from, where it goes to." [1]

Encouraged by his mother, who described herself as a "Sunday painter," Benson began his study of art by sketching birds. Determined to be an illustrator of ornithological texts, he first painted a rail and a snipe he had brought back from a shooting expedition in the Essex marshes (FIG. 2). He painted them, in the words of one critic, "with stark and youthful realism . . . exactly as they hung, suspended ingloriously by the feet" from the barn door at 46 Washington Square. [2] These early works show a grasp of light and its effects far beyond what one would expect from an untutored adolescent. Shadows are correctly placed, and highlights create form. The birds have a convincing realism: their feathers gleam, and their proportions are accurately rendered.

Three years at the School of Drawing and Painting of the Museum of Fine Arts in Boston honed Benson's artistic skills. He did so well that, while still a student there, he was hired by the Salem Evening Drawing Class, to teach the residents of his hometown the finer points of sketching.

Frank W. Benson photographed while painting *Mother and Children,* New Castle, New Hampshire, 1894 (see FIG. 6).

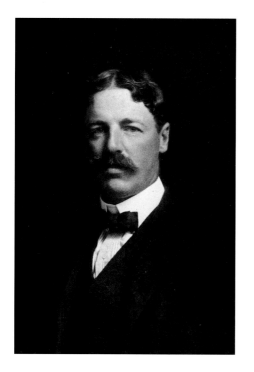

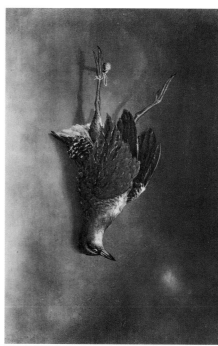

FIG. 1. Frank W. Benson. Photograph courtesy of Faith Andrews Bedford.

FIG. 2. Frank W. Benson, *Rail,* ca. 1878. Oil on board, 18 x 12¼ inches. Private collection. Photograph courtesy of Berry-Hill Galleries, New York. This is one of Benson's earliest known paintings, done at about the age of sixteen.

FIG. 3. Frank W. Benson, *Salem Harbor,* 1882. Etching on paper, 4⅛ x 7⅛ inches (Paff no. 1, ed. 1,500). Photograph courtesy of Faith Andrews Bedford.

The family journals are full of Benson's notations of visiting various galleries and private collections. It would seem that the young art student sought as much exposure as possible to as many different types of art as he could find. Benson's first etching, a study of the boats in Salem Harbor, was done while he was editor of a student art magazine. It shows glimpses of the mastery of light for which his later etched works were famous (FIG. 3). Although Benson's first etching shows a well-developed sense of composition, a clear understanding of spatial relationships, and a knowledge of the effects of light, he felt he "did not know enough about drawing to make etchings" and put away his etching tools for more than thirty years.

Five years before Benson began studying art, a number of French painters began experimenting with new ways of depicting light and shadow in canvases painted out of doors. Both subject matter and technique were a far cry from the accepted mode of the day. The group was dubbed "The Impressionists" by a contemptuous Parisian critic, and their paintings were refused by the prestigious annual Paris Salon. Yet, by 1880, when Benson first entered art school, an American writer, while criticizing the lack of spirituality and poetry in the group's paintings, noted that they, nevertheless, had a "keen appreciation of aerial chromatic effects."[3]

Just before Benson's departure for Paris to study at the Académie Julian, the Studio Building in Boston hosted an exhibition of works by several of the Impressionists: Manet, Monet, Renoir, Pissarro, and Sisley.[4] Since he rarely missed the opening of a new show, it is quite likely that, on the eve of his departure for Europe, Benson stood before these paintings and studied carefully their high-keyed palette, their broken brush strokes, and their loose handling of paint.

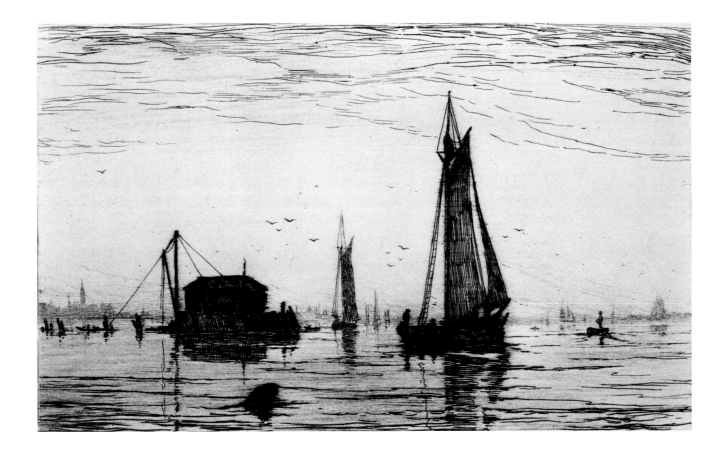

Few works from Benson's Paris years remain. Those that do show that he eagerly embraced the tenets of the academic tradition and listened closely to the criticisms given by the French masters at Julian's. Although several artists gave critiques at the academy, it was Jules-Joseph Lefebvre and Gustave Boulanger who were most often in the studio. As Benson's close friend and Paris roommate, Joseph Lindon Smith, noted, "No students get more attention from their teachers than we do at Julian's from old Boulanger and Lefebvre." Indeed, it was Boulanger who gave Benson the highest commendation anyone had ever known him to bestow: "Mon cher jeune homme, your career is in your hands. If you carefully analyze the personality of your model, you will do very well."[5]

The two friends had seen paintings of French seaside life at the Paris Salon. Hearing that several of the artists they admired would be summering at the little fishing village of Concarneau, they determined to capture the elusive quality of the light on the coast of Brittany for themselves. In the company of such older, well-established artists as Arthur Hoeber, Edward Simmons, Clifford Grayson, and the brothers Alexander and Birge Harrison, Benson went on sketching sorties, took part in beach picnics, and dined at the Grand Hotel.

Observing the subject matter of the other artists' summer works, Benson undertook a number of seascapes and scenes of young girls in Breton costume on the headlands. In these paintings, one can see his mastery of light upon the water—a subject he was to return to with much success in ensuing years. *Moonlight on the Waters* (CAT. 37) is an excellent example of his early forays into such effects. A comment written some years later of a similar work might just as easily have been inspired by this one. "[There] is a long path of moonlight on the sea," a critic wrote. "It is

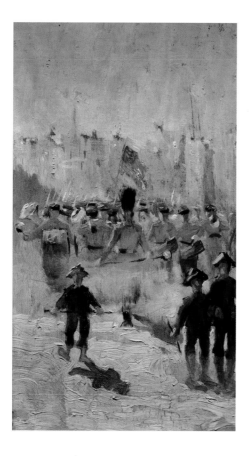

FIG. 4. Frank W. Benson, *Paris Parade,* ca. 1885. Oil on canvas, 12½ x 7½ inches. Private collection. Photograph courtesy of Berry-Hill Galleries, New York. This early experimentation with Impressionism was done by Benson when he was studying at the Académie Julian in Paris.

more than a path; it is a broad avenue of light, which removes the horizon by contrast with the darker water, almost infinitely. The dancing waters break up the edge of the moon path into iridescent gleams. The picture is full of the vastness and deep sweetness of a summer night at sea."[6]

Although Benson's experimentation with light as he touched it to the curling tips of waves breaking upon the Breton seashore allowed a glimpse into his future mastery, it was a tiny painting that he brought home with him from Paris that truly foretold his fascination with the concepts of Impressionism. In 1885, Benson and his friends had visited the Parc Monceau to see the Statue of Liberty being made ready for shipment to the United States. *Paris Parade* (FIG. 4) is a bright and sunny depiction of a small band and a group of soldiers marching down a city street. The presence of an American flag in Benson's painting would indicate that this was one of several parades held in the statue's honor. The whole work has a quick and informal air about it. The heavily textured lower portion of the small painting seems to anchor the three little boys who precede the parade, imitating with their sticks the baton of the marshal. Sunshine reflects off the guns of the soldiers in the sprightly procession. Forms dissolve in the brilliant light, and the bright bits of paint are dashed in with broken brush strokes, giving the whole canvas a shimmering quality.

During Benson's first year in Paris, an exhibition had been held in New York to raise funds for the base of the Statue of Liberty. The critic for the *Art Amateur* wrote of the works of Manet and Degas that were hung in the show and made this prediction: "All the good painting by the men who will come into notice during the next ten years will be tinged with impressionism."[7] This opinion, undoubtedly read by Benson—a faithful subscriber to most of the art journals—was indicative of

the growing acceptance of the French Impressionists and the fact that American artists would gradually come to admire this approach to painting. Years after Benson returned home from his studies in Paris at the Académie Julian, a French critic admired his justly famous plein air works: "Il est un maître des effects du lumière." (He is a master of the effects of light.)

During Benson's summer in Concarneau, old Salem friends, the Peirsons, spent several weeks at the Grand Hotel where Benson and Joseph Smith had rooms in the garret. Mrs. Peirson and her daughters Ellen and Katie joined the two young men on a number of their outings. Soon Benson suggested that he paint a portrait of Ellen as a present for her mother. The sittings took far longer than necessary, Smith recorded in a note to his mother. It was clear to him that Benson had fallen in love. He and Ellen announced their engagement the following year.

Benson's journals and letters show him to have been an eager pupil, receptive to new ideas. He absorbed much from his two years in France and a brief sojourn in England. As he sailed home in the summer of 1885, he undoubtedly realized that now the challenge was to find something of his own to say in his own style.

Like many artists just starting out, Benson began doing portraits as soon as he returned from Europe. After opening a studio at 2 Chestnut Street in Salem with another young and promising artist by the name of Philip Little, Benson began turning out a number of commissioned works.[8] At first, these were mostly portraits of family and friends. We are fortunate to be able to display two paintings from Benson's first year of portraiture. In them, we can see the many influences that were helping to form the young painter.

Benson painted *My Sister (Portrait of Betty)* (CAT. 1) as a present for his mother more than one hundred years ago. Yet its look is as fresh and contemporary as if it had been painted yesterday. The light, mottled background is a perfect foil for the gauzy treatment of Betty's dress as well as for her shiny fall of dark hair. The solemn, big-eyed girl appears to have taken very seriously her role as one of her big brother's first models.

Benson seems to have employed a very different approach for his *Portrait of Margaret Washburn Walker* (CAT. 2). Like John Singleton Copley, he appears to have depicted his sitter as the persona she wished to project. The placement of Walker's figure, the setting, and the objects Benson used seem to seek to create a biography or social identity on the canvas, one that visually demonstrates the sitter's social standing. In the colonial period, such visual codes were well understood by the society of the day. By the time Benson began painting portraits, however, symbols such as flowers for women and books for men had been replaced by a more subtle rendering of the subject's demeanor and informed taste in fashion than by the traditional iconographic "props."

Yet Benson, perhaps in a subtle bow to Copley, seems to have experimented with accessorizing Walker's portrait with such things as a small sewing table and a vase of yellow roses. This work employs the frequent Copley formula of a three-quarter view, with the figure of the sitter

strongly lit and placed close to the picture plane to confront the viewer. Did Walker pluck a few roses from the arrangement and pin them to her collar? Did Benson suggest their use as a means of repetition within the composition? Walker's brightly colored dress with its white lace collar and cuffs contrasts sharply with the almost black background. Was this her suggestion or Benson's?

A pair of orange gloves is draped on the table, recalling Benson's comment that the painting he most admired from his years in Paris was Titian's *Man with a Glove*. Were the gloves Benson's way of paying homage to a man whose work he passed every day as he walked through the Louvre from his quarters on the Left Bank to the Académie Julian? Were the accoutrements things he arranged, or were they requested by the sitter? This work is unusual in Benson's oeuvre, however, because, in his later commissioned portraits, he rarely used anything more elaborate in the way of props than a chair, an architectural fragment, or a simple drapery.

Unlike Copley, Benson did not usually subject his portrait models to long hours of sittings. As his wife, Ellen, once told her granddaughter, "When Pa was courting me in France it took him six weeks to paint my portrait. Once we were married, it took him one."[9] The portrait of Walker seems to have been an exception. On the back, it is noted that it required twenty-eight sittings— an unusually large number for any painter, especially Benson. Was the sitter displeased? Did she ask him to change the work numerous times? Was the sitter's mother demanding, requesting endless adjustments, or did the number of sittings reflect Benson's nervousness and his striving for perfection in a portrait that appears to have been his first commission? This is the only instance in which Benson is known to have noted the number of sittings required for a portrait.

It is clear that a number of Benson's sitters wished to have themselves portrayed as modest, unadorned, disciplined citizens rather than drape themselves with the trappings of wealth and class that had once been deemed essential elements of portraiture. The denial of ostentation could be as telling as its opposite. While Copley's sitters may have wished to have their station in the increasingly consumer-oriented society of late-colonial America clearly stated in a portrait, the judges, college presidents, ministers, and the owners of textile mills and shoe factories who sought out Benson needed no such definition. Neither, for the most part, did their wives and families.

The exception to this was a number of "society portraits" in which Benson was commissioned to portray women (often together with their children) in opulent gowns in poses reminiscent of the languid elegance portrayed by John Singer Sargent. Benson undoubtedly first met Sargent when he came to America in 1887 to paint several portraits and probably admired Sargent's work when it was hung at the St. Botolph Club the following year. American portrait work, coupled with a commission to decorate the new Boston Public Library, set the stage for decades of travel for Sargent between his home in England and Boston. He stayed in a hotel when in Boston and took his meals with Benson and other artist friends at the Tavern Club, a men's club whose members met in a suite of rooms directly below the studio of the artist Frederick Porter Vinton. Family his-

tory has it that Benson often lent his studio to Sargent, especially when he was away during the summers. Correspondence reveals that the two were close friends.[10]

One can see some of Sargent's influence in Benson's *Portrait of Mrs. Hathaway* (CAT. 11). The wife of his good friend Horatio Hathaway, Mabel Hathaway chose to sit for her portrait in a satin dress of a rich pastel blue. The folds of the fabric create complicated patterns of planes and swirls. The strong conjunction of light and shadow is softened by Benson's efforts to keep even the darkest areas of the work luminous through reflection. Yet, while Sargent's portraits are marked by brilliance and cool detachment, one senses that Benson took to heart the words of Boulanger to "carefully analyze the personality of your model" and established a rapport with his sitters that allowed him to capture their characters as well as their images. With the exception of Walker (who may have requested to be portrayed smiling), Benson's sitters display neither melancholy nor gaiety. With the exception of children, they tend to gaze at the viewer with an assured sense of self.

It would appear that Benson's most successful portraits are those of a person in a natural setting, a *portrait d'apparat,* as his French masters called it. We are fortunate to have hanging a fine representation of such work. The portrait of Philip Little, Benson's childhood friend, early studiomate, and later neighbor, seems to capture his personality very well. Benson's study of his own little son, George, who patiently posed for *Portrait of a Boy* (CAT. 5), is a rare glimpse of this active boy rarely seen in his father's work. The portrait of fellow artist and ornithologist Alexander Pope has a naturalism that sets it apart from the more formal works, as does the relaxed pose Benson has allowed his old friend Richard Saltonstall. The shy sweetness of his nieces Ruth and Rosamund Benson in *Two Little Girls* (CAT. 7) could only have been captured by someone who knew them well. Playmates of his own daughters, these two little girls were frequent visitors to his house on Washington Square.

Forty years after Benson began doing portraits and long after he had given up taking commissions, he expressed these sentiments to his daughter Eleanor: "There is a saying that there is nothing more to be found in a picture by the beholder than has been put into it by the painter. The more a painter knows about his subject, the more he studies and understands it, the more the true nature of it is perceived by whoever looks at it, even though it is extremely subtle and not easy to see or understand. A painter must search deeply into the aspects of a subject, must know and understand it thoroughly before he can represent it well."[11] Change "subject" into "sitter," and one has a glimpse into Benson's success as a portraitist.

In 1887, a commissioned work was done for his friend Charles Hamlin (CAT. 3). The painting's palette is subdued, the lines are decisive, and the paint is much less freely handled than in Benson's later works. The light falls brightly on the left side of Hamlin's face, highlighting the strong bone structure. The warm brown of the background and the deep black of the sitter's suit maintain a harmonious tone, causing the viewer to focus on the lights and shadows. Painted just

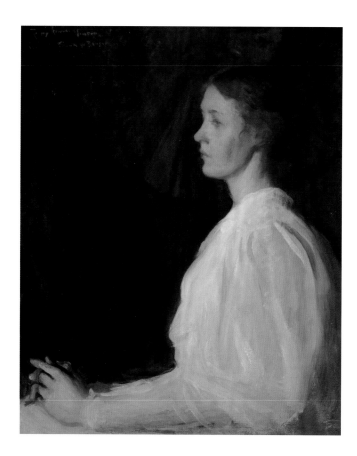

FIG. 5. Frank W. Benson, *Seated Figure (Woman in White),* date unknown. Oil on canvas, 30 x 25 inches. Private collection. Benson presented this work to his close friend and mentor Frederick Porter Vinton, the Boston portraitist.

two years after Benson's return from Paris, this portrait of a lawyer and respected professor at Colby College demonstrates the academic teachings of Benson's French masters.

This portrait of Hamlin also seems to show the influence of Frederic Porter Vinton. Vinton's austere portraits of men featured darkly colored backgrounds and intense lighting and usually placed the sitter in the center of the canvas, facing the viewer in a commanding pose. Vinton, six years Benson's senior, was already well established when Benson returned from Paris. The two became friends through their membership in the Tavern Club. Vinton was generous with his critiques of the work of young artists. Judging by letters between Vinton and Benson, the two became extremely close.

It is worth noting that, despite the general distaste for and suspicion of the work of the Impressionists in the late 1870s and 1880s, by 1891, the year Benson was given his first private exhibition, Vinton discussed and seemed to endorse their techniques at a lecture at the St. Botolph Club: "The theory is that colors must no longer be mixed on the palette, but are to be laid side by side, either in dots or dashes, in pure tints, and left to mix optically on the retina."[12] He himself enjoyed plein air painting during vacations, and his landscapes show his interest in Impressionist technique. There was a growing acceptance of the Impressionists in Boston, such that in 1892, when an exhibition of French work was held there, the majority of the paintings were loaned by contemporary collectors in that city.

Almost ten years after completing his portrait of Charles Hamlin, Benson gave a painting to his mentor that included what was, for Benson at least, a sentimental inscription: "To my friend Vinton" can be seen in the upper left corner of a study of a model entitled *Seated Figure* (FIG. 5).

The subtle play of white on white, the highlights in the model's hair, and the strong contrasts of light and shadow are not only a tribute to Vinton's own approach but also a harbinger of Benson's own growing interest in Impressionism. The curious arrangement of the folds of the drapery, which suggest a halo around the model's head, are reminiscent of the angels so often painted by Abbott Handerson Thayer, another of Benson's mentors. Between 1889 and 1893, Benson and his family spent the summers in a little cottage on the shores of Dublin Lake at the foot of Mount Monadnock in New Hampshire. Here Benson hiked, fished, hunted, and painted with Thayer, absorbing much from the eccentric artist. Yet, save for two paintings and his mural series for the Library of Congress, little of Benson's known figural work resembles Thayer's canvases of winged women and haloed virgins.[13] Records show that Benson did very few allegorical works. While newspaper reviews of the early 1890s note the influence of Thayer on some of his paintings of women, later critics praised Benson for developing his own treatment of the female figure, "realizing instead of idealizing the delicacy and vivacity of American girlhood."[14]

While Benson's father, George Wiggins Benson, a prosperous cotton broker, initially had misgivings about his oldest son becoming an artist, he must have been proud to see the business acumen he was developing. As soon as Benson returned from Paris, he put advertisements in the Boston and Salem newspapers, as well as the catalogues of many of the New England art schools, announcing his availability as a portrait painter. He also undertook a heavy exhibition schedule that placed his work squarely in the public's eye. Hanging paintings in as many shows as he could enter, Benson was immediately noticed as an "up and coming young artist" and began garnering praise. Benson must have been delighted when a reporter noted that his portrait of a young man, his very first work hung in a Boston exhibit, showed "a good deal of life and character."[15]

Two semesters of teaching in the school at Portland's Society of Art helped shore up the résumé of the young artist and probably helped him garner the position of instructor at his alma mater, the School of Drawing and Painting of the Museum of Fine Arts in Boston, in 1889. His friend and former classmate Edmund Tarbell began teaching there the same year.

How fine it must have been for Benson to read in the *Boston Evening Transcript* an announcement of his appointment. Referring to Benson and Tarbell, the writer gave a glowing account of their efforts: "[They] gained honor for refined and careful technique not only in Paris but in this country. Those who saw perhaps the most interesting exhibition that pure American art has known—the exhibition last spring of the Society of American Artists in New York—will remember what a fine show these young men made. How full of delicate perception of youth and simplicity were the portraits they exhibited."[16] In the same edition of the *Evening Transcript,* it was also announced that Benson had won the third Hallgarten prize at the annual show of the National Academy of Design for his painting *Orpheus.*[17] The now-unlocated painting that depicted the Greek god of music playing a harp for a tiger was praised as "a charming idyll. . . . The figure is well

drawn, the whole well conceived and the landscape is of a soft Corot-like quality of green which is poetic and beautiful."[18] The Hallgarten prize was the first of many medals and awards for Benson. Indeed, he later became known as America's "most medalled" painter, winning almost every available prize of the day.

Together with Tarbell, Benson developed the Museum School into one of the preeminent art schools in the country, remaining on its faculty until 1913. As Laurene Buckley discusses in her essay, the lives of these two men were deeply intertwined. They shared not only the leadership of the Museum School but a studio as well; there was also a close relationship between their two families. Their children were playmates, and visits to the summer homes of each other were frequent. The first private showing for each was a joint exhibition at the Chase Gallery in Boston in 1891. It was an excellent opportunity for the two friends to show their best work and, hopefully, reap sales and commissions. Benson's growing mastery of light was not lost on the art critics because, as one wrote, both he and Tarbell took "exceptional delight in color problems, particularly in studies of light under various conditions."[19]

Such exhibitions and the positive reviews they received, coupled with the growing prestige of the Museum School under his codirection, brought Benson much notice. As his reputation grew, he began painting the leading citizens of New England. Later, he traveled far afield to Chicago, Pittsburgh, Philadelphia, and beyond to paint portraits of influential Americans and their families.

Portraiture, however, is hard on an artist. Thayer grew to despise doing portraits; Sargent gave them up gladly. Benson, too, soon discovered the trials of this field of art. His patience was sorely tried by wiggling children, mothers who wanted the waists of their daughters made smaller, patrons who wished to crowd a portrait's composition with pets and possessions, and men who felt he had made their wives too plump. In responding to sheet-music magnate Gustave Schirmer's letter of appreciation for his portrait of Schirmer's daughter Gertrude, Benson made a candid observation: "I have had a great pleasure myself in doing it, more so than often falls to my lot in doing work for other people. This comes . . . from the freedom you all allowed me in all ways. Few people know enough to allow such freedom from interference or I think they would always get better pictures."[20]

While portrait commissions had been his bread and butter, Benson was delighted when his continued success permitted him to leave portraits behind. Years later, he reminisced about that liberation: "[I] welcomed my freedom when I could give up portraits of people and picture the out-of-doors and the live things I loved."[21] By 1922 when Benson painted the *Portrait of Richard Saltonstall* (CAT. 12), he had almost entirely given up portrait work except for the occasional study of his grandchildren or a very close friend. Saltonstall was one of these friends. He was a collector of Benson's works and a summer neighbor of his on North Haven Island, Maine. The two men were even distantly related. Benson had painted a number of portraits of the Saltonstall family, but none is as successful as this one. Although Benson had long ago eschewed the symbolic trappings that had

been used by portraitists since colonial times, he employed a room-like setting for his portrait of Saltonstall. Shown in a moment of quiet leisure reading at a table on which Benson had arranged a number of objects, Saltonstall is the very figure of a gentleman of means.

The first ten years of Benson's career might well be looked upon as a period of experimentation. During this time, he turned out landscapes, seascapes, portraits, and a set of murals for the Library of Congress. He did some paintings of his family in the out-of-doors, a few still lifes, and a small number of wildfowl paintings. In all these varied contexts, his growing interest in the effects of light is evident, but nowhere can we get such an early glimpse of his mastery than in a brief series of works in which he concentrated on the mellow, muted effects of interior light thrown from the dancing flames of a fire or the gentle glow of an oil lamp. In these works, we see subtle portraits of his wife and sisters because, at this point in his career, professional models were still beyond Benson's means. A series of beautiful canvases featuring young women in elegant gowns, these "firelight paintings" earned Benson some of his earliest praise.

In *By Firelight* (FIG. 49), the froth of the model's dress is set against the polished glaze of a porcelain jar, and the warmth of the light dwindles in the blackness of the shadows. The counterpoints are many, but one has a sense of integration within the overall design. As Benson once said, "People in general have a sense of beauty and know when things are right. And design is the only thing that matters."[22] The model for *By Firelight* is believed to have been Benson's youngest sister, Elizabeth, whom he had painted five years earlier after his return from Paris.

When *By Firelight* was first exhibited at the National Academy in 1892, one critic noted that it was a "picture rich in feeling and with just enough, and not too much of that artificial lighting sometimes too dangerously experimented with by this artist even whose failures have been interesting."[23] Another critic called the work "a nice contribution."[24] A third touched on Benson's use of light when he remarked that the painting was an "exceedingly clever study in illumination, like his treatment of lamplight last year."[25]

Benson's handling of the effects of firelight was vivid. When the work was seen in Chicago, it was viewed by three artists whose conversation regarding it was later reprinted in a small booklet entitled *Impressions on Impressionists.* The sculptor Lorado Taft evaluated it in this fashion: "Look at those mellow shadows. . . . See how it is done! See your effect of firelight now. Look at that arm. A stripe of pure vermilion and then next to it one of clean, vivid blue, and then this mass of transparent shadow. You step back three steps and they blend into the tenderest gradations, but preserve a purity that you don't see once a year in a painting."[26] *By Firelight,* with its warm glow and exotic tigerskin rug must have instantly appealed to its original owner, Mrs. Phineas T. Barnum, wife of the famous circus impresario.

By 1893, when Benson moved from the Harcourt Studios to a new atelier on St. Botolph Street, the "firelight paintings" no longer dominated his interior work. The new studio, which was

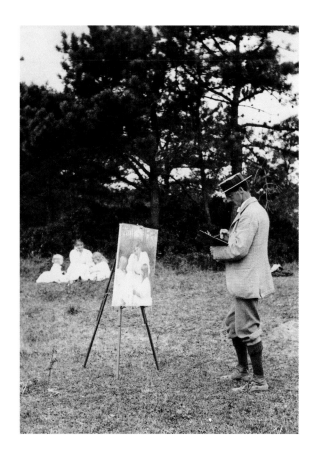

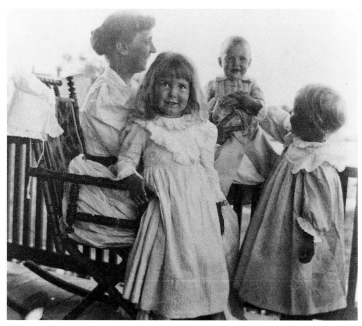

generously illuminated by tall windows, may have influenced this shift, but other factors in Benson's life help explain his move away from this type of work.

Once his children were born, Benson had a whole new set of models to paint. Beginning with his earliest known outdoor painting of Ellen sitting in a flower-strewn meadow with George, two years old, and Eleanor, four years old, Benson began a pattern of painting *en plein air* during the summers and finishing up these works in his studio during the winters.[27] *Mother and Children* (FIG. 6), done in 1894 in New Castle, New Hampshire, the first year Benson spent a full summer there, won a prize at its very first exhibition. As a Boston critic noted, "[It] shows a chasteness of sentiment and a classical yet refined treatment, an expression of wholly mother love passes through every touch; there is a subtle modeling of the baby flesh, a pensive tranquility that gives Mr. Benson a unique niche."[28]

That niche, however, was not yet plein air work. Very few of Benson's outdoor works done between 1892 and 1898 were of figures. Most of the open-air canvases that Benson completed during this period were landscapes of Mount Monadnock (CAT. 74) and the surrounding countryside, seascapes of the ocean near New Castle, and scenes of boats at anchor in Portsmouth Harbor. Occasionally, his outdoor works featured birds against the sky.

Benson spent the summers between 1893 and 1899 in New Castle, where he and Edmund Tarbell both rented houses for the summers (FIG. 7) and taught open-air art classes together on the town wharf. Much has been made of Benson's friendship with Tarbell. The three were often discussed together (along with their friend Joseph DeCamp) when being reviewed, a development that

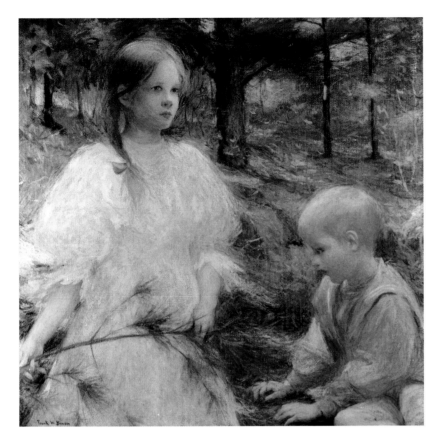

the three may not have appreciated. One reviewer coined the unfortunate term "The Tarbellites" to describe the painters of the Boston School.[29] By lumping these artists together, he obviously found it easier to dwell on their similarities rather than focus on their unique approaches. At the beginning of their careers, it may well have been said that their choice of motifs was often similar. By the time of Tarbell's and Benson's joint retrospective in 1938, the work of these two men could not have been more different.

It was long thought that Tarbell was the first of the two to move into plein air work with his painting *Three Sisters,* done in 1890. However, Benson's painting of his fiancée, Ellen, done in 1887 and set in the garden behind her family's home in Salem, was actually the first outdoor work either man exhibited. *In Summer* (FIG. 25) was Benson's first painting to be shown at the Society of American Artists in New York and was viewed by one art critic as "clean and fresh in color, and very good in ensemble." This same critic felt that Benson was a new "painter of whom much may be expected."[30] This reviewer's belief was obviously well founded because *In Summer* was later chosen for the International Exposition of 1889 in Paris. It was Benson's first painting to hang in Paris, and it would not be his last.

The reviewer's comments that *In Summer* was "flooded in sunlight" was an observation that was to be heard time and time again about Benson's later plein air paintings, but not for a dozen years. During this period, Benson mainly concentrated on the effect of interior illumination. Benson himself later admitted that, although he tried his hand at outdoor work during the 1890s, he was not pleased with the results and scrapped numerous canvases.

It is perhaps no small coincidence that Benson's first true foray into the world of Impressionism took place the year he and nine other men broke away from the Society of American Artists to hold their own small exhibitions. These men, dubbed "The Ten" by one reviewer, were not young rebels but accomplished, mature artists who wished their paintings to be viewed in like company where the few works that each man hung could be adequately displayed and easily viewed.

Benson's first foray into the true tenets of Impressionism was *Children in the Woods* (FIG. 8) done in New Castle in 1898, the summer following the formation of this important group. Its brush strokes are feathery and agitated, and the canvas virtually seems to vibrate.[31] As an experiment, an introduction to a new note in his work, this painting is effective. Although admired by critics at its first showing in New York, it is not one of his best works and demonstrates why Benson felt that his outdoor paintings, up until that time, had not been entirely successful.[32] By this point, Tarbell, who had been concentrating on works created *en plein air,* began to move his easel indoors. It was as though the two were trading places. The interior painter stepped into the sunshine, and the man whose work had focused on sunlight retreated to the more muted interior light. How much they influenced one another's work is difficult to tell. Surely, there was much give and take between two men who not only shared studio space but a deep and abiding friendship. The summer after *Children in the Woods* was created was the last one in which these two men would be neighbors. The year 1899 was also a true turning point for Benson. With the creation of *The Sisters* (FIG. 29), it was obvious to critic and art enthusiasts alike that Benson had definitely found a new direction, one that was uniquely his.

The Sisters, painted in New Castle just as the old century was drawing to a close, can well be said to mark the beginning of Benson's mature Impressionist period. For close to two decades, Benson produced a body of work that, while encompassing many of the techniques of the French Impressionists, "goes one better," as a later critic wrote. Widely reproduced, Benson's light-filled paintings of his children at play in the halcyon days of summer are some of America's best-loved works. A writer for the children's magazine *St. Nicholas* acknowledged this: "Hidden somewhere about Mr. Benson's studio, I am convinced there is a little jar marked "Sunshine" into which he dips his brush when he paints his pictures of the summer. It is impossible to believe that mere paint, however cleverly laid on, can glow and shimmer and sparkle as does that golden light on his canvas."[33]

The Sisters was greeted with praise wherever it was shown. Few artists of the time captured so well the dazzling effects of sunlight on figures and landscape. When the painting was exhibited at the Ten's second exhibition in New York, it was highly lauded: "The baby standing in the sunlight on autumnal grass against a background of sea, with a little girl seated near, is a thoroughly successful and beautiful attempt to paint in the open. The flesh painting is luminous, the sunlight strong and true, the attitudes of the children natural, and the coloring delightful."[34] A writer for another paper wrote this praise: "What a joyousness of sunshine, and a buoyancy of racing air; how invigor-

ating the free play of brushwork and purity of color and, as well, the knowledge and subtle craftsmanship displayed."[35]

This study of Benson's two youngest children, Elisabeth and Sylvia, was chosen to hang at the 1900 Paris International Exposition where it was awarded a silver medal. Upon its return to America, it was quickly sold to the Sebright-Knox Art Gallery in Buffalo, New York.

We are fortunate to be able to exhibit *Child in Sunlight* (CAT. 13), which is the single figure of Sylvia as a baby. While clearly drawn from the larger work, this portrait of Benson's youngest child has a number of subtle differences. He has placed Sylvia closer to the picture plane and bracketed her figure between the pier and the newly added boat. Numerous landscape elements have been eliminated. Yet, it is no less "painted with capital animation . . . full of sunshine, skillfully distributed" than the larger work.[36] By the time he was a father of four, Benson knew all too well how quickly childhood disappears. Clearly, he decided to capture this "ideally blithe vision of youth and summer sunlight" for himself. *Child in Sunlight* hung in his home for the rest of his life.

Following a brief summer in Ogunquit, Maine, where Benson painted in the company of his friend Charles Woodbury, he visited North Haven Island in Maine's Penobscot Bay. Charmed by an old farm at the end of the island, the Bensons began summering there in 1901. It became a perfect backdrop for the artist's plein air paintings. While Benson's mastery of light had already been well established in his portraits, landscapes, and interiors, his first seventeen years on North Haven seem to have opened a window into his painting through which sunlight flooded. Critics were unanimous in their praise for Benson's plein air works. This exhibition features a variety of his Impressionist canvases, allowing the visitor to observe his ability to convey a wide range of effects, from the brilliant sunshine of an August day to the hushed quiet of a woodland scene, all portrayed in his free and spontaneous style.

In Benson's outdoor canvases of his family, he strikes a genteel, refined note that is often both portraiture and genre painting. Yet his plein air works, set as they are in the intimate familiarity of the gardens and hillsides that surrounded his summer home, are free from the narrative message so often associated with genre paintings of the day.

The American acolytes of the French Impressionists took from their predecessors the high-keyed palette, the broken brush strokes, and the suggestion of breezes felt against a gown or veil, the leaves of a tree, or meadow grasses. Many of the Americans, though, and this included Benson, did not allow light and color to disintegrate form. Perhaps reluctant to trust appearances and sensations, Benson tended to crystallize form and focus on a conceptual element. He used light to his advantage but did not overwhelm a painting's integrity with overuse. As he once pointed out to his daughter, "[The] effects of intense sunlight are largely an interrelationship of values within a given range."[37] Only when his purpose was deliberately lyrical, such as in *Child with a Seashell* (CAT. 14) (a study of his daughter Eleanor in the North Haven woods), did he slip into the painterly mode of

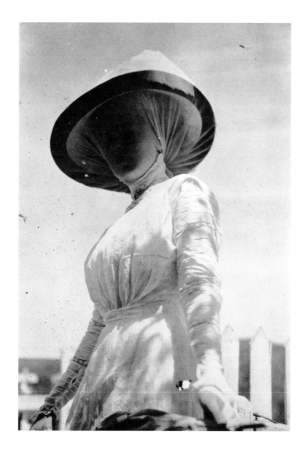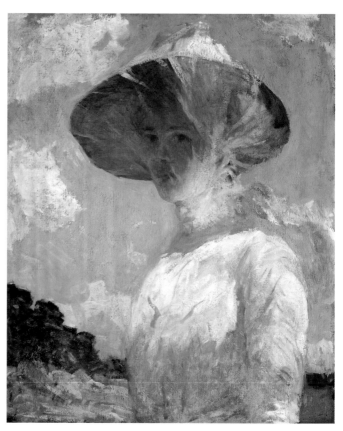

a diaphanous visualization that is suggestive of luminist haze.

To aid in the completion of his outdoor paintings, Benson often took photographs of his children as they modeled for him. Family albums are full of images that can be directly related to well-known paintings and offer tantalizing glimpses of works that Benson may have completed but which are now unlocated. A photograph of Eleanor in a veiled hat holding a parasol (FIG. 9) was undoubtedly used in the completion of *Against the Sky* (FIG. 33), done in 1906. Benson used the motif of women in veiled hats a number of times, for figures in interior settings as well as for plein air work. This photograph may also have assisted Benson in the creation of the now-unlocated *Young Girl with a Veil*, first seen in 1912 at the inaugural exhibition of the Newport Art Association in William Morris Hunt's old studio. The painting was praised for its "delicate and high pitched effect of color."[38] The study for this work (FIG. 10) offers viewers an opportunity to observe Benson's ability to depict his daughter Eleanor's features as seen through the gauzy filter of a veil. As he did with *Child in Sunlight,* Benson kept this work for himself; he left it to Eleanor upon his death.

In the summer of 1911, Benson painted a portrait of Eleanor and Elisabeth on the garden bench. This work, now entitled *Sunshine and Shadow* (FIG. 11), is the original from which a larger painting, *Sun and Shadow,* was painted. (This latter, now-unlocated, work was finished in time for the Ten American Painters' annual show in New York City in the spring of 1912.) As with *Child in Sunlight,* Benson had meant to keep *Sunshine and Shadow* for himself as well, but after what may have been many persistent letters from a collector, W. H. Johnson, he agreed to sell the painting to him. "I have a picture that I can now offer you," Benson wrote Johnson. "[It is] one that I had meant

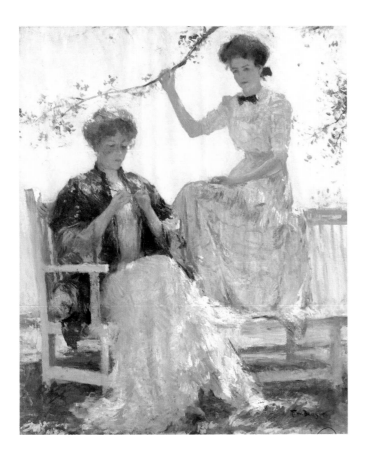

to keep myself, as it is the original picture from which my 'Sun and Shadow' in the Corcoran Gallery was painted."[39] It appears this collector was looking for works that were within a certain price range: "As I am getting more and more each year for my work it is unlikely that I shall often have canvases that I can offer you for $1,000 but I assure you that I shall feel the greatest interest in being represented in your collection just the same, and I appreciate most highly your expression of feeling about my pictures."[40]

In the fall of 1912, just prior to the Corcoran exhibition, Benson received a letter from the director of the St. Louis Art Museum asking if they might trade their painting *Summer Afternoon,* purchased several years earlier, for the new one, *Sun and Shadow.* Obviously perturbed by the request, Benson replied that to effect such a switch would not be an even trade, and he would require three thousand dollars for the exchange: "I think it very unlikely that I could sell the first . . . picture again for the very reason that you had exchanged it, while the other is one that I am confident of selling at my price, both because it is a better picture and because my things sell so much more easily than when Mr. Ives [the previous director] bought the Summer Afternoon."[41] The museum declined Benson's terms. Exhibited at least six times in the ensuing years, *Sun and Shadow* was last seen in the spring of 1921 at the Detroit Institute of Arts.

In contrast to some of his other plein air paintings, Benson uses a subdued palette in *Sunshine and Shadow.* The dark note of Eleanor's coat is repeated in the deeper shadows beneath the bench, while bright patches of sunlight dot the two figures. It is a tranquil scene of the idyllic moments Benson so often chose to paint. Protected from the strong sunlight of a summer's day by

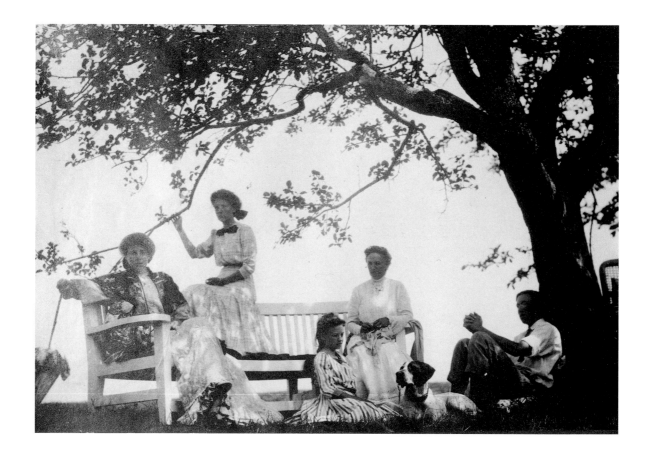

the spreading branches of a large tree, Eleanor, in a blue mandarin coat, appears to be engrossed in a bit of knitting or crochet work, while her sister Elisabeth perches on the back of the garden bench that Benson used so often in his North Haven works. The composition is pleasing, but one cannot help but note that Elisabeth's position seems somewhat precarious. While the branch in the upper left lends a note of interest to the painting, it may well be that she had to hold onto it to maintain her balance. Poses such as these make it easy to understand why Benson paid his children fifteen cents an hour for holding such difficult positions.

That such scenes were actually part of the life at Wooster Farm on North Haven Island is illustrated by a photograph Benson took of his family gathered on the bench (FIG. 12). While *Sun and Shadow* depicts Eleanor and Elisabeth in the left portion of the photograph, Benson also painted a work entitled *Family Group* (FIG. 13) that greatly resembles the right portion of the photograph, although he had replaced his wife, Ellen, with his daughter Eleanor. This painting's creation preceded that of *Sun and Shadow* by two years. Exhibited several times over the next four years, it is now unlocated and may well have been destroyed when Eleanor's home was burned in the Salem fire of 1914.[42] Benson used such snapshots as part of his working process. His daughter Eleanor remembered her father posing her and her sisters and then photographing them, often trying out various versions of a pose. Although Benson preferred to work out of doors, when the light was not right or bad weather forced him into the studio he had created in the barn at Wooster Farm, he would use the photographs to refresh his memory.[43] Benson often brought his summer canvases back to his Boston studio to complete. There, the photographs served to recapture his "visions of the free

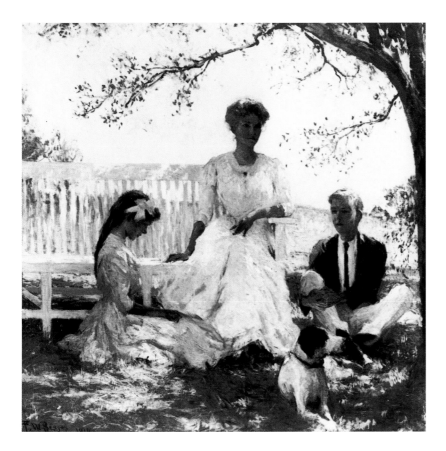

FIG. 12. The Benson family posing on the white garden bench, North Haven, Maine, ca. 1910. Phillips Library, Peabody Essex Museum. This photograph undoubtedly acted as an aid in the completion of not only *Sun and Shadow* but also *Family Group*.

FIG. 13. Frank W. Benson, *Family Group,* 1910. Oil on canvas, dimensions unknown. Photograph courtesy of Faith Andrews Bedford. This portrait of Eleanor seated on the bench with George and Sylvia at her feet was exhibited numerous times and is presumed to have been destroyed in the Salem fire of 1914.

life of the open air, with figures of gracious women and lovely children, in a landscape drenched in sweet sunlight and cooled by refreshing sea breezes."[44]

When one compares the photographs Benson took of his daughter-models to the actual paintings, one can see that Benson allowed himself a great deal of artistic license with his subjects. The girls become more graceful and the figures more elongated. We can see where Benson added elements that were not present, eliminated those he deemed distracting, and cropped the landscape to fit his desired composition. As Eleanor once said, "He always made us more beautiful than we were."[45] Perhaps this is how he saw them.

Another portrait Benson might like to have kept is *My Daughter Elisabeth* (CAT. 22). As if tiring somewhat from painting his daughters in the bright glare of direct sunshine, Benson placed Elisabeth in the filtered light beneath a tree. The delicate branches above Elisabeth's head and the rattan chair give a decidedly oriental note to this portrait of a "sensitive intelligent American girl who looks out on the world from under her broad brimmed . . . summer hat with a steady, frank, inquiring gaze."[46] In Benson's affectionate portraits of his daughters *en plein air,* one does not sense the isolation or remoteness often glimpsed in similar works painted by other artists of the time such as Thomas Wilmer Dewing or Philip Leslie Hale. Painted towards the end of his plein air period, *My Daughter Elisabeth* was finished in time to be unveiled at the National Association of Portrait Painters exhibition at the Art Institute of Chicago in January of 1916. It was privately shown in Boston and six more museums, including the Detroit Institute of Arts, where funds were raised for its purchase.[47]

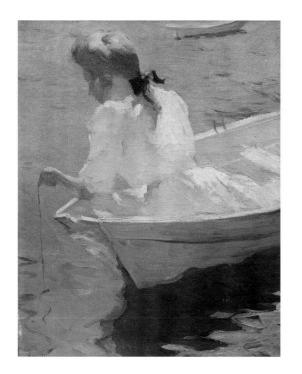

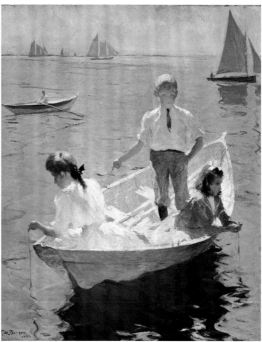

FIG. 14. Frank W. Benson, *Eleanor in the Dory* (former title: *Study for Calm Morning*), 1904. Oil on canvas, 20 x 16 inches. Private collection. This is one of at least three studies that Benson painted for *Calm Morning*.

FIG. 15. Frank W. Benson, *Calm Morning,* 1904. Oil on canvas, 44 x 36 inches. Museum of Fine Arts, Boston. Gift of the Charles A. Coolidge family.

My Daughter Elisabeth is an excellent example of what Benson meant when he explained a basic premise to his daughter Eleanor: "Design is the only thing that matters. Picture making has become to me merely the arrangement of design within the frame. It has nothing to do with the painting of objects or the representation of nature. You must make your plan from the beginning and put down on your canvas the lights and darks and lines and directions that indicate that plan so that it shows from the start that it is good."[48] Benson has carefully arranged his blocks of light and dark, focusing on tone and depth. His diagonals keep the viewer's eye moving about the canvas, while Elisabeth's upright form centers the composition. Subtle repetition is created as the line of the collar and the crossed ribbons echo the open weave of the rattan chair. Yet Benson's methods are not obvious. He left much to the viewer's own discernment. As he once said, "People . . . don't know that they have [this sense,] but they recognize great painting."[49]

In an effort to create great paintings, Benson was exceedingly hard on himself. He abandoned paintings that were half-finished, he destroyed canvases even after they had been framed and exhibited, and he painted over works that most artists would have deemed perfectly acceptable. Beautiful studies exist for paintings that are not known to have been completed. *Girls in the Garden* (CAT. 17) appears to be such a work. Its small size and the fact that there are no records of a finished version of this painting of Benson's three daughters would indicate that this may well have been a study rather than merely an unfinished oil. It is puzzling because all the ingredients of a fine painting are there: brilliant sunshine, a pleasing pattern of lights and darks, and a well-balanced composition. Yet, Benson did not sign it.

Benson's usual method of beginning a painting was to sketch it lightly on a canvas that had been prepared with a wash of light gray. While he usually then composed and painted the finished oil directly on the canvas, he occasionally made small studies, combining them into a larger work. *Eleanor in the Dory* (former title: *Study for Calm Morning*) (FIG. 14) is one of these. For the well-known oil *Calm Morning* (FIG. 15), now in the collections of the Museum of Fine Arts, Boston, Benson made three known studies. One study features George standing in a dory while his sister Elisabeth dangles a fishing line over the side. In the study loaned to this exhibition, we see Eleanor in a white dress leaning over the stern of the boat trailing a fishing line in the water. Sunshine shimmers on the waters of Penobscot Bay; its reflection bathes the children in a golden light. It is no wonder that a critic made this comment on the painting: "The ruling pre-occupation, that of the sunlight effect, as it affects color, brings about this result of brilliant sameness, so that the dominant note is rainbow-like, and the minor key is conspicuous by its absence."[50]

When Benson's friend and neighbor the sculptor Bela Pratt dropped by Benson's North Haven studio one summer's day, he saw another version of the study that included Eleanor. His enthusiasm for the small painting obviously prompted Benson to give the study to him. Pratt later wrote this account to a former model: "I wish you could see the picture that Frank Benson painted and gave to me this summer. It is a redheaded girl against a background of blue water. It is the best thing Frank ever painted and hangs here over the table in the office. I gave him a bronze cast of Artemis which he admired vastly."[51] Benson may well have agreed with Pratt because, at the time he finished *Calm Morning,* he provided this assessment to Joseph H. Gest, director of the Cincinnati Museum of Art: "This is, I think, my best out of door work."[52]

The painting *In Summer* (CAT. 19) might also be viewed as a study for a larger work, *Summer* (FIG. 16). However, correspondence and interviews with descendants of the sitters have led this author to believe that Benson first completed the larger multifigure work before he drew out various elements to create other paintings. By the time *Summer* was first seen the winter after its completion, it had already been bought by Isaac Bates for the Rhode Island School of Design in Providence. Benson was able to capitalize on an obviously successful motif by using the image of his daughter Elisabeth and Anna Hathaway, who are sitting on the left side of the painting, and creating *In Summer*.[53] The central figure of Eleanor became *Sunlight*. At the request of her father, Benson also completed a portrait of the figure on the right, Margaret Strong. Photographs exist for the figural groupings of *Sunlight* (FIG. 17) and *In Summer* (FIG. 18) as well as for a three-figure group that does not relate to any known painting.

While the larger work is perhaps one of Benson's most famous and most often reproduced paintings, the smaller canvas, *In Summer,* is no less a tour de force. When Benson copied the two girls on the left of the *Summer* canvas to a smaller format, he adjusted the composition to compensate for the missing figures. Elisabeth's hat has been moved closer to her. A blue shawl or jacket and

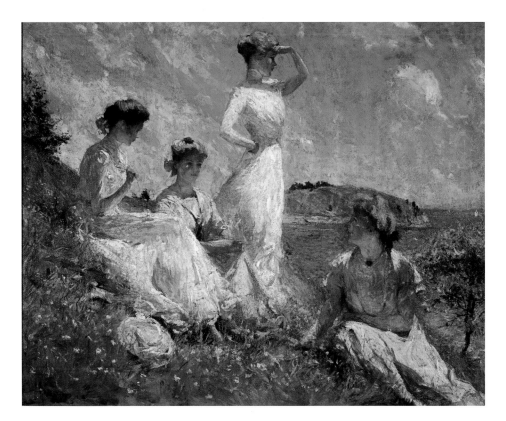

FIG. 16. Frank W. Benson, *Summer,* 1909. Oil on canvas, 36⅜ x 44⅜ inches. Museum of Art, Rhode Island School of Design, Providence. Bequest of Isaac C. Bates. Benson painted his daughter Elisabeth, seated at the left side of the work with her friend, Anna Hathaway, and Eleanor, standing. A neighbor, Margaret Strong, is at the right of the painting. From this work, he created at least three others. The portrait of Margaret Strong now hangs in the National Gallery of Art in Washington, D.C.

FIG. 17. Elisabeth Benson and Anna Hathaway, North Haven, Maine, ca. 1909. Phillips Library, Peabody Essex Museum. Benson often used photographs as an aid in completing his summer paintings as they were being finished in his studios at North Haven or Boston.

FIG. 18. Eleanor Benson, North Haven, Maine, ca. 1909. Photograph, Phillips Library, Peabody Essex Museum.

a number of trees on the horizon have been removed, perhaps as distracting elements. The figures have also been moved closer to the picture plane and, without the upright figure of Eleanor to crowd them, the composition seems more open. The brilliant blue of the sky with its many clouds in the larger work has been rendered more subtle and monochromatic in the smaller one; it has a calmer quality.

Public and critic alike were captivated by these "indescribably delicate and luminous pictures of his daughters in their light summer gowns."[54] In them, one can glimpse the passage of girls to womanhood, a rich family life, and the idyllic times at North Haven that became Benson's children's spiritual inheritance. Benson's plein air paintings were welcomed not only as stunning displays of his mastery of light but also as an antidote to the relentless industrialization that was sweeping America. His sunny records of tranquil settings may have helped fan the national nostalgia for old New England. His interiors, replete with antiques and elegant objets d'art, reflected a life to which people could aspire, or at least admire.

When not at his summer home on North Haven Island, Benson painted studio works— stunning interiors with models and still lifes. His figural compositions, part figure study and part still life, are dramatic works that combine graceful women in elegant gowns with carefully arranged displays of porcelains, flowers, bowls of fruit, and luxurious fabrics. While the majority of Benson's interiors were done in his Boston studio, a few were created at North Haven. Benson's home, Wooster Farm, was an old, foursquare frame farmhouse. Its central chimney provided fireplaces that warmed the family on rainy days and cool, foggy Maine evenings. The fireplace in the

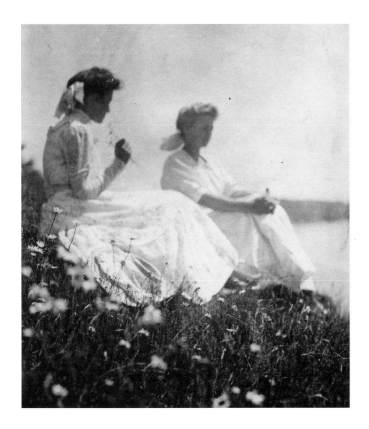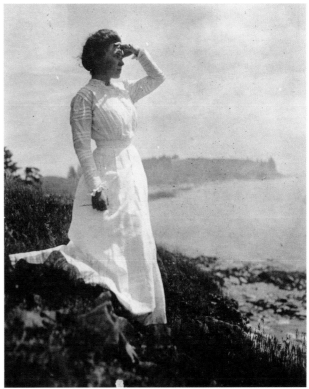

living room of Wooster Farm became the focal point for Benson's first known North Haven interior, *Rainy Day* (CAT. 23). In this painting, we see young Elisabeth curled up in the same rattan chair that her father would use nine years later for her outdoor portrait, *My Daughter Elisabeth*. The daylight that comes through the window has a distinctly cool and misty quality, and it dimly lights the fascinating interior full of old furniture and decorative objects that the Bensons had collected in their four years of living on the island. As Dean Lahikainen notes in his essay in this volume, Benson carefully chose the accessories and furniture he used in his interiors and still lifes. They reflect not only his own particular taste and sense of aesthetics but give a glimpse of the objects that had been handed down for generations through both the Peirson and Benson sides of the family.

Another rare North Haven interior is *Young Girl by a Window* (FIG. 19).[55] Painted during the summer of 1911, this work had already been sold by the time it was first seen at the Ten's New York show the following spring. Seated in the now-familiar rattan chair, Eleanor's graceful figure curves slightly toward the light of the window while her hand reaches out toward a vase of flowers. It is as if she were the human connection between the sunny garden just outside the window and the flowers that so recently grew there. The diffused light filtering through the curtain illuminates Eleanor's Chinese mandarin coat. The sunlight is echoed in the bright oranges and yellows of the flower arrangement. This decidedly golden palette was a sharp contrast to the bright blues and whites of his outdoor works, but the critics welcomed the change, calling the work an "attractive pictorial effect." Introduced at the same show where *Sunshine and Shadow* was first seen, this canvas was only exhibited once and remained in a private collection until it was donated to the University of Georgia.

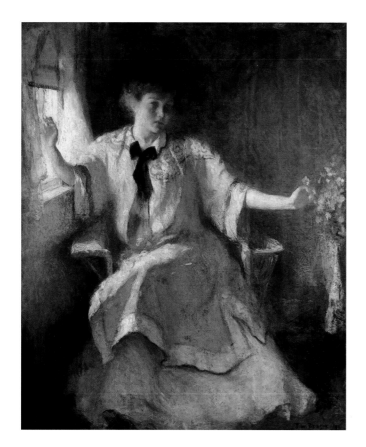

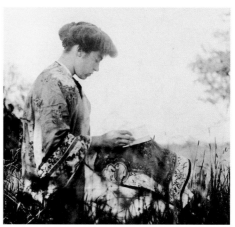

FIG. 19. Frank W. Benson, *Young Girl by a Window (Woman near Window, Maid in Waiting)*, 1911. Oil on canvas, 30 x 24 inches. Eva Underhill Holbrook Memorial Collection of American Art, Georgia Museum of Art, University of Georgia. Gift of Alfred Holbrook, 1945.

FIG. 20. Eleanor Benson wearing her Chinese mandarin coat, North Haven, Maine, ca. 1908. Photograph courtesy of Faith Andrews Bedford.

Benson made frequent use of the beautifully embroidered silk mandarin coats that had been brought back from the Orient by his ancestors. His daughters and his wife had them and used them as evening wraps. In New England, these coats were perennially in fashion; many of the hand-embroidered ones Benson used in his paintings still exist. The way their silken sheen reflected light appealed to Benson. Their shimmering colors and rich designs figure in over a dozen of his paintings from the next decade, both in still lifes and in interiors with figures.

Benson photographed Eleanor in her blue mandarin coat sitting on a hillside reading at Wooster Farm (FIG. 20). Since these delicate coats were not worn routinely, it is not likely that Eleanor was accustomed to wearing hers merely to sit on a grassy slope and read. It is more probable that Benson took this photograph of his eldest daughter as she posed for a painting. If so, such a work was probably not completed because no such painting has been discovered, and no description of it has been found in the literature. There exist in the family photograph albums many such snapshots—groupings of women in studied poses and artfully contrived settings—that suggest that Benson was contemplating painting such scenes. Whether he ever actually executed paintings of these groupings is not known.

In 1904, two years before *Rainy Day* was created, Philip Leslie Hale, Benson's friend and fellow instructor at the Museum School, stimulated serious reconsideration of Vermeer's work. He published a monograph on this subject in the Masters in Art series. The effect of Hale's writings on his Boston colleagues can be seen in works that reflect Vermeer's treatment of light and subtle tonalities in carefully composed interior settings. His fellow Boston painters—Benson, Tarbell,

Paxton, and DeCamp—were inspired by this reassessment of the Dutch master. The Boston School of figure painting soon became the standard for restrained, elegant interiors with models engaged in quiet pursuits. Other members of the Ten American Painters group soon followed suit. Childe Hassam's famous "window series" was first exhibited in 1907, and critics praised this new note in American painting, pronouncing it "all the careful drawing in color of the little Dutchmen and the modern knowledge of light added."[56]

An admirer of Vermeer's work even before Hale's treatise, Benson had always kept a small print of his *Young Woman with a Water Jug* in his studio. When his daughter Eleanor began to paint, he gave it to her as a fine example of the painting of natural light, the richness of old world tonality, and the importance of well-balanced, simple composition.

Few of Benson's paintings show his interest in the work of the seventeenth-century Dutch masters more than *Figure in a Room* (CAT. 27). In this work, one can see strong allusions to Vermeer's style in the arrangement of furniture, drapery, and accessories. Vermeer's creation of a large blank space between the window and a painting or mirror on the wall is echoed time and again in Benson's interiors. In this work, the mirror high up on the wall behind the model was used to good advantage, not only as a design note but as a means of reflecting the model. In the elegant composition of *Figure in a Room,* the golden light from the window suffuses the whole. Its warmth is echoed in the color, both of the drape and the wall. The model's dark blue mandarin coat (seen also in *Sunshine and Shadow*), with its notes of coral, is echoed in the blue of the oriental drape on the candlestick table. Glimpses of the model's white dress add bright highlights to her dark costume. Benson even made the flat wall interesting, with its subtly rendered surface, its distance behind the model, and the play of light upon it. The three-quarter standing figure is posed in a shallow dimension, unlike a number of Benson's other works of this era that place the viewer at a greater distance from the model. Where the Dutch painters might have placed a box of jewels on the small table, Benson used instead Bela Pratt's statue of Artemis.

That the figure of Artemis is but a dark silhouette against the dusky curtain illustrates well what Benson meant when he was advising Eleanor about subtlety and gradations: "What gives charm to a picture is not the brilliant color—the strong contrast—but the delicate bits, where one thing comes against another with no difference in value, and only a slight one in color. This is what is hard to do, and hard to see. Only a trained eye can see it. But the doing well of these bits is the most essential part of making an interesting picture. What makes the difference between a good picture and one where only the obvious differences are put down is how these delicate, intimate details are made."[57]

It would appear that the light that falls upon the model in *Red and Gold* (CAT. 29) might well come from an unseen window because it lacks the warm tones that Benson employs when his illumination is lamplight or firelight. Nevertheless, this work, done more than fifteen years after

Benson's firelight series, employs the same dramatic contrast of light and dark. The model is posed leaning on a table covered in white damask and appears to have been caught as she decides whether to wear the string of beads that lies before her on the table. The dark cord on her fan and her deep-toned sash echo the black of the Chinese screen behind her. Yet her raven-black hair is even darker than either of these elements. Her eyes meet the viewer's with a steady gaze. The color scheme is refined. The whites of the tablecloth and her dress are offset by the deeper tones of the screen, while the red shawl, which Benson had previously used in one of his firelight paintings, adds a note of exotic brilliance.

Equally rich in color is Benson's last known interior, *Reflections* (CAT. 30). The model, believed to be Elisabeth, wears a yellow mandarin coat and gazes serenely at her reflection in a silver mirror. First seen at an exhibition at George Gage's gallery in Cleveland, the painting was immediately bought by Edwin C. Shaw, president of the Akron Art Institute and a collector of Benson's work. In this painting, the light illuminates the model from the right, brightening the hem of her dress, the sleeve of her coat, and the rich brocade of the tablecloth before fading away into the dim recesses of the room. The delicate crystal chandelier is merely suggested in the upper left-hand corner of the work because Benson clearly wants to focus the viewer's attention on his model. The light that falls on the objets does not sacrifice the solidity or the character of these elements but heightens Benson's choice of arrangement of space against space and tone against tone.

Benson's mastery of light in his interiors is emphasized by his painterly technique: his pigments were applied carefully and with restraint. When several of his interiors were seen in 1922 at the Carnegie Institute, they elicited the following review: "[These paintings are] highly technical and tonal in quality. . . . There is none of the sensational work, nothing to strike the eye forcibly. All of the paintings are done according to traditional training. . . . they make a fine collection."[58]

In *Reflections,* as in so many of Benson's interiors with figures, the accoutrements and the objets d'art are almost as important as the model. Indeed, the young women who posed for these works could almost be viewed as decorative elements within still lifes. Some modern-day critics have found fault with Benson and his contemporaries for depicting women as idle, vacuous creatures. Yet Benson's models are not merely elegant decorations but have a serious, intelligent bearing. Benson's paintings of women—both models and his own daughters—pay recognition to those attributes. As a father of three daughters, he was able to capture easily the sense of hearth and home—the feminine preserve of the day. He portrayed his models in quiet, private moments and posed them in such a natural way that they were easily recognizable to the viewer as a wife, sister, or daughter.

Benson's interiors reflected the dominant cultural ideal of his day. That paintings such as these sold, and sold quickly, was not lost on Benson. He was a consummate businessman and adept at marketing his works. Both his plein air works of his children and his interiors with figures embodied a reaction to the realism that was creeping into art and was resisted by many. As one

critic remarked, "We must have our ideal of grace, of dignity, of elegance; and we naturally turn to those . . . who, whatever their defects, in some measure satisfy our desires."[59] Benson's settings and his models were chosen for the sense of beauty that they personified and for the New England way of life that they reflected.

Benson's famous still lifes illustrate well his focus on the importance of composition as well as on light and shadow. When he was teaching his daughter Eleanor to paint, he commented frequently on the importance of these things: "But at all times observe minutely the delicate variations of value between one thing and another or between the light and shadow. Do not paint the figure, the rabbit, the instrument. Paint the light and shade and interrelating values of the whole thing."[60]

In the still lifes that we have hanging in this exhibition, one can easily discern Benson's opinion on this subject: "In arranging a still life, you are carried away by the beauty of the things themselves, instead of arranging them so that light is beautiful. Don't paint anything but the effect of light. Don't paint things."[61]

When *The Silver Screen* (CAT. 31) was first seen, this "arrangement of fruit and rare stuffs seen in a beautiful enveloping light with pale gold, tender blues, silver white and hints of remote pinks and ivory tones" was called masterly. "The perfect harmony of color and design of this picture gives absolute satisfaction and a rare quality in this age of modern . . . methods."[62] The textures of the silver screen, glass, bowl of fruit, and embroidered cloth are evoked in the richly worked surface of this handsome painting. Again, we see the lustrous yellow mandarin coat, now draped gracefully on yet another piece of oriental fabric, this time a French blue through which are woven golden and apricot threads whose colors echo those of the coat and the fruit in the glass bowl. To carry the Asian theme further, Benson carefully placed a porcelain jar to the right of the composition, its strong verticality echoed in the lines of the screen, the legs of the gateleg table, and the folds of the tablecloth. Benson also concentrated on teaching Eleanor the proper way to paint cloth: "Describe the lights and shadows of the drapery in masses. Pay special attention to the direction of folds in relation to the design. Invent if necessary."[63]

As if to keep the viewer from becoming overwhelmed by the brilliance of the colors in *The Silver Screen,* Benson added touches of dark in the base and top of the jar, the edges of the coat, and the table legs. He encouraged Eleanor to achieve such a balance: "When we speak of color, we do not mean colors, such as the green of leaves or the pink of cheeks. We mean the effect of light on an object, and the effect which one color has on another nearby."[64]

The Silver Screen sold very shortly after its first exhibition in Boston, and Benson had, yet again, tapped a responsive chord in his collectors.[65] His tabletop still lifes won several awards, and all sold quickly. Benson obviously found the challenge of creating still lifes rewarding. Just before sending the one that was to mark the inauguration of this period in his painting to the Corcoran Gallery of Art for its seventh Biennial Exhibition of Contemporary Oil Paintings, he chose to share

this confidence with the director, C. Powell Minnigerode, an ardent admirer of Benson's work: "I have just been looking at it here and I think it the best painting as painting that I have ever done."[66] Enthusiastic words, indeed, for a man who was unusually modest and self-effacing.

Benson's love of the effects of light is very much in evidence in his still lifes, which he began to do in earnest after 1919.[67] He completed over thirty such works in the next twenty-four years—mostly variations on a theme. He frequently used the luminous quality of a silver screen to reveal the subtle reflections of the colors in the objects placed before it. Vases of water became beautifully translucent. The brilliant colors of the objects he arranged on the table complement each other. The shadows of the objects become as much a part of the composition as the objects themselves. His highlights—usually deft strokes of white—keep the paintings vital. His subtle gradations of color and sense of tone and harmony maintain a vibrancy in his still lifes that belies the genre's alternate title of *nature mort.*

In his still lifes, as in few other areas of his art, Benson sometimes missed the mark and forgot his own advice that "Design makes the picture." As he told Eleanor, "Good painting can never save the picture if the composition is bad. Good painting—representation of objects—is utterly useless unless there is a good design. That is the *whole object* of painting, and unless you can think in those terms, you will never be a good painter."[68] There are a few unfortunate examples of still lifes where the elements have no relationship to each other and are merely things scattered about on a tabletop. It is true that they were all sold. One wonders, though, how Benson let them pass his discerning eye; he would actually scrape the paint off an offending work, as he once advised Eleanor to do. "It is perfectly possible, with all those handsome things to paint, to go on making each thing better and better and at the same time to have the picture grow worse and worse," he once commented when she was working on a still life. "The reason it looked well at the beginning was because in order to get the thing laid out quickly you have to make everything flat and simple. Don't paint each object for itself, separately, but as a part of the whole. Paint the atmosphere, in which all the objects are, and in which they have their relations to each other. Don't fuzz things up, and mess the paint around. If it isn't right, pushing it around and blending it in won't make it so. Scrape it off and put in something that is right, drawing the shapes carefully."[69]

Although *The Silver Screen* and Benson's best known still lifes—the ones in major museums —are oils, many of Benson's works in this genre were done in watercolors. This light, quick medium is perfect for translating the fleeting blooms of a garden. From his backyard in Salem, Benson would gather dogwoods, peonies, and tulips and take them to his Boston studio at the Riverway, combining them with the same oriental jars and draperies that he used in his larger canvases.

By the time he had reached his late seventies and was no longer traveling regularly to his Boston studio, Benson moved his paints and easel to his home at 14 Chestnut Street.[70] In the backyard of his home on that broad tree-lined street where stood some of Salem's most beautiful

Federal-period houses, he found plenty of flowering things to portray in his late still lifes. Ellen had a small garden in Salem and also kept her windowsills full of potted plants: miniature orange trees, azaleas, and ivies.

Mrs. Stephen Phillips well remembered stopping by to visit her elderly neighbor in the late 1930s and 1940s and watching him create one of his watercolors: "The birds hopping in the trees, the light slanting down through the leaves, the look of the light of an early spring morning . . . he caught it all so quickly."[71]

Despite tremors in his hands, Benson was able to control the flow of pigment on paper in a way that enabled him to create colorful works deftly. Mrs. Phillips particularly admired a painting in which Benson had combined two small azaleas—one in a terra cotta pot and one in an oriental vase—with a Chinese figurine (CAT. 36). Ever the gracious host, he gave it to her immediately. We are fortunate to be able not only to hang this charming work but also to exhibit the little figurine that plays such a featured role in this handsome composition. One can quickly see Benson's eye for design at work as he places the various elements on different levels. The strong horizontals in the pot and saucer of the azalea on the left, the design of the vase, and the panel behind the figure, are balanced by the verticality of the figurine, the doorway moldings, and the little trees themselves. Benson's placement of the tiny Japanese woman and her drum is so natural that she might almost have been standing beneath a flowering plum in her native land. The deep russet of her gown is a few shades deeper than the pot that, in turn, is a deeper hue than the soft coral of the azaleas. These warm tones complement the various shades of blue that Benson has used on the oriental jar, the tablecloth, and the background. He captures the clear sunlight with bright washes of yellow and plentiful use of white. The oriental motif is further carried out by the embroidered silk drape on the table that echoes both the musician's costume and the delicate foliage of the azaleas.

When Benson was in North Haven, he had a much wider palette of flowers from which to choose. If he was an artist with paint, his wife, Ellen, was an artist in the garden. The cool mists off Penobscot Bay created deep green foliage and nourished ferns. Ellen's gardens were full of billowing clouds of phlox and petunias, soft drifts of cosmos and lavender, and bright pools of cheerful marigolds and nasturtiums. The colors were made more luminescent as the fog drifted across the grass in long fingers of pale gray. "It was," as his daughter remembered, "like looking out at an ever-changing painting."[72]

Nasturtiums in a Vase (CAT. 33), a loose arrangement of this bright summer flower gathered in a pottery vase, is a typical result of the Bensons' combined efforts. The brilliant oranges, golds, and crimsons of the flowers spill over the edges of the vase and mix their colors with the jaunty flowers on the Mexican jug. Ellen's daughter remembers her mother carefully arranging a vase of flowers and placing it on the dining room table only to find that her husband had spirited it up to his studio to paint it.

Benson's North Haven floral watercolors featured many different flowers and a variety of vases. Unlike his oil tabletop still lifes, for the most part, these works focused on the flowers and their containers and were not parts of arrangements of various fabrics, furnishings, and objets d'art. Such titles as *Peonies, Hawthorne Jar, Phlox, Pewter Pitcher* (phlox in a pewter pitcher), *Blue and Gold* (marigolds and bachelor's buttons), *Pink Peonies, Nasturtiums, Study of Phlox,* and *Mixed Flowers* give a glimpse into the wide range of blossoms that Ellen arranged and Benson painted. What these simple compositions might lack in complex shadows of object against object or undulating folds of fabrics, they made up for in sheer joyous color. In *Bouquet of Flowers,* Benson painted Shasta daisies, Icelandic poppies, and bachelor's buttons in brilliant shades of butter yellow, orange, royal blue, and brilliant white arranged in a simple white bowl against a mottled background of deep eggplant.

In *Peonies in Blue China* (CAT. 32), Benson departed from his simple arrangements and returned to a composition more often found in his oil still lifes. The pale pink peonies have been arranged in what appears to be a blue-and-white cider jug that was seen earlier in *Rainy Day,* while behind that is placed an oriental jar with a pierced black wooden top. The background is a screen or a draped piece of fabric on which is embroidered an ornamental design of flowers. The whole painting is a whirl of floral images and bright color. This painting was originally purchased by Duval Dunne, the son of the man who bought Benson's large oil still life *The Silver Screen.*

Benson did not just paint the flowers of North Haven; he painted the gardens as well. His watercolor studies include two versions of the gardens that Ellen and Sylvia planted together.[73] He also painted numerous watercolors of the little pond behind Wooster Farm that Ellen had filled with water lilies and ringed with iris. This small pond lay close to the edge of the spruce woods where Benson often posed his children for his plein air oils. Benson found the changing nature of this little pond fascinating and painted it often. He is known to have done at least five watercolors and one large oil of this lovely water garden. Much as Monet painted haystacks or cathedrals in different lights, Benson painted the pond in different seasons. The similarities between his studies of the lily pond and Monet's many paintings of his water gardens in Giverny were not lost on the critics. When *Lily Pond* was first seen at a one-man show of Benson's watercolors at the Guild of Boston Artists in 1923, a critic noticed it: "Perhaps following the Frenchman's distinguished example, Mr. Benson has constructed on a summer's day in Maine a watercolor that could not fail to attract a painter's attention."[74]

The palette for Benson's "lily pond" series ran the gamut from the light greens of early summer, with pale rushes ringing the pool and small white blossoms of the water lilies just beginning to unfold, to the lush dark greens and violets of mid-summer. In autumn, he painted the pond in hues of brown, with pale cattails standing at the edge and fallen leaves dotting the surface.

In *Iris and Lilies* (CAT. 50), we can see that Benson has rendered the far bank in swaths of indigo, violet, and green while the dark surface of the water is scattered with the bright highlights

of white lilies caught by the rays of sunlight. Such a study of wild iris and water lilies illustrates well Benson's mastery of color and light as well as his effective use of the white of the watercolor paper itself.

Benson did not take up watercolors to paint flowers. It was just such floral paintings that originally turned him away from the medium. "I had always looked upon watercolors rather indifferently, most of the ones I had seen had been soft and pretty," he told an interviewer in 1935. "But, I came to realize that the medium was one which could be exceeding strong and expressive."[75] It was the realization that he could use watercolors to paint the scenes that he saw on his many fishing trips that opened up a whole new period in Benson's career.

In 1921, while making preparations for his annual salmon-fishing trip to Canada's Gaspé Peninsula, Benson heeded his son's advice and packed a pad of watercolor paper and a box of colors. He had painted scenes of men at sport sporadically for over twenty years, first in ink wash and later in oils, but there are no known watercolors done during his first twenty-five years of salmon fishing. There did not seem to be any need for a learning period. By the time he took up watercolors seriously, Benson had been out of art school for nearly forty years. His first watercolor, *Malin Run,* done at Gus Hemenway's fishing camp, the Bon Salmon Camp on the Bonaventure River, is as handsome as those done during the peak of his watercolor work (the 1920s and 1930s).

The rivers Benson fished, the marshes in which he hunted, the upland fields that held rabbit and quail, his companions, their camps, boats, and catch would all figure prominently in his watercolors from that point forward. Soon, he was taking the easily transportable watercolor pad on all his trips, not only in New England but also on vacations in Alabama, shooting trips to North Carolina and Lake Erie, winter hikes to the hills of New Hampshire, and to local skating ponds.

The rapidity with which he could capture a fleeting moment in watercolors appealed to Benson because, as he once told Eleanor, "Those things which you do when you are freshly inspired and excited by the beauty of what you are seeing before you are important things. If you go back to them later and think you will improve them by making them carefully, slicking them up, you will lose that important thing and there is no method of getting it back. It is gone for good. Let things look rough, rather than try and smooth them out. There is a certain inspiration which comes when you work quickly and surely and [are] enthusiastic about the beauty of the light."[76] Benson's grandson remembers watching him begin a watercolor, realize it was not going well, and crumple it into a ball.[77]

The response to this new dimension in his art was astonishing. It quickly became clear that Benson could turn out these works so quickly and sell them so promptly that some sort of record-keeping was in order. To keep track of what he had painted, where it was exhibited, and who bought it, Sylvia, his youngest daughter, who was by then acting as his secretary, began keeping a list of her father's watercolor work. By 1946 when she discontinued the list, he had painted 563 that were sold or exhibited.[78] The list does not include the dozens he gave away or the more than

fifty he executed between 1946 and his death five years later.

In a 1922 review of Benson's watercolors (a group he had brought back with him from a winter trip to the Bahamas), the critic for the *Boston Evening Transcript* wrote that, upon seeing the works, he was "struck with the joy of existence, the fact that merely being is an exhilaration and the convincing proof that youth is not a question of years." Although *Sunlight in the Woods* (CAT. 76) was painted two years after Benson's Caribbean trip, it illustrates well the critic's comment. Summer sunlight suffuses the painting, and the rhythm created by the tree trunks adds interest to the composition. That Benson should have mastered this new technique in so short a time astonished the reviewer: "He has great knowledge of the limitations of aquarelle, knowing when to stress his medium or to have respect for the beauty of the white surface on which he is working, or with a brush full of color, express a brilliant note of sunlight through foliage."[79]

In numerous watercolors done on the Gaspé Peninsula, we can see that this medium was perfect for conveying Benson's fascination with the complex light effects to be found in moving water. The patterns as the water rippled over rocks or flowed swiftly are conveyed with flickering brush strokes over transparent washes accentuated with splashes of color. Still pools and wide rivers are well developed in wide bands of translucent color.

When one considers *Morning Sunlight* (CAT. 67), a work probably done on one of the many rivers Benson was fishing in Canada, one can see why critics saw a similarity to the watercolor work of John Singer Sargent and, most especially, to that of Winslow Homer: "The love of the almost primitive wilderness which appears in many of Homer's landscapes also characterizes Benson's work, and the swift, sure touch with which he suggests rather than describes these solitudes of northern woods is very much like Homer's."[80]

Benson's approach to watercolors indicates that he might have studied Homer's methods. For the most part, he abandoned detailed drawing and let his brushes convey broad outlines and delicate details. The majority of the painting is created freehand with brush and pigment. By using transparent washes to reflect light, he discovered that his colors became more luminous. Careful control allowed him to build up washes of color and still maintain transparency. Benson conveyed mists by soaking his paper and then placing his paints. Using this new technique, he was able to convey water, atmosphere, and light skillfully. Often, his sportsmen have indistinct features, focusing the viewer's attention on the composition—as carefully planned out in his on-the-spot watercolors as in his monumental oils.

Benson's watercolor of a salmon rising to the fly evokes the thrill of the catch combined with the ambivalence a skilled fisherman must feel at the end of a fight with a big fish. His paintings of the masculine pursuits of fishing and hunting in the unspoiled wilderness reminded Americans that, despite the creeping urbanization of their country, vast tracks of open land still existed.

Benson's sporting watercolors were, indeed, "strong and expressive." Their vigorous quality

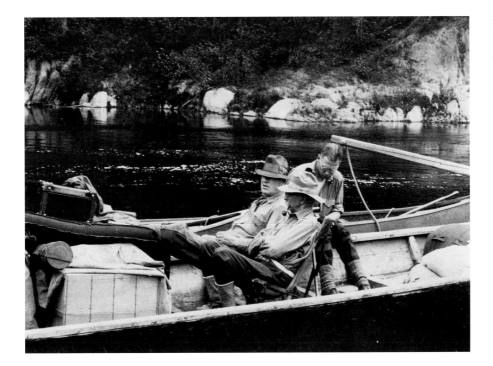

appears to be an extension of the male camaraderie that was such an important part of Benson's life. Most of his friendships were made at the all-male Tavern Club, where artists and affluent men from Boston's business and professional worlds gathered, not only to share meals but also to prepare theatricals, organize outings, and play billiards—a sport at which Benson excelled. Many of his salmon-fishing trips as well as his trips to the private Long Point Hunting Club were made in the company of his two closest friends, Arthur Cabot and Augustus Hemenway (FIG. 21). Cabot, a Boston physician, was a major collector of Benson's work as well as that of other American Impressionists. He purchased Benson's first exhibited oil of wildfowl and later donated it to Harvard University. Hemenway, a wealthy real estate broker, also owned a number of Benson's works, as well as paintings done by other members of the Boston School. Many other Tavern Club members were also collectors of Benson's sporting works. Indeed, whenever Benson had an exhibition of his sporting watercolors, the list of lenders looked almost like a Tavern Club roster.

The decorative aspects of Benson's sporting watercolors were as important to him as the arrangement of a still life. The startled ducks rising up into a storm-darkened sky in *Ducks with Purple Sky* make a striking pattern of white against the deep background (CAT. 49). The sky is a murky purple as the approaching storm bears down on the wildfowl; one can almost hear the distant thunder. It is an excellent example of how Benson set his sporting subjects within an envelope of light and atmosphere.

While his early desire to be an ornithological illustrator obviously found fulfillment in such works as *Sighting* (CAT. 64) and *Misty Morning* (CAT. 65), these are not static textbook illustrations;

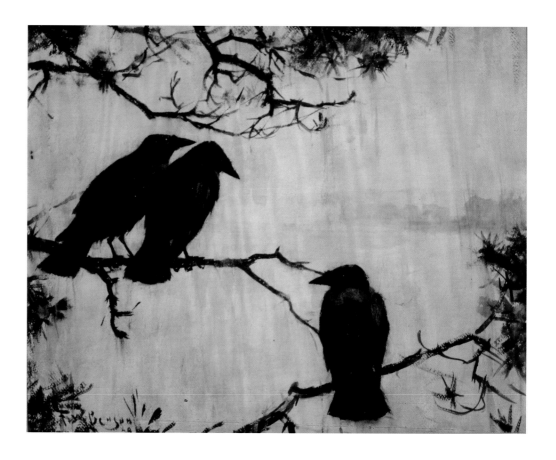

they are the very essence of birds caught in a fleeting moment. The former demonstrates clearly the effect Abbott Thayer's theories of natural coloration had on Benson's studies of birds. In a number of Benson's works, the representation of the bird's coloration and its natural habitat is so accurate that it is difficult to see the subject.

As Roger Tory Peterson, the famed ornithologist, once wrote in *Audubon Magazine,* there were two groups of artists who painted birds: "those who paint bird portraits"—and here he mentioned Audubon—and "those who paint bird pictures," of which he felt Benson to be a fine example.[81] "I truly admired Frank Benson and feel that he was the best painter of birds I have ever known. He has had many imitators over the years but none have come close to touching his mastery of a bird in flight or at rest."[82]

Crows in the Rain is just such a well-observed study of two rain-drenched birds on a branch (FIG. 22). "A picture or drawing is like a poem," Benson once observed. "When the poet starts, he has no more and no different words to work with than you have. A work of art is made by his choice—selection and combination of ordinary material."[83] It is clear from the oriental feeling of this watercolor that this painting/poem is a haiku. The clusters of pine needles could have been painted by a Japanese master. The misty atmosphere contrasts with the hard black forms of the crows and the dark branch on which they perch. It is puzzling that Benson did not paint crows more often because he found the birds' antics fascinating. Each spring, his son, George, would climb a tree and remove a baby crow or two from its nest to be family pets. Though the Bensons grumbled about their mischievous ways, they were rarely without these feathered summer companions (FIG. 23).[84]

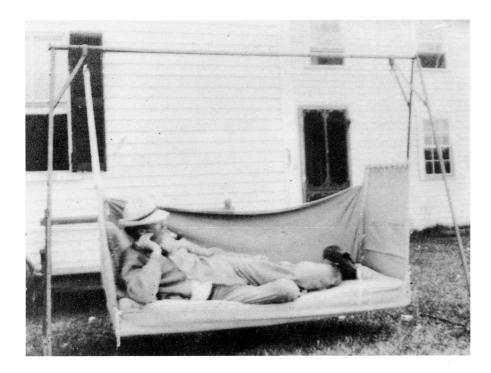

FIG. 22. Frank W. Benson, *Crows in the Rain,* 1929. Watercolor, 19¼ x 24 inches. Collection of Lisa K. Dreyer and Javier Romero Dominguez-Roqueta. Photograph courtesy of the Marine Art Gallery, Salem, Mass. Benson rarely depicted crows in his works. When he did, as in this stunning watercolor, the results were often dramatic.

FIG. 23. Benson relaxes on a swing and feeds tidbits to the family's pet crow, North Haven, Maine, ca. 1908. Photograph courtesy of Faith Andrews Bedford.

Benson had one problem concerning his sporting watercolors: he could not keep up with the demand. His reply to a plea from a New York dealer for more of his popular sporting works confirmed this: "I cannot make any promises for next year as I have not the pictures. Several requests that came before yours I am not able to grant as I have sold all the watercolors some 40 in number that I made in the fall and winter and it is quite impossible for me to make any arrangements long beforehand. I am sorry, for I should like to do as you ask me to."[85]

Initially, Benson was pleased with the response to his new medium. As he wrote C. Powell Minnigerode, "It certainly is very heartening when you do something in a new way to find that other people are pleased with it. It makes life much more fun than it was before."[86] However, as time wore on and the interest in his watercolors only increased, the burden of his success began to grow. He was often not even able to have enough to exhibit at his own one-man shows: "I made [a painting of wildfowl] the other day at home and I looked forward to exhibiting it and, almost before it was dry, a visitor saw it and carried it off! It's my good fortune to be doing what people like, but it keeps me on the jump."[87]

Benson's landscapes were as much in demand as his sporting watercolors, but he painted relatively few of them. While birds had long been his passion, landscapes allowed him to focus on the familiar in a manner that permitted the viewer to see it in a new way. He might well have been remembering a work such as *The Lone Pine* (CAT. 78) when he was cautioning Eleanor about her approach to painting: "Whenever I find myself—as I do sometimes—painting a 'scene,' I am disgusted with myself. Take a small piece of something with a handsome shape—don't include too much.

That tree trunk against the cedars veiled by the thin underbrush in front [is a good example]."[88]

As Benson once said, "If a landscape is not worth painting purely as a design in light and shade, it is not worth painting at all."[89] Certainly, this is the case in his watercolor *Fox Island Thoroughfare* (CAT. 77) because the juxtaposition of shadows and sunlight adds depth to the work. Watercolors such as this convey the same freshness and immediacy as do his works of men at sport or depictions of birds. The qualities of watercolors allowed Benson to convey both the tactile and visual qualities of landscapes such as these.

Looking at *Snowy Hill* (CAT. 79), one might think that Benson was disregarding his own advice about painting landscapes: "[Don't] look for the sort of scenery that a photographer would look for with lots of sky and distant hills. Be broad-minded and don't go out with a pre-determined notion of what you want to find to paint. Intimate studies of light and shadow in a small area are most interesting. A thing to be beautiful must be complicated."[90] The painting's high horizon focuses our interest on the foreground and thrusts the broad expanse of snow-covered mountain into a background role. It appears that this work was painted in late afternoon when winter's early dusk casts long lavender shadows across the valley, leaving the peak of the mountain still bathed in sunlight; the dark shapes of the evergreens punctuate the deepening shadows. The lightly suggested bare branches in the foreground are a good example of what Benson meant by "intimate studies." Painted when Benson was eighty-four, this painting does not reveal the unsteadiness of his hand. Using narrow brushes and animated brush strokes, Benson skillfully conveys the impression of a thicket of winter-bare branches.

Benson was fascinated with the colors of shadows on snow: purples, blues, azure, chartreuse, and yellow. He often painted directly onto the watercolor paper without first giving the paper a wash of pure water. This allowed his colors to float across the texture of the paper rather than seeping into it. The result was that a great deal of white paper showed through in large areas as well as appearing as small dots glimmering through the color that then created the effect of dazzling sunlight. Nowhere is this more evident than in his "snow series," a group of landscapes that allowed him to explore the unique atmosphere created by sunlight on a wintry day.

The treatment of a landscape and water play a large role in Benson's striking oils of sporting subjects. Although Benson had exhibited paintings of wildfowl as early as 1894, his earliest known sporting oil to include a figure—a man shooting coot—was done in 1906. Painted for Harry V. Young in 1915, *Hunter in a Boat* (CAT. 39) is the third known variation on that theme. On a chill, wintery day, a hunter pulls hard at his oars as he assesses the waters and tries to decide whether or not to put out his decoys. Above him, the coots rise and fall with the swells of the ocean beneath them. Benson's years of observing birds stood him in good stead; although simply expressed, these wildfowl could only be coot. The stark contrast of the man and boat silhouetted against the lighter sky further intensifies the stormy quality of the painting.

A painting that Benson exhibited in 1914 shows marked similarities to *Hunter in a Boat*. Calling the painting a "South Shore Epic," F. W. Coburn, the art critic for the *Boston Herald,* gave this description: "On a sloppy and choppy day under a broken . . . sky, a hunter rides his dory with a stern full of decoys up towards a gaunt ocean reef. . . . Above and beyond a few coots are hurtling through the air. The huntsman, his oars poised in the air, is presumably [trying to decide] whether or not it is time to let loose the decoys."[91] Coburn conveyed the feel of the painting well, but he was mistaken about the location: the lonely section of sea depicted in both works is most likely Blackledge Rock outside Salem Harbor.

In using oil paint to depict the scenes he had seen so often on his shooting and fishing trips, Benson's touch was powerful, as befits his subject matter. Using the density of the medium to convey the often heroic figures in his sporting oils, he conveys the strength of men utterly at ease in their wild surroundings. They become at one with the rivers they fish, the marshes in which they patiently wait for wildfowl, and the seas they harvest.

Benson's treatment of water in an oil painting is seen in the late canvas entitled *Dory Fishermen* (CAT. 41). The mood of this could not be more different than that conveyed in *Hunter in a Boat*. Pale streaks of light color the sky and reflect off the silvery water. The blue Camden Hills of Maine establish the horizon, and the impression is of a canvas of pale blues, broken only by highlights on the water. The Impressionist approach can be seen in the quick, light brush strokes, the importance of the play of light, and the sense of a moment captured on canvas. The men in the two Atlantic dories are working in partnership; their camaraderie is well expressed. Painted during Benson's last decade, this work seems to be a remembrance of times past, since Benson wrote in the North Haven log of the enormous catches of mackerel he and his son, George, caught in their nets. This could very well be a study of Benson pulling in a heavily laden net while his son looks for an opportunity to assist him, and their hired man, Irwin Dyer, stands in another boat ready to help bring in the catch.

When Benson was eighty-five, he contributed to an exhibition of sporting art held at the Museum of Fine Arts in Boston. Even at his advanced age, Benson was still happy to send pictures to shows. A newspaper account of an exhibition, believed to be this one, placed Benson at its core: "[No] exhibit of this sort could be complete without Frank Benson, loved of hunter and fisherman. . . . he can fill an atmosphere with moisture as almost no one else can. He can also fill it with light superlatively. He is a brilliant colorist."[92]

One of the paintings Benson hung at that exhibition was entitled *The Blind*. Although it is not certain whether this is the same painting featured in this exhibition as *Goose Blind* (CAT. 57), the description of superlative light certainly fits it well. This handsome canvas was inspired by the ritual of the early morning duck shooting Benson so enjoyed. In the predawn hours, a hunter stands gazing up at a graceful V formation of geese wending their way across a buttermilk sky. The man is

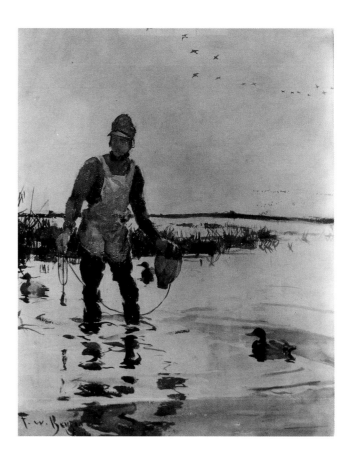

FIG. 24. Frank W. Benson, *Setting Decoys,* 1923. Watercolor on paper, dimensions and location unknown. Photograph courtesy of Faith Andrews Bedford. A hunter is depicted setting his decoys in the early morning light; the landscape would indicate that this was done at Long Point.

somewhat diminished by the vastness of sky and the expanse of water. The shimmering light almost turns the hunters to silhouettes. Did Benson plan to render humans insignificant in the face of nature's grandeur? The geese stream away overhead, unfettered. Perhaps, if we could see clearly the face of the hunter, we might discern a look of wistfulness or longing, not for the moment of the hunt but for the beauty of the birds themselves and their ability to fly so high and so freely. For a related duck hunting image of Benson's, see *Setting Decoys* (FIG. 24).

Twilight (CAT. 73), undoubtedly a scene from one of Benson's journeys to the Gaspé Peninsula, presents a similar sense of man's insignificance in the greater scheme of nature. The tiny figure, placed off center on the canvas, is silhouetted against a patch of luminous water, the only part of the painting that is not engulfed by evening's shadows. Benson the colorist is very much in evidence as he washes his canvas with deep blues and violets, rich greens, and smoky grays. A purple haze almost obscures the distant mountain, making it difficult, as it is in nature, to tell where the mountain ends and its reflection begins. As the swift waters carry the hunter downstream, he gazes at the distant shore, knowing that he needs to return to camp quickly before darkness falls completely. In a work such as this, one can clearly see what Benson believed about color: "Drawing can be learned. A sense of color must be born in a person. When we speak of color, we do not mean colors, such as the green of leaves or the pink of cheeks. We mean the effect of light on an object, and the effect which one color has on another nearby."[93]

While Benson seemed to enjoy painting his daughters on the hillsides of North Haven in the brilliant sunshine of midday, he seems to have preferred the effects created by early morning light

or dusk for many of his sporting works. In *Cup of Water* (CAT. 70), twilight is reflected in the shimmering water of a river. As the guide dips his cup into the silvery stream, he is undoubtedly looking forward to a good meal and a much-deserved rest after a strenuous day of fishing for salmon.

The campfire has already been lit in Benson's oil *The Campfire* (CAT. 66). Darkness has already cloaked the hills with deep shadows as twilight fades from the sky, and the last bit of evening light is reflected in the river. The fire's bright flames warm the men gathered around it and help stave off the evening's chill. Smoke and bright embers swirl upward into the gathering dusk.

Few artists of Benson's day chose to paint the sporting subjects that earned him such acclaim: "To the great ornithological work that Wilson and Audubon did in America 100 years ago Frank W. Benson has added something imperishable—an artist's dream they knew not; a knowledge of bird flight which places him in a class by himself."[94]

As Benson grew older, hunters and fishermen figured less and less in his works, and he returned, once again, to his early love—birds. In his monumental oils of wildfowl, we can see Benson's emphasis on composition and the effects of light: "A good picture has a certain austerity, a distinction, whether of the thing itself, the lighting, the color, or the arrangement. Mere draftsmanship, representing nature, does not make a picture."[95]

Certainly, *Great White Herons* (CAT. 51), a striking arrangement of brilliant white birds against a blue August sky, fulfills all Benson's criteria for a good picture. Looking like a panel from a Japanese screen, the three herons are each shown in a different position of flight—a device Benson was fond of using to show off the various attitudes birds assume while flying, landing, and taking off. The Japanese feel is further enhanced by the top bird's position—almost cropped by the edge of the canvas. The brilliant white of the birds' plumage is echoed in the open blossoms of the water lilies beneath them and the white of the clouds in the distance. Light grazes the tops of the marsh grass, turning it brilliant chartreuse, while its stems assume a shadowed darkness that is reflected in the smooth surface of the water.

Equally decorative is *Long Point Sunset* (CAT. 42), the large oil of ducks coming in for a landing on the marshes of Lake Erie. Benson the painter is depicting two pairs of ducks silhouetted against a silvery-blue twilight sky streaked with pink and peach. Benson the ornithologist, however, once again takes pains to show his birds in various positions as they drop down for their evening's rest. No one bird replicates the pose of another. Benson has left just enough light to allow the viewer to appreciate the ducks' markings and the softness of their feathers as they extend their wings for landing. The delicate marsh grass echoes the delicate wing tips of the birds, while the clump of trees in the distance helps delineate the horizon.

On the other side of night, an equally decorative effect is achieved in *Ducks at Dawn* (CAT. 43) where the light is that of the rising, instead of the setting, sun. High noon appears to be the time of day depicted in *Osprey and Fish* (CAT. 60): the brilliant, choppy waters are brightly lit, and intense

sunlight glances off the silver scales of the fish and the feathers of the bird. This is a powerful canvas, evoking as it does the mighty pull of the bird's wings as it rises from the water with its catch.

While Benson may have been famous for effective use of color in his watercolors and oils, he was equally well known for his work in black and white. Beginning in the 1890s, Benson began doing a few sketches of hunting scenes in a black-and-white wash and giving them to his shooting companions. From there, he branched out to drawings of wildfowl. Publicly exhibited for the first time in 1913, these wash drawings—all of them of birds—garnered almost instant praise. "Every essential of good art is there," wrote a Detroit reviewer. "Always there is good design. There is beauty of line. There is elimination of all save that which is necessary. There is a fine sense of values. The medium is a wash of ink with beautiful gradations which give one a sense of color."[96] Although only one wash drawing is on view in this exhibition, it is an excellent example of his success with this medium. *Ducks Coming off the Marsh* (CAT. 56) illustrates well how Benson varied the intensity of his wash to project a sense of color, value, depth, and delicacy.

Perhaps it was his interest in black and white; maybe it was the realization that images of wildfowl did, indeed, sell. Possibly, it was because he was looking for a way of relaxing or of wrestling with a new challenge. Whatever the reason, Benson, after a hiatus of thirty years, began etching again in 1912. Beginning with a few sketches copied from old photographs, he quickly moved on to scenes of North Haven, a few wildfowl pictures, and a study of his son with his pet osprey. Obviously excited by this medium, Benson completed a dozen works in his barn studio at Wooster Farm that first summer. His letters to a fellow artist, Charles Woodbury, reveal that in etching, as in painting, he felt that design was important and that restraint was better than too much detail: "I like [your] prints. They show the most contrast in their values—after all, if you cover the whole plate with lines, there has got to be contrast—and some of the most slightly done are among the best."[97]

During the next three years, Benson continued to experiment with the process of etching, struggling to get it just right. As Samuel Chamberlain would later write, "Scraping, burnishing and polishing, he often puts a plate through half a dozen different states in searching for the perfect balance of black and white that marks his great plates."[98]

When a few of Benson's friends convinced him to hang a grouping of his experimental etchings at a one-man show, they sold out almost immediately. While the art critic for the *Boston Herald* admired the sort of work that Benson had done before (sporting works in oils, a group of wash drawings, and paintings of his daughters on sunlit hillsides), it was the "stunning series of new and beautiful painter-etchings" that he felt were "a fresh revelation of creative individual art work of distinctive importance. He is an original and remarkable etcher. To say the etchings are as good in their way as the paintings is the highest praise possible. . . . The very ecstasy of flight is expressed in the swift gliding of these birds in the air. It is as natural as breathing; and to see them

flying is to feel that you, too, could fly."[99]

From this point on, Benson was deluged with requests for his etched work. Collectors put in requests for one of everything he did. For a time, a month did not pass without an article about his prints appearing in a newspaper or magazine. The demand grew so great that he had to delegate the selling of his etchings to an agent, George Gage of Cleveland. Even then, the demand became too great for Gage, who appointed two sub-agents in New York City.

When one considers Benson's etchings, one can see what all the excitement was about. Using "mere" black and white, Benson was able to convey atmosphere, mood, weather, and, yes, even color. Using a burnisher and scraper, Benson achieved excellent tonal and luminous effects, such as the reflective quality of the still water in *The Gunner's Blind* (CAT. 54). The gunners standing out in sharp relief against a dramatic sky in this sparkling print prompted this remark from Samuel Chamberlain: "I see you are etching in color now."[100]

Benson's careful handling of this sense of "color," which could range from a misty gray to rich, velvety black, creates the mood and atmosphere of environments as disparate as a cool Maine twilight or a sultry noonday in Florida. The harmony between setting and subject is not merely observed but felt. Benson's compositions, with their balance of open spaces, middle values (often conveyed by crosshatching), and dark solid shapes, are what help establish the contrasting values of his etchings. Deep shadows extend across still waters from clumps of rushes; branches of trees blacken against the pale glow of an evening sky.

The etchings in this exhibition have all been selected for their qualities of light. Benson was able to portray nighttime sky in works such as *Dusk, Moonlight, Evening,* and *November Moon* (CATS. 59, 38, 44, and 48, respectively). In the last of these, five geese make a pattern against the glow of a rising moon whose reflections shimmer in the water beneath them. Early morning is equally well described in such etchings as *Sunrise* (CAT. 55), *Dawn* (CAT. 47), and the previously mentioned *The Gunner's Blind*.

Benson's many fishing trips gave inspiration to such works as *Casting for Salmon* (CAT. 72), where the single figure of a fisherman is reflected in the moving waters, and *A Cup of Water* (CAT. 71), which depicts a fisherman dipping his cup into the smooth waters of a stream, his reflection making a twin beneath him. In works such as these, the perfect harmony between setting and subject is tangible.

The majority of Benson's 359 etchings depict wildfowl (including twenty-two different species of ducks and over two dozen different birds).[101] He portrayed them in practically every aspect of their lives. They fly, swim, eat, drink, and are even shown as part of the hunter's kill: "Every artist must see things in his own way. He will do this as the Japanese have done it for centuries—study some object in nature until he can draw it from memory by repeated practice. In that way I learned how birds appear in flight, watching them by the hour, returning to the studio to

make drawings, then back to the birds to make corrections."[102]

A number of Benson's works featuring birds show a decidedly Japanese influence. Two of the works hanging in this exhibition, *After Sunset* (CAT. 58) and *Cloudy Dawn* (CAT. 46), focus not only on the qualities at the end and the beginning of the day, but on the spare, open design presented by the birds in flight. This arrangement is not accidental, and it is not natural: "Satisfactory photographs of birds in nature are rare because the most important element in the picture, namely, arrangement and composition, cannot be governed in the case of birds in flight. In my work I put them where I want them."[103] Where he wanted them was in graceful arabesques, in curving lines, in stark designs, gathered in groups of just two, or sweeping across the sky in great flocks.

The delicate lines, the play of light, the color values, the use of empty space, and the graceful depiction of his subjects are all more painterly than one would expect an etching to be. The term painter-etcher was an oft-used and apt description of Benson, and, quite soon, he was called the dean of American etchers and master of the sporting print. His blacks are rich and velvety, and his mid tones convey well the murky light of an approaching storm or the morning just before dawn. Firelight and candlelight are well expressed, and the etchings chosen for the show demonstrate all these effects.

While best known for his etched work of wildfowl, Benson also used the arts of etching and drypoint to depict landscapes and portraits. *Head of a Young Girl* (CAT. 26) may look familiar because it was based on Benson's North Haven interior entitled *Young Girl by a Window* (CAT. 25). Just as the light from the window bathed the figure of Eleanor in the oil painting, that same light is equally well portrayed in the etching of the same subject. In this exhibition are portraits of Benson's daughter Elisabeth and his close friend Augustus Hemenway.

Perhaps one of his loveliest etched figures is *Candlelight* (CAT. 28), a study of his wife, Ellen. A candle stands atop her bureau at Wooster Farm, but all we see of it is the halo it casts around Ellen's figure. The candlelight thrusts deep shadows into the corners of the room and above the mirror in which Ellen is partly reflected. This is one of Benson's most intimate and personal etchings. Like most of Benson's other etched works, *Candlelight* sold nearly its entire print run almost immediately. "We are not exactly happy over the etching question ourselves," Sylvia wrote to a New York gallery owner who had handled Benson's work for several years. "A sudden increase in the demand last year used up our stock in a month. This year they have been mostly sold in a week, apparently. Out of an edition of 150, we keep 25 to sell at advance prices when the first 125 are sold. Every agent but one or two has already wired or written for more prints and they are all issued except about 5 sets which I can sell ten times over. I am trying to take care of old customers, but the thing is beyond me."[104]

It was a problem that many artists might wish to have. Benson's light-filled works, be they in watercolors, wash, etching, or oils, were in nearly constant demand during his lifetime, and that

interest continues still. His last watercolor, a study of the ebbing tide at North Haven, done just a few months before his death at age eighty-nine, is as masterful as any of his earlier works. He felt fortunate that he could work at what he loved: "My work is so interesting that I never really live fully or feel the day to be important unless I have something going on."[105]

What was the secret of Benson's long and successful career? Quite possibly it was that, in his own need to continue to put challenges before himself, he created art that changed with the times and was regarded as fresh and new by traditionalists and new collectors alike. By the time the Ten American Painters had been exhibiting together for seventeen years, young art critics began to view the venerable members of the group as unfashionable. In reviews of their shows, however, these same critics often singled out Benson for praise as one who had kept his art alive and vital by constantly trying new techniques and media and exploring new motifs. In 1938, when the work of Benson and Tarbell was seen together at a retrospective, a reviewer made this summation: "Benson's [art] is amazingly abreast of its day. Tarbell's is that of an era just past. . . . [Benson's] art refuses to age, and it is his latest work, by way of miracle, that is his youngest."[106]

Benson's constant striving to achieve a far distant goal drove him on to greatness. "[Art] is not easy. It is never easy," he told Eleanor towards the end of his life. "There is no magic about it. . . . It has to be studied and worked at, and even then you never really learn it. No one has any magic way of doing it. No one has anything to start with except an over-mastering desire to do it, and the more you have the desire, the more you will work at it and the more you will learn. I am still working at it and learning, and that is all I care about."

It was quite easy, really. Benson followed the light, and success followed him.

Faith Andrews Bedford is a great-granddaughter of Frank W. Benson and the author of numerous works chronicling his life and career.

Notes

1. Frank W. Benson to Eleanor Benson Lawson, "Advice to an Artist: Notes Taken after Criticism after Painting," a typewritten account of the critiques that Benson gave his daughter when she was learning to paint. Benson Papers, Peabody Essex Museum. Hereafter, these are abbreviated as FWB, EBL, "Advice," and Benson Papers.

2. Samuel Chamberlain, "Frank W. Benson—The Etcher," *Print Collectors' Quarterly* 25, no. 2 (April 1938): 167.

3. Samuel Benjamin, *Art in America* (New York: Harper and Brothers, 1889), 192.

4. The show's catalogue was illustrated by Benson's friend and classmate Edmund Tarbell.

5. Lucien Price, *Frank W. Benson, 1862–1951: A Joint Retrospective Exhibition* (Salem, Mass.: Essex Institute and Peabody Museum, 6 June–30 September 1956).

6. "Two Notable Exhibitions: The Thirteenth Show of the 'Ten Americans,'" *New York Evening Mail, 25* March 1910, p. 8. This was written about *Summer Night* (ca. 1909).

7. *Art Amateur* 10 (January 1884): 42.

8. Long known as the Studio Building, this graceful, brick double house was built in 1825 and was also home to several other artists and musicians as well as a private school. Benson rented the room from a family friend, John Robinson.

9. Granddaughter Nancy Lawson Brown, interview with the author, October 1986. The Bensons were married in the Unitarian Church on Salem's Essex Street on Wednesday, 18 October 1888.

10. In 1921, when the director of the Corcoran Gallery, C. Powell Minnigerode, wanted a Sargent painting for a show, he wrote to Benson: "Knowing that you are probably his most intimate friend, the thought occurs to me that you might be able to squeeze such a picture out of him." C. Powell Minnigerode to FWB, Washington, D.C., 21 October 1921, Benson file, Corcoran Gallery of Art Archives, Smithsonian Institution, Washington, D.C.

11. "Advice."

12. Greta, "Art in Boston," *Art Amateur* 24 (May 1891): 141.

13. In the early nineteen hundreds, Benson created a few decorative works or "panels" such as *The Necklace* or *Decorative Panel—October*. While very different from his interiors with figures, these works do not bear the hallmark of Thayer's influence so very visible in the painting *Summer* (National

Museum of American Arts) or *Autumn and Spring* (Rhode Island School of Design, Providence).

14. *Museum of Fine Arts Bulletin* 6 (1908): 34.

15. *Boston Evening Transcript,* 23 January 1886.

16. *Boston Evening Transcript,* 1 October 1889.

17. He was a legendary Thracian poet and musician whose music had the power to move even inanimate objects. This now-unlocated painting, which hung in Benson's house until 1913, may well have been destroyed in the Salem fire of 1914.

18. *Boston Evening Transcript,* 1 October 1889.

19. "The Fine Arts," *Boston Herald,* 8 March 1891.

20. FWB to Gustave Schirmer, 22 June 1891, Benson Papers, Archives of American Art, reel 313. Hereafter, this is abbreviated as AAA.

21. FWB to his nephew Wyman Richardson, 14 October 1947, Richardson Papers, private collection.

22. "Advice."

23. Clarence Cook, "The Sixty-Seventh Annual Exhibition of the National Academy of Design in New York," *Studio* 7 (1892): 163.

24. "Monthly Record of American Art," "The Academy of Design," *New York Sun,* 9 April 1892.

25. "The Academy of Design," *New York Sun,* 9 April 1892. The author is referring to Benson's painting *Twilight* (1891) that won the Clark Prize awarded for the best American figure composition painted in the United States by an American citizen without limitation of age—a prestigious honor for an artist to achieve so early in his career.

26. Hamlin Garland, Lorado Taft, and Charles Francis Browne, "A Critical Triumvirate," in *Impressions on Impressionists* (Chicago: Central Art Association, 1894), 10–11.

27. Eleanor was born in 1890, George in 1892, Elisabeth in 1893, and Sylvia in 1898.

28. *The Bostonian* 1 (18 February 1895). Clipping in the Museum School scrapbooks, Museum of Fine Arts, Boston. The author of the present essay has previously stated that this painting was done in 1893, possibly in Dublin or New Castle. Further study of other family photographs of this time indicates that George was two, thus making the date of the painting 1894 and placing the location of the work in New Castle.

29. Sadakichi Hartmann, "A National American Art," *Art Critic* 1 (1894): 70, 75.

30. *Nation* 46 (1888): 373.

31. In a discussion of a Ten American Painters show, one reviewer divided the group into the "vibratory seven" and included Benson in this appellation—undoubtedly because of this work.

32. Writing to Smith College, which had acquired the work, he said, "I think I might call it my first successful out of doors picture of figures though I attempted quite a good many others."

33. *St. Nicholas Magazine* (1909): 883.

34. *New York Times,* 19 March 1901.

35. *New York Sun,* 20 March 1901.

36. *New York Tribune,* 21 March 1901.

37. "Advice."

38. Unidentified Boston newspaper, 25 July 1912, private collection.

39. FWB to W. H. Johnson, 14 January 1914, private collection.

40. Ibid.

41. FWB to R. A. Holland, 16 October 1912, Benson file, St. Louis Art Museum.

42. On a black-and-white photograph of *Family Group* is written in Benson's hand "destroyed." That such a handsome painting should have been deliberately destroyed is unthinkable, especially in view of the fact that Benson chose to exhibit it in several major annual museum exhibitions and a special loan exhibition. Knowing that the central figure is Eleanor, and presuming that this work was given to her as a wedding present when she married Ralph Lawson in October of 1913, the author has concluded that "destroyed" means that it was burned with all of Eleanor's and Ralph's belongings in the Salem fire of 25 June 1914.

43. Joan Lawson Andrews (Eleanor Benson Lawson's daughter), interview with the author, September 1989.

44. William Howe Downes, "The Spontaneous Gaiety of Frank W. Benson's Work," *Arts and Decoration* 1 (March 1911): 196–97.

45. Joan Lawson Andrews, interview with the author, October 1976.

46. *Boston Globe,* 12 November 1912. While this comment was written by Anthony Philpott three years earlier about Benson's portrait of Sylvia entitled *My Daughter* (Corcoran Gallery of Art), such comments were frequently used to describe Benson's paintings of his daughters. Charles Caffin, writing in *Harper's Monthly Magazine,* offered this description: "The type has something of the character of a fine blood-

ed race-horse, long in its lines, clean cut, spare of flesh, the bone and muscle felt beneath it, movement throughout accentuated—unmistakable signs of pedigree. Psychologically also the type is a product of intensive breeding—a cross between the exacting narrowness of Puritanism and the spiritual sensuousness and freedom of Emerson; a transcendentalism of morals and imagination, blended with a little of the questioning and unrest of modern thought. It is, indeed, a new type: strenuous with a sense of inherited responsibilities, but still having a certain air of self-compelling restraint, as if it held itself back a little in view of possibilities scarce yet realized" [119 (1909): 106].

47. At one point in its exhibition, the price for this work was three thousand dollars.

48. "Advice."

49. Ibid.

50. "The Fine Arts," *Boston Evening Transcript,* 4 November 1903.

51. Bela Pratt to Charlotte Barton West, 1909, Charlotte Barton West Papers, AAA. This author previously felt that the study of which Pratt spoke was a study for the four-figure work entitled *Summer,* now in the Rhode Island School of Design, Providence. The actual painting of which Pratt speaks is similar to the work exhibited here and belongs to a Pratt family member. Benson used the little statue of Artemis (the virgin goddess of the hunt and the moon and twin sister of Apollo) as an element in at least two interiors with figures: *The Open Window* (Corcoran Gallery of Art, Washington, D.C.) and *Figure in a Room* [New Britain (Conn.) Museum of American Art].

52. FWB to Joseph H. Gest, 11 May 1905, Benson file, Cincinnati Museum of Art.

53. The Hathaways and Bensons were close friends. Benson painted not only this study of Anna but also portraits of both her parents.

54. *Boston Evening Transcript,* 9 May 1908.

55. When at North Haven, Benson painted very few indoor works. Currently, the paintings that are known to have been painted in the farmhouse or studio are: *Rainy Day, Young Girl by a Window, Elisabeth, The Sunny Window, Portrait of My Daughter, Elisabeth by the Window* (watercolor), and several still lifes done in watercolors.

56. "The Ten American Painters," *Independent,* 27 March 1905, p. 949.

57. "Advice."

58. *Pittsburgh Sun,* 23 January 1922.

59. David Malcolm, "A Reaction from Realism: The Revived Taste for the Eighteenth-Century Painters," *Art Amateur* 34 (January 1896): 34.

60. "Advice."

61. Ibid.

62. Unidentified newspaper clipping, 28 May 1922, Museum School scrapbook, Museum of Fine Arts, Boston.

63. "Advice."

64. Ibid.

65. One of these was F. L. Dunne, a Boston tailor whose suits Benson admired as much as Dunne admired Benson's work. The men in the Benson family believed that it was better to own a second-hand Dunne suit than a new one from anyone else. Nevertheless, despite Dunne's reputation, Benson's paintings were beyond his reach. They struck a bargain: Dunne would make Benson a new suit every few years for the rest of his life, if Benson would let him have *The Silver Screen*. Ever the meticulous bookkeeper, Benson's notations "$500 credit from F. L. Dunne" appear carefully entered in the credit column of his ledgers. Dunne and his family eventually became serious collectors, owning several of Benson's major works.

66. FWB to C. Powell Minnigerode, 17 November 1919, Benson file, Corcoran Gallery of Art.

67. Benson had been experimenting with still lifes since the early 1890s. His beautiful study of peonies dated 1893 is the earliest known work of this type and was given to his brother John. The softness of the pale alabaster petals makes a delicate counterpoint to the simple blue-and-white Canton vase. The mastery of this motif is so evident that one wonders why he did not do more of this sort of work. The first known exhibition of a still life occurred in 1904 at the Art Institute of Chicago (which was probably the same one hung at his first one-man exhibition at the St. Botolph Club in Boston later that year).

68. "Advice."

69. Ibid.

70. Although he had not been using his studio regularly since about 1937, Benson kept it until 1944, when he finally turned it over to a younger artist and divided the many screens, tables, chairs, draperies, and oriental and antique objets d'art among his children.

71. Mrs. Stephen Phillips, interview with the author, October 1987.

72. Joan Lawson Andrews, interview with the author, October 1987.

73. *Seaside Gardens* and *Seaside Gardens II* (1927).

74. *Boston Evening Transcript,* 1923, Guild of Boston Artists Papers, AAA, reel MB52. Hereafter, this is abbreviated as GBA.

75. *Boston Sunday Herald,* 9 June 1935.

76. "Advice."

77. Frank Benson Lawson, interview with the author, October 1987.

78. This author had previous stated that Sylvia Benson's list ended at number 531 and was discontinued in 1941. Further research has revealed that she continued her list and her box of index cards until 1946, ending at number 563. This discovery means that Benson's total lifetime list, including those completed after 1946 and those he created and immediately gave away, may well exceed 630.

79. *Boston Evening Transcript,* 2 May 1922.

80. *Boston Evening Transcript,* 3 May 1922.

81. Roger Tory Peterson, "Bird Painting in America," *Audubon Magazine* 17 (1942).

82. Peterson, interview with the author, Warrenton, Va., 22 April 1995. As a young man, Peterson took part in a number of Essex County Ornithological Club outings with Benson.

83. "Advice."

84. "The two crows, Jim and Anna, taken from the nest in North Salem in June are a nuisance," Benson wrote in the log he kept at Wooster Farm. "They ate most of our strawberries and pulled up what plants they could. Next year we shall try to get along without them."

85. FWB to Robert Macbeth, 11 May 1922, Macbeth Papers, AAA, reel MMc 26.

86. FWB to C. Powell Minnigerode, 20 December 1921, Corcoran Gallery of Art.

87. FWB to Robert Macbeth, 31 March 1926, AAA.

88. "Advice."

89. Ibid.

90. Ibid.

91. *Boston Herald,* 4 January 1914, Benson file, Fine Arts Department, Boston Public Library.

92. *Worcester Evening Gazette,* believed to be 1946, artist's scrapbook, Benson Papers.

93. "Advice."

94. Anthony Philpott, quoted in an unidentified newspaper clipping (probably the *Boston Globe,* where he was the art critic), November 1936, artist's scrapbook, Benson Papers.

95. "Advice."

96. *Bulletin of the Detroit Art Museum,* April 1914, as quoted in the *Boston Herald,* 3 May 1914.

97. FWB to C. H. Woodbury, North Haven, Maine, 22 August 1913, Woodbury Papers, Print Department, Boston Public Library.

98. Chamberlain, "Frank W. Benson," 175.

99. *Boston Herald,* 9 February 1915.

100. Chamberlain, "Frank W. Benson," 179.

101. It has long been thought that Benson's print work numbered 355 etchings and drypoints. However, this author's research has uncovered four more: two etchings done during Benson's student days (a Christmas card sent from Paris in 1883 and a sailboat), a single print of a gull, and a bookplate done for his friend and fellow artist Dwight Blaney. John Ordeman (author of *Frank W. Benson: Master of the Sporting Print* and compiler of all five of the catalogues raisonné of Benson's print work into one volume) has done research that reveals that Benson designed another bookplate for ornithologist Dr. Lombard Carter Jones, but it is not known to have ever been executed. Thus, the total of Benson's etched work currently stands at 359.

102. Frank W. Benson, "Twenty-Five Years of Etching," *Christian Science Monitor,* 5 July 1941.

103. FWB to C. S. Band, 7 August 192– (date unclear), Benson Papers.

104. Sylvia Benson to Albert Milch, 9 October 1926, Milch Papers, AAA.

105. FWB to EBL, 4 August 1917, Benson Papers.

106. Unidentified clipping, 1938, Benson microfilms, Museum of Fine Arts, Boston.

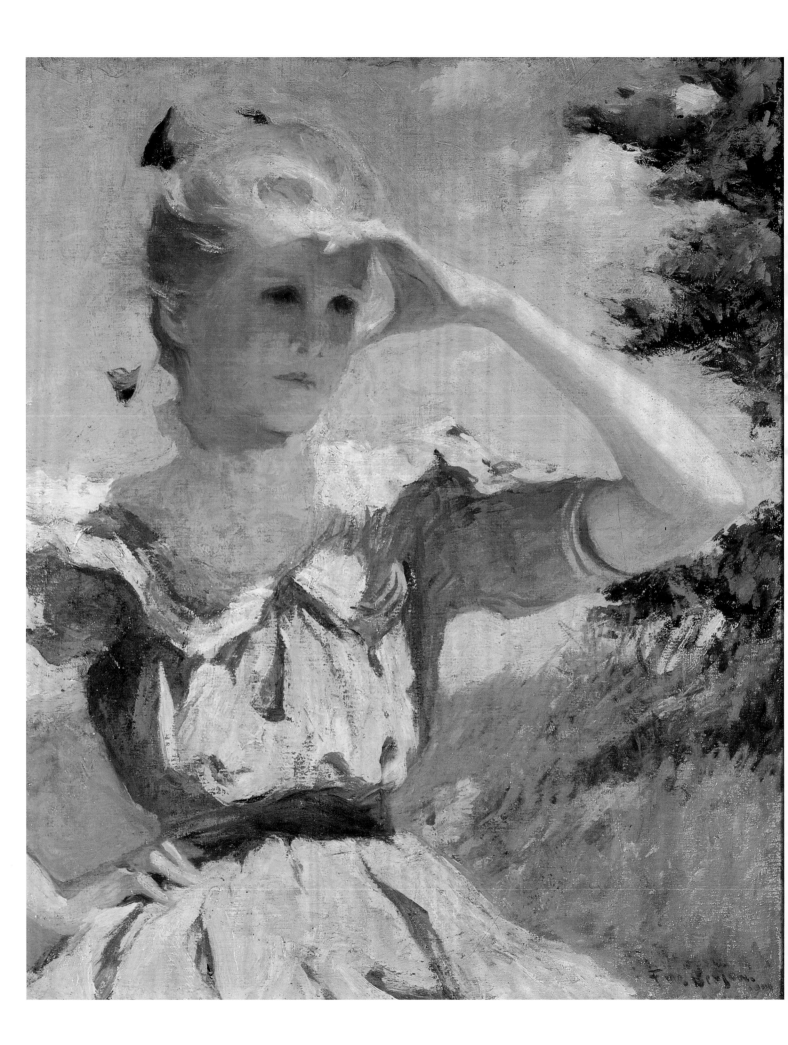

A "Gospel of Light": Frank W. Benson and the Boston School Giants

BY LAURENE BUCKLEY

Frank W. Benson's role within the so-called Boston School of painting at the turn of the nineteenth century has been sporadically documented in such surveys as R. H. Ives Gammell's *The Boston Painters, 1900–1930* (Orleans, Mass.: Parnassus Imprints, 1986) and Trevor Fairbrother et al., *The Bostonians: Painters of an Elegant Age, 1870–1930* (Boston: Museum of Fine Arts, 1986).[1] More recently, Benson's association with the perceived leader of the school, Edmund C. Tarbell, was clarified in William H. Gerdts's "Frank Benson—His Own Man," in John Wilmerding et al., *Frank W. Benson: The Impressionist Years* (New York: Spanierman Gallery, 1988), and his associations within the Ten American Painters group were discussed by Sheila Dugan in William H. Gerdts et al., *Ten American Painters* (New York: Spanierman Gallery, 1990).

In the last several years, lost works by Joseph Rodefer DeCamp, Tarbell, and Benson—the major triad of the Boston School—have reappeared. Perhaps it is time to look again at Benson's relationship within this special coterie, whose entries in exhibitions throughout New England and the Midwest were regularly reviewed together. In fact, their various styles and subjects eventually coalesced in the public's mind as a distinct Boston phenomenon.[2] This essay makes no attempt to document which of the three arrived first, second, or last, at a particular subject or style. Rather, in reviewing the criticism of the various annual exhibitions of the period at the Boston Art Club, National Academy of Design, Society of American Artists, Pennsylvania Academy of the Fine Arts, Philadelphia Arts Club, and Ten American Painters—regular venues for Benson, Tarbell, and DeCamp—the author has selected those works that best define Benson's contribution in shaping the group's composite themes of outdoor family life and women in interiors, among others. This material also allows another opportunity to see how the critics viewed Benson's works in opposition to or as an enhancement of those of Tarbell and DeCamp.

Even before the three artists began showing their work together, there were close ties among them. Benson and Tarbell had studied at the Museum of Fine Art's School of Drawing and Painting before leaving for Europe (Benson in 1883; Tarbell in 1884 and again in 1885) to enroll at the Académie Julian in Paris. Upon their return to Boston, they were asked in 1889 to teach at the Museum School,

59

where DeCamp had been an instructor since 1885. He, too, had ventured abroad (to Munich's Royal Academy), after studies in his native Cincinnati at the McMicken School of Art and Design.

All three painters worked side by side or actually shared studios at times (see the essay by Dean Lahikainen), even though they lived in places not far from the Hub—Benson in Salem, Tarbell in Dorchester, and DeCamp in West Medford. When other artists who began their careers in Boston—Thomas Dewing, Childe Hassam, and Robert Reid—left for the more lucrative atmosphere of New York, Benson, Tarbell, and DeCamp stayed and eventually flourished. Their marriages were also successful, and their wives, children, and grandchildren were all featured in their art.[3] They often spent the off-season near each other; Benson and Tarbell taught at least one summer class together in 1894 in New Castle, New Hampshire.[4] Tarbell and DeCamp were both painting in Annisquam, Massachusetts, at least during the summers of 1894 and 1895, and later were frequent visitors to Benson's Salem home and his summer place in North Haven, Maine, which was very near the DeCamps in Vinalhaven.

After a series of early, formal portraits of family members and posed models (a sub-theme for Benson and Tarbell being the female figure in firelit interiors), all three artists turned to Impressionism, having absorbed the technique mostly from the Americans—John Leslie Breck, Theodore Wendel, and Lilla Cabot Perry, among others—who were returning to this country in the 1880s from Giverny, France, the home of Claude Monet. Benson's *In Summer* (FIG. 25) was described as "a portrait of a young lady in a white dress, who is sitting in the shade on a lawn, which in the middle distance is flooded with sunlight and extends to a background of trees, and

houses, and garden walls beyond."[5] *In Summer* and Tarbell's *Three Sisters: A Study in June Sunlight* of 1890 (FIG. 26) were seen as debut works in the new style, even if experimental: "It is very simply painted—too simply at times," wrote one reviewer of Benson's Impressionist brushwork in *In Summer*, "for it amounts to positive thinness in certain passages."[6] On a more positive note, he continued the review: "It is to be especially noted as the work of a young Boston artist who has not exhibited before in New York, and who may be safely set down as a painter of whom much may be expected."[7]

Tarbell was also considered "a recent recruit in the impressionist army" with his *Three Sisters,* when the painting was shown in 1890 at the St. Botolph Club Gallery.[8] "As a study of sunlight, the work is a great success . . . an interesting example of the art tendencies of the day, of the modern thirst for more light."[9] Yet the reviewer applauded Tarbell's restraint, a feature that would become the hallmark of the Boston branch of American Impressionism as well as a distinguishing difference between Benson and the other two Bostonians: "He [Tarbell] does not employ the worsted-work or stipple style of brushing, which is a characteristic mannerism of the true-blue impressionist; neither does he regard composition as of no consequence; and he certainly did not learn his drawing of an impressionist. So he really has a great deal to unlearn before he can be considered a thorough-going impressionist at all."[10] Meanwhile, DeCamp was making great strides in painting the Impressionistic landscape. An unlocated work entitled *Mill Pond* (ca. 1890) was said to represent "complete adherence to the impressionist idea."[11] When DeCamp added people to his landscapes, however, as in the portrayal of his wife, Edith, and children Sally and Ted in *The Hammock* (FIG. 27), there occurs a similar dichotomy to that in Tarbell's work between the free,

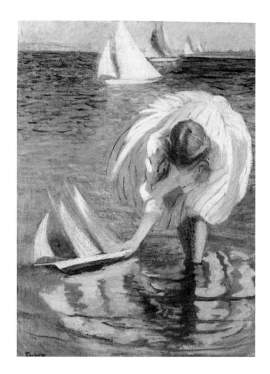

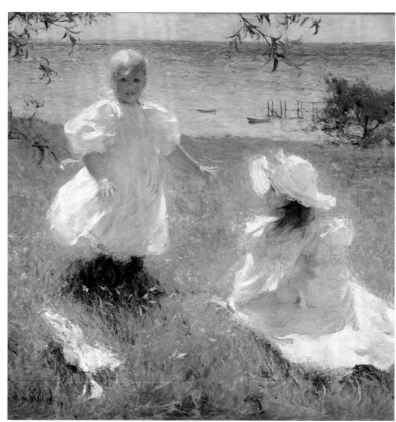

painterly background and the tighter brushwork of the figures.

Benson's "complete adherence" to Impressionism came in 1898 with *Children in the Woods* (alternately, *In the Woods* or *My Children in the Woods,* FIG. 8), a depiction of his daughter Eleanor and son, George. The painting demonstrates the distinct characteristics of his approach. Now figure and backdrop are equally fluid in delineation, the little girl in white was said by one critic to be as "much a part of the place as the trees themselves."[12] Light permeates the scene selectively but also in an equally painterly fashion throughout, "filtering through the trees on to their fair hair," noted the critic for the *Mail and Express*.[13]

Tarbell's early attempt at a childhood theme, *Girl with Boat* of about 1899 (FIG. 28), showing his daughter Josephine leaning over a toy boat, was praised for its rendering of air and light, but more so for its solid composition, a swirl of skirt capturing the focus of the canvas. "The little girl, barefooted, stoops to right the boat. The spirit of the drawing, the brilliance of color, vivid suggestion of light and breeze, are admirable; but still more the fine assurance of the broad, free strokes of the brush-work. The picture is brimful of cleverness, that is not allowed to run away with itself," wrote the noted critic Charles Caffin in 1900.[14]

With *The Sisters* (FIG. 29) of 1899, Benson took the subject of children outdoors to new heights, eliciting boundless praise: "Two little children playing in a meadow by the sea. These are veritably children; healthy, natural types, spontaneously represented; fresh, happy, lovable," exalted the *Boston Evening Transcript*.[15] "What a joyousness of sunshine and buoyancy of bracing air; how invigorating the free play of brushwork and purity of color and, as well, the knowledge and subtle

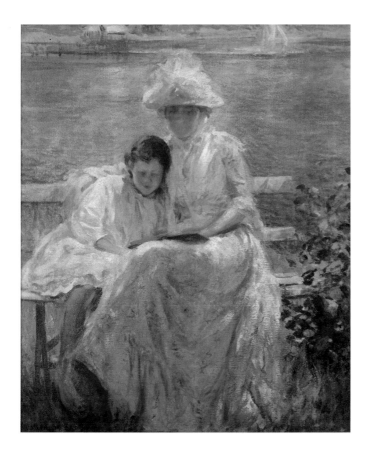

FIG. 28. Edmund C. Tarbell, *Girl with Boat,* ca. 1899. Oil on canvas, 40 x 30 inches. Private collection.

FIG. 29. Frank W. Benson, *The Sisters,* 1899. Oil on canvas, 40 x 39½ inches. Daniel J. Terra Collection, 1999.111, Terra Foundation for the Arts. Photograph courtesy of the Terra Museum of American Art, Chicago.

FIG. 30. Joseph DeCamp, *June Sunshine,* 1902. Oil on canvas, 30 x 25 inches. Photograph courtesy of Adelson Galleries, New York.

craftsmanship displayed!"[16] Such comments were reminiscent of the praise given two decades earlier in the 1870s for Winslow Homer's outdoor childhood themes, symbolic of the country's new freedom after an exhaustive civil war. Benson's images of children, and his *The Sisters* in particular, which had just won a silver medal at the Paris Exposition of 1901, were also taken for symbols of innocence, but also as a counterpoint to the first stirrings of European modernism: "It [*The Sisters*] is charmingly spontaneous and fresh in color, as well as treatment, and bids defiance to the pessimism and eroticism so prevalent in all forms of art just now."[17]

There were other reasons that Benson's vision of healthy children bathed in summer light was appealing. It was, after all, a time of tremendous influx of various new populations, not only immigrants from abroad but also rural inhabitants moving to the urban centers of the country. Boston was reaching new levels of overcrowding, and the wholesomeness of country life was seen as an escape as never before. Benson's images of joyous life at the seashore struck an obvious nerve with the critics and public alike, and his complete abandon in painting such scenes struck an even deeper note. When DeCamp painted his wife and children at the Gloucester shore, as in *June Sunshine* (1902; unlocated, FIG. 30) and *September Afternoon,* the praise was more reserved: "By Joseph DeCamp there are two variations on the same theme, a woman and child beside a river, both of which are entirely satisfactory and in their delicacy of color and charm of tone are not to be passed by."[18]

All three artists were enthralled with the figure perched on a hilltop against a glorious cloud-filled sky. Homer also pursued such subjects, but the more relevant antecedent was Claude

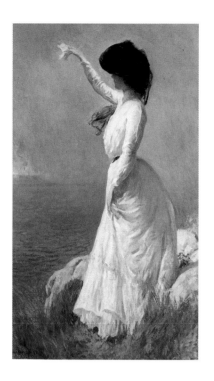

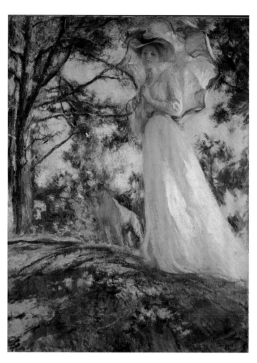

FIG. 31. Joseph DeCamp, *Farewell*, 1900–2. Oil on canvas, 36 x 21¼ inches. Unlocated. Photograph courtesy of Geoffrey Clements.

FIG. 32. Edmund C. Tarbell, *On Bos'n's Hill*, 1901. Oil on canvas, 40 x 30 inches. Cleveland Museum of Art. Gift of Mr. and Mrs. Thomas A. Mann and Robert A. Mann.

FIG. 33. Frank W. Benson, *Against the Sky*, 1906. Oil on canvas, 41 x 31¼ inches. Collection of Senator and Mrs. John D. Rockefeller IV. Photograph courtesy of Richard York Gallery, New York.

FIG. 34. Frank W. Benson, *Eleanor*, 1901. Oil on canvas, 29½ x 25 inches. Museum of Art, Rhode Island School of Design, Providence. Gift of the estate of Mrs. Gustav Radeke.

Monet, whose imagery was classic in this country by the turn of the century.[19] DeCamp's *Farewell* (FIG. 31), of about 1900 or 1902, is perhaps the most conservatively painted of all three examples and true to his reputation for draftsmanship and proficiency in technique. Tarbell's *On Bos'n's Hill* of 1901 (FIG. 32) includes his wife, Emeline, and the family dog ascending the pine-studded hill adjacent to his New Castle property. The painting represents Tarbell at his closest to Benson's inviting breezy look, yet the posed and somewhat stiff appearance of figure and dog, although praised for its "impression of pure stimulation and healthful repose," sets it apart from Benson's freer versions.[20]

Benson's superb exploitation of the hilltop theme is most evident in a work such as *Against the Sky* (FIG. 33). Now we see almost complete absorption of figure and sky, as noted by one reviewer to be the artist's main strength: "It is with the open air that he [Benson] plays to the best purpose: it fairly electrifies the figure in his prize-winning picture 'Against the Sky.' Figure and sky are bathed in the same beauty; the model is not posed, she is part of her surroundings."[21] Another critic found *Against the Sky* a near perfect rendering of "utmost brilliancy. . . . Against the Sky . . . is an audacious, delicate and joyful accomplishment. The blue summer sky fills the canvas except that portion pre-empted by a young woman, modern, her trim figure clad in a light gown, her peaked hat swathed in a veil which the breeze of the crest on which she must be standing extends in sweeping curves around her shoulders.[22] The unbroken light of a summer day brings her figure, her draperies and her yellow parasol up to their utmost brilliancy. It is a restless canvas, but it is the restlessness of the breeze and of the ether, and, in that sense, inspiring."[23]

The next year, Benson's *Eleanor* (FIG. 34), another hilltop scene, brought even higher

praise: "Eleanor, a lovely girl in pale rose pink muslin, contrasted with a white picket fence . . . greeted the eyes with a smiling and sunny cheer of color which was like a bird's song on a spring morning, a thing so full of joy and spontaneity that it made the day happy. . . . Mr. Benson does not always strike twelve, but when he is most himself . . . there is no one to excel him in freshness, purity, sweetness . . . and the joy of living."[24]

In short, Benson was able to capture the very spirit of life, the joie de vivre, in his style of Impressionism, compared to the more restrained examples of the same themes by Tarbell and DeCamp—pure emotions versus their intellectual approach. Time after time, the adjectives used to describe Benson's plein air work were those of free abandon, a loosening of the restraints of everyday living, while Tarbell's and DeCamp's work in the style celebrated an ordered existence.

Despite their individual artistic personalities, however, there was a perceived unity, even talk around the mid-1890s of the "making of a school" of Boston painting, centered around "Tarbell, Benson, DeCamp with satellites, the Tarbellites."[25] When a splinter group of mostly American Impressionists broke from the Society of American Artists to form Ten American Painters, the Bostonians Tarbell, Benson, and DeCamp were asked to take part, clearly because of their close camaraderie and stylistic affinities. The Ten's annual exhibitions, from 1898 to 1918, were highlights of each art season, both in New York and Boston. Reviewers regularly began grouping the three Bostonians in their writings as they looked for cogent reasons for the Ten group to exist and to continue. Time and again, they turned to this subgroup from Boston as the standard-bearers of light-filled canvases and as the figure painters of the group: "Tarbell, Benson and

FIG. 35. Frank W. Benson, *A Woman Reading,* ca. 1903. Oil on canvas, 42 x 30 inches. Courtesy of the John H. Vanderpoel Art Association, Chicago.

FIG. 36. Edmund C. Tarbell, *A Girl Crocheting,* ca. 1905. Oil on canvas, 30 x 25 inches. Canajoharie Library and Art Gallery, Canajoharie, New York.

FIG. 37. Joseph DeCamp, *In the Studio,* ca. 1905. Oil on canvas, 41 x 25 inches. Collection of Mr. and Mrs. Thomas A. Rosse.

Decamp, the Boston giants, alone hold unweariedly aloft the banner of exclusive devotion to the gospel of light . . . as it is disclosed in the human figure, and particularly in the female figure; for they still are painting girls, and nothing but girls."[26]

By 1908, the Boston triad had clearly become nationally known for this figural Impressionism, even beyond the shows of the Ten—in effect, as one critic later noted, "unprovincializing themselves."[27] As early as 1900, Benson was pronounced the specialist in pictures of "blonde haired girls" basking in the sun and for his "free light motifs."[28] At least once, in 1901, when the Ten American Painters exhibition as a whole was disappointing, reviewers turned to Benson's outdoor scenes as a breath of fresh air: "What a relief it is to turn to Frank W. Benson's 'Sisters,' two little children playing in a meadow by the sea," wrote the *New York Sun* reviewer.[29] "Mr. Benson, year by year, matures in force and persuasiveness; his themes are never hackneyed for his sympathies reach continually after new studies of interest."[30]

The promise of Impressionism was wearing thin, however, and even by 1904 and 1905, a *Mail and Express* reviewer wondered aloud as to the cross-fertilization of the style within the group of Ten: "Has the informal artists association of these ten men been the means of setting up between them a current of influences tending to wear down what originality certain of them possessed?"[31] Another offered this cautionary reflection: "Our brilliant painters . . . are in danger of becoming makers of sketches, in which detail is lost in the glare. . . . Glorious and fascinating as are the phenomena of light and color, there are other elements in pictorial art, equally desirable and needful for its completeness and interest which ought not to be forgotten nor neglected."[32]

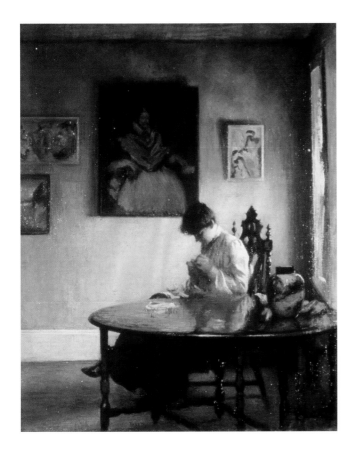

It was time for a new direction, one that would take all three artists indoors—Tarbell and DeCamp more or less permanently, and Benson, at least for a time. Benson's *A Woman Reading* (FIG. 35), shown in the 1903 Ten show, was one of the threshold works that led the way: "The soft color, with the supple pose of the woman, in an interior lighted in the most subtle manner, is really a gem," noted the *Pittsburgh Index* critic.[33] Another, however, found the work studied: "The flesh tones are far from agreeable, while the work after all is in the nature of a studio study and does not hold the spectator."[34]

It was a work by Edmund Tarbell, however, that would turn the tide. "It would be extremely difficult to find, among American paintings produced within the past twenty years, anything to equal the 'Girl Crocheting'" (FIG. 36), wrote the *Boston Evening Transcript* writer.[35] "There is nothing to be added, nothing to be taken away," the critic continued, commenting upon the simple elegance of the scene of a woman quietly engaged in a domestic activity, a reminder to many of the interiors of Jan Vermeer and other Dutch "Little Masters."[36]

DeCamp followed suit in 1905 with an interior scene entitled *In the Studio* (FIG. 37), showing himself painting a model. The work also received its fair share of praise, mostly for its solid realism, technical achievement, and "working out of complex problems," but not for its spontaneity: "He puts his figures before us in a convincing manner. . . . What we miss is the indefinable element, the note of style, which would superimpose charm upon the realism."[37] Charm was the one element *not* missing from Benson's *Rainy Day* of 1906 (CAT. 23): "All the world will like his 'Rainy Day'—a girl curled cozily up in a basket chair, in an old country house," exclaimed Philip Leslie

Hale, himself one of the Boston School.[38] One *Providence Sunday Journal* critic called her a "quaint little girl, curled up in a chair," while another remembered that this posture is what "young girls can and always do, curl up to read, in a wicker chair before the fire."[39] Benson's female figure is the adolescent spirited woman, a frisky soul to Tarbell's and DeCamp's more self-absorbed, staid renderings of housewives engaged in domestic chores. She emphatically does not conjure up visions of the old master imagery seen in Tarbell's *A Girl Crocheting* (FIG. 36).

Tarbell had found his signature subject with this work, however, and embarked on an entire series of such interiors: *Girl Mending* (ca. 1906; Indiana University Art Museum, Bloomington), *Golden Crescent* (ca. 1906; unlocated), *Girls Reading* (ca. 1907; private collection), *Preparing for the Matinee* (1907; Washington University, St. Louis, on loan to the St. Louis Art Museum), *Josephine and Mercie* (ca. 1907; Corcoran Gallery of Art, Smithsonian Institution, Washington, D.C.), *Girl Cutting Patterns* (ca. 1908; private collection), *Girl Reading* (ca. 1909; Museum of Fine Arts, Boston), *Interior* (ca. 1909; private collection), and culminating in a work such as his 1906 *New England Interior* (FIG. 38), which, in its title alone, gave credence to Tarbell's associations with tradition. At least one critic felt that the work lacked the spark of humanity: "To reach genuine mastery . . . Mr. E. C. Tarbell's 'New England Interior' should have interested the observer in the two women sewing, who are now treated almost as part of the furniture of the room. . . . Everything is done with admirable skill. But the old Dutchmen who did this first gave a touch of human identity and individuality to their figures, and in this Mr. Tarbell, with all his taste and knowledge, falls short."[40]

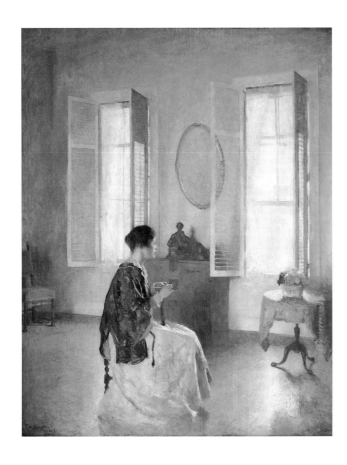

FIG. 38. Edmund C. Tarbell, *New England Interior,*
1906. Oil on canvas, 30⅜ x 25¼ inches.
Museum of Fine Arts, Boston. Gift of Mrs.
Eugene C. Eppinger.

FIG. 39. Joseph DeCamp, *The Guitar Player,*
1908. Oil on canvas, 49¾ x 45¼ inches.
Hayden Collection, Providence.

FIG. 40. Frank W. Benson, *The Open Window,*
1917. Oil on canvas, 52¼ x 42¼ inches.
Corcoran Gallery of Art, Washington, D.C.

DeCamp also persisted with the theme of the mature female in quiet home settings, often playing musical instruments, in his own string of important images: *The Heliotrope Gown* (ca. 1905; private collection), *The Cellist* (1908; Cincinnati Art Museum), *The Pink Feather* (1908; private collection), *The Blue Cup* (1909; Museum of Fine Arts, Boston), and his masterpiece, *The Guitar Player* (FIG. 39), which was considered the successor to *A Girl Crocheting* for its draftsmanship: "Technically, it is one of the most perfect examples of painting that we have seen by an American artist for many years."[41] It was also noted for its Dutch origins: "If a Dutch 'Little Master' of the calibre of Vermeer or Metsu could be imagined enlarged to the lifesize scale, it would look not unlike this modern masterwork."[42]

When Benson continued to explore the theme of women in atmospheric interiors, as in *Girl Playing Solitaire* (1909; Worcester Art Museum), *Examining the Lace* (1910; unlocated), or *The Lesson* (1911; private collection), he would often be represented as trespassing on Tarbell's territory. An *American Art News* reviewer drew this conclusion about Benson's *Seamstress* (1914; private collection): "Benson this year has gone into Tarbell's province and shows an admirable 'near-Vermeer' in the 'Seamstress,' one of those delightful, truthful interiors."[43] Even a masterful work like *The Open Window* (FIG. 40) of 1917 was given derivative connotations: "F. W. Benson . . . in 'The Open Window' approaches the chosen ground of E. C. Tarbell, painting the modern interior adorned with figure as if in memory of the old Hollanders. . . . The effect of sunlight struggling through curtains is well expressed, but in general it may be said that Benson has not succeeded very well in making one feel the atmospheric quality of such a room as Tarbell has often done it. . . . If former-

ly Mr. Benson was all for outdoors—for figures spangled with sharp sunlight and shadow or blown upon by gales, he is now attempting the kind of picture Mr. Tarbell made his own."[44] In addition, when Benson exhibited these interiors alongside his plein air subjects, the critics invariably made it clear that they preferred the plein air works.[45]

It is no wonder, then, that Benson continued his outdoor Impressionism long after the other two and even added works on paper to his repertoire—watercolors and etchings—of sporting subjects rather than family members, beginning in the 1920s. *Evening Light* (1908; Cincinnati Art Museum), *Sunlight* (1909; Indianapolis Museum of Art), *Afternoon in September* (1913; Los Angeles County Museum of Art), and *Eleanor and Benny* (1916; private collection)—all came after Tarbell and DeCamp had gone "indoors" and reinforced Benson's reputation as the painter of the "wholesome charm of all free and healthy girlhood."[46] "Mr. Benson knows well his métier," observed Arthur Hoeber of *International Studio* magazine in 1908, "painting with certainty and capacity, securing his results with a freedom of touch, a healthiness of method that cannot be over-commended."[47]

Today, the works of the three Boston painters often coalesce in an image that represents the characteristics of New England taste and craftsmanship, a carryover perhaps of the Puritanism of an earlier era, and an image that harkens back even further to European roots. Frank Benson tried the traditional route and created some of the best of the genre, but returned again and again to his favorite subject of sunlit, open-air scenes. In a 1911 article titled "The Spontaneous Gaiety of Frank W. Benson's Work," the noted art critic William Howe Downes said it best:

> "As I look back and recall the general impression of the exhibitions [of the Ten American Painters] as a whole, it is Benson's contributions that have given the greatest pleasure and remained in the mind as the most gracious memories. . . . He is more natural than DeCamp . . . and in comparison with Tarbell's interiors his outdoor effects are more unlike anything that we recall in European art, more racy of our soil and with a more distinctly modern note." [48]

Dr. Laurene Buckley is the executive director of the Queens Museum of Art, New York.

Notes

1. Joseph Edgar Chamberlain, "The Tenth Year of the 'Ten,'" *Evening Mail,* 19 March 1908, p. 6.

2. For a full summary of DeCamp's life and work, see Laurene Buckley, *Joseph DeCamp: Master Painter of the Boston School* (Munich and New York: Prestel, 1995). For Tarbell's career, see Patricia Jobe Pierce, *Edmund C. Tarbell and the Boston School of Painting, 1889–1980* (Hingham, Mass.: Pierce Galleries, 1980); and Laurene Buckley, *Edmund C. Tarbell: Poet of Domesticity* (projected publication date, 2001). For Benson's history, see Faith Andrews Bedford et al., *Frank W. Benson: A Retrospective* (New York: Berry-Hill Galleries, 1989) and Faith Andrews Bedford, *Frank W. Benson: American Impressionist* (New York: Rizzoli International Publications, 1994).

3. Benson and Tarbell were both married in 1888; DeCamp married in 1892, with Tarbell as a witness. Benson was the godfather to Tarbell's first child, Josephine, who was named after Joseph DeCamp.

4. An advertisement appeared that June and noted that "Mr. Tarbell and Mr. Benson will teach a class at Newcastle [*sic*], N.H., from June 15 to September 15. Price of tuition, six dollars per week. Two criticisms will be given each week, and as the number of pupils will be limited, no deduction will be made for absence on a day when criticisms are given. Board should be engaged as early as possible." (Boston School Library Scrapbooks, Archives of American Art, Smithsonian Institution, Washington, D.C., reel 4999, frame 586).

5. According to Faith Andrews Bedford, the original was cut down to its present size under his instructions by his eldest daughter, Eleanor (Bedford, *Frank W. Benson: American Impressionist,* 41).

6. "Society of American Artists," *Evening Post,* 28 April 1888, p. 5.

7. Ibid.

8. "The Fine Arts," *Boston Evening Transcript,* 30 December 1890, p. 6.

9. Ibid.

10. Ibid.

11. Ibid.

12. B. F., "Ten American Artists," *Evening Post,* 6 April 1899, p. 7.

13. "Art Notes," *Mail and Express,* 4 April 1899, p. 5.

14. C. H. Caffin, "Third Exhibition of the 'Ten American Painters,'" *Harper's Weekly* 44 (1900): 338.

15. "The Fine Arts," *Boston Evening Transcript,* 21 March 1901, p. 10.

16. Ibid.

17. B. F., "Pictures of 'The Ten,'" *Evening Post,* 20 March 1901, p. 4.

18. "The Art World," *Commercial Advertiser,* 1 April 1902, p. 6.

19. An exhibition of Monet's landscapes was shown at the St. Botolph Club in 1892; it was entirely made up of loans from local collectors.

20. "Exhibition of Ten American Painters," *New York Sun,* 1 April 1902, p. 6.

21. "The Ten American Painters," *Boston Evening Transcript,* 21 March 1907, p. 12.

22. Another favorite theme for the Boston painters was the veiled woman, shown either outdoors (the veil adding to the sense of breezy atmosphere) or indoors (where she often presented a flirtatious or sensual being). Tarbell's early *Blue Veil* (1898; Fine Arts Museums of San Francisco) or his *Summer Breeze* (1904; unlocated), Benson's *Girl with the Veil* (1907; Rainier Club, Seattle), and DeCamp's *Brown Veil* (1908; private collection) are good examples. Veils were popular with women of the period and were often carefully coordinated to match the entire costume ensemble.

23. "The Influence of Individual Art Shows," *New York Herald,* 31 March 1907, p. 4.

24. Arthur Hoeber, "Ten American Painters," *Boston Evening Transcript,* 20 March 1908, p. 15.

25. Sadakichi Hartmann, "A National American Art," *Art Critic* 1 (1894): 70, 75.

26. Chamberlain, "The Tenth Year of the 'Ten,'" 6. See also "Ten American Painters," *New York Times,* 2 April 1902, p. 8; "Art Exhibitions," *New-York Daily Tribune,* 2 April 1902, p. 9; and "Work of the 'Ten American Artists,'" *Providence Sunday Journal,* 25 November 1906, p. 10. The Boston three were hung in a group, at least once in a Ten American Painters show (1902), but probably in many other annual exhibitions as well.

27. "Boston," *American Art News* 7 (21 November 1908): 5.

28. Philip L. Hale, "About the Pictures," *Boston Daily Advertiser,* 21 November 1900, p. 8.

29. "Around the Galleries," *New York Sun,* 20 March 1901, p. 6.

30. Ibid.

31. "Art," *Mail and Express,* 2 April 1902, p. 9.

32. "The Fine Arts," *Boston Evening Transcript,* 4 November 1903, p. 16.

33. Raymond Gros, "The Carnegie Art Exhibition," *Pittsburgh Index,* 7 November 1903, p. 8.

34. "Art and the Artists," *Commercial Advertiser,* 21 April 1903, p. 7.

35. "The Fine Arts," *Boston Evening Transcript,* 21 June 1905, p. 19.

36. Ibid.

37. "The Ten American Painters," *New-York Daily Tribune,* 26 March 1905, p. 7.

38. Philip L. Hale, "Paintings Shown by Ten American Artists," *Boston Herald,* 11 November 1906, p. 30.

39. "Work of the 'Ten American Artists,'" *Providence Sunday Journal,* 25 November 1906, p. 10.

40. "Art Proficiency in the Ten's Show," *Evening Mail,* 21 March 1907, p. 5.

41. "The Fine Arts," *Boston Evening Transcript,* 30 January 1908, p. 11.

42. Ibid.

43. "The Ten's Annual Show," *American Art News* 12 (21 March 1914): 3.

44. "The Ten American Painters," *Art World* 2 (June 1917): 239.

45. See, for example, "The Art World," *Commercial Advertiser,* 19 March 1901, p. 6; C[harles] de K[ay], "The Ten American Painters," *Evening Post,* 20 March 1908, p. 7; and "Art Exhibitions," *New-York Daily Tribune,* 2 April 1902, p. 9.

46. Virgil Barker, "The Exhibition of American Paintings at the Corcoran Gallery," *Art and Archaeology* 5 (March 1917): 159.

47. Arthur Hoeber, "The Ten Americans," *International Studio* 35 (July 1908): 24.

48. William Howe Downes, "The Spontaneous Gaiety of Frank W. Benson's Work," *Arts and Decoration* 1 (March 1911): 196–97.

Redefining Elegance: Benson's Studio Props

BY DEAN T. LAHIKAINEN

When Frank Benson set up his first professional studio in Salem in 1886, he began the long process of defining his own artistic vision. Drawing upon his academic training in Paris and exposure to avant garde art movements, he searched to find his own voice in an era of great aesthetic eclecticism. In his earliest portraits and exhibition pieces, Benson embraced several of the most popular trends of the day, but made each image his own by carefully selecting accessories. While these props played a critical role in shaping the composition, they also carried important iconographic messages that clearly reflected his Salem background and strong interest in the emerging Colonial Revival style, then in its early stages of development. He also embraced the fascination for Japanese art and culture then at the height of popularity.[1] By using antique furniture, "colonial" architectural details, and Japanese porcelains and screens, Benson created images of an elegant modern world that looked to the American past for inspiration. This essay explores the use of props in Benson's portraits, interiors, and still lifes.

In 1886, Benson completed his second commission, a three-quarter-length portrait of Margaret Washburn Walker (CAT. 2). He reveals for the first time his interest in two of the subjects that would be central to his artistic explorations for the next fifty years: the still life and the single female figure in an interior space. He also shows his interest in depicting antique furniture. Walker sits next to a polished mahogany worktable that was made in Salem about 1815. The table provides a surface for a vase of yellow roses and a pair of artfully draped gloves. The polished brass ring drawer pulls add bright accents against the dark background. Benson already understood the value of props as compositional devices as well as their role in capturing reflected light to enhance the illusion that the objects and subject are sitting in real space. As Benson later told his daughter, "Anything is important which increases the effect of light and shade" in a picture.[2]

Benson's interest in old furniture can be traced to the influence of the great collector Henry Fitz Gilbert Waters (1833–1913), one of the most intimate friends of the Benson family. Waters lived directly across Salem Common from the Bensons in an eighteenth-century house where he amassed one of the earliest collections of American antiques. One observer noted that,

The Salem Evening Drawing Class, 1882, detail (see FIG. 42).

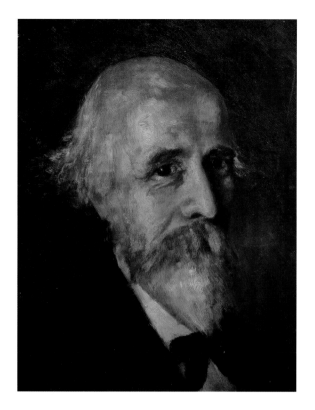

FIG. 41. *Henry Fitz Gilbert Waters,* 1882. Oil on canvas, 8 x 10 inches. Peabody Essex Museum.

FIG. 42. The Salem Evening Drawing Class, 1882, by Edwin N. Peabody, Salem, Mass. Phillips Library, Peabody Essex Museum. Frank Benson served as instructor for a year, beginning in December 1881.

FIG. 43. Frank Benson, Joseph Linden Smith, and Henry Fitz Gilbert Waters at Morley's Hotel, London, 1885. Phillips Library, Peabody Essex Museum.

by the time of the centennial celebrations in Philadelphia in 1876—one of the main catalysts for arousing widespread interest in the colonial era—Waters's house was already "crowded from attic to cellar, with ancient furniture and bric-a-brac, Elizabethan sideboards, quaint dressers, and tables, venerable beds with testers, columnar clocks, andirons, warming pans, candlesticks, logger-heads, a multifarious assortment of colonial belongings large and small. The craze for such accumulations was then not marked in the community. As a collector he was early in the field, and had an abnormal acuteness and zest in detecting things rare and valuable."[3] A wide array of antiquarians, collectors, architects, and writers sought his advice, and Waters generously shared his collection. He helped organize one of the first exhibitions of antiques held in the United States at the Essex Institute in 1875.

After graduating from Harvard in 1855, Waters operated a small private school for boys, but gave it up after serving in the Civil War. He did some private tutoring in the following decades, and among his pupils were Frank Benson and his two younger brothers, John and Henry. Beyond the classroom, Waters spent long evenings with the Benson family leading discussions covering a wide array of topics from genealogy to architecture.[4] Frank Benson's obvious affection for Waters is evident in the fact that Waters was the subject of his first portrait, done in 1882. It was shown that same year in his first public art exhibition (FIG. 41). Waters was a frequent visitor to the Salem Evening Drawing Class during the year Benson served as instructor. He may well have had a hand in the decision in 1882 to create a colonial tableau for the students to draw, consisting of a model in period costume working a spinning wheel (FIG. 42). When Benson went to Paris to study art a

year later, his homesickness was eased by visiting Waters in London, where he had assumed his new
job as researcher for the New England Historic Genealogical Society. "I feel so much at home,"
Benson wrote his parents, "but I suppose that is because I am so much with Mr. Waters."[5] An 1885
photograph shows Benson with fellow art student Joseph Linden Smith cavorting with Waters at
Morley's Hotel in Trafalgar Square (FIG. 43).

Waters's influence on Frank, John, and Henry Benson was considerable and fostered their
artistic interests and appreciation of Salem's long history. Through Waters, they came to know
many of the seminal figures in the development of the Colonial Revival style in the Boston area.
Key among them was the Boston architect Arthur Little and his uncle Clarence Cook. Cook first
surveyed Waters's collection in 1876.[6] Cook was an influential reform art critic for the *New-York
Daily Tribune* and was among the first to advocate in print the value of antiques and their suitability
for the modern home. In his most popular book, *The House Beautiful* (1878), he extols the virtues
of old furniture as emblems of "a refined and cultured time," noting that the mania "for old furni-
ture is one of the best signs of returning good taste in a community that has long been the victim
to the whims and impositions of foreign fashions."[7] This interest went hand-in-hand with a growing
appreciation of colonial architecture. That same year, Little spent the summer sketching old houses
in the Salem vicinity under Waters's guidance. The following year, he published one of the first
books on colonial architecture, *Early New England Interiors,* which features a Federal-period mantel
in Waters's home. In the introduction, Little echoes his uncle's belief that everyone should "revere
our Colonial style, which is everywhere marked with peculiar dignity, simplicity and refinement."[8]

Little was able to practice what he preached in his first major commission, a Manchester, Massachusetts, summer home called Cliffs completed in 1879, and one of the first houses with details inspired by colonial prototypes.[9] It was also at this time that Frank Benson began his life-long friendship with Arthur Little's younger brother, Philip, who also hoped to be an artist (CAT. 8). Both enrolled in the Museum of Fine Arts School of Drawing and Painting in 1880, and often the pair commuted together on the train. Benson was a frequent guest at the Little summer home in Swampscott, where he also made friends with other members of the family, including Davis Mason Little who became a silversmith (FIG. 44). The interrelationship of the Benson and Little families grew even stronger in 1884 when John Benson began his architectural apprenticeship with Arthur Little.

During John Benson's apprenticeship, he, too, came to embrace the emerging colonial style and eagerly reported his progress to Waters. "I think you would like our office," he wrote upon arriving in 1884, "it is all fitted up in the colonial style of architecture which I have learned is the prettiest style of architecture." Arthur Little had learned the importance of sketching while work-ing in the architectural office of Peabody and Stearns and encouraged his interns to do the same. Sketches provided inspiration for new furniture designs and architectural details. "I have been drawing old fashioned furniture lately," John Benson wrote, "and we have got two arm chairs up here in the office which I drew. This morning I drew three old fashioned colonial banisters. . . . I wish you were home, you would be delighted with Mr. Little's houses in Manchester. There are four of them [designed for a Dr. Bartol in 1882] and they are built in the old fashioned style and as

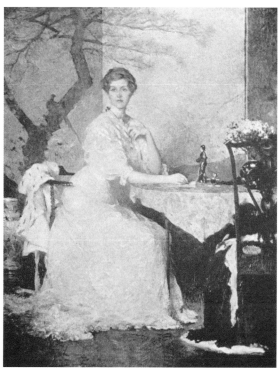

I have drawn nearly all the furniture, it might be even more interesting to you. I catch on to every-
thing old fashioned that I see, and I am beginning to see what a fine old place Salem is."[10] Little's
new style also received expression in Salem with the extensive remodeling and redecorating of the
Emmerton House at 328 Essex Street in 1885 and at his brother Philip's house at 10 Chestnut
Street in 1886.[11] Both of these early commissions introduced the Colonial Revival style to the
community. As one can see later, Arthur Little's work and John Benson's enthusiasm for the new
style had a significant impact on the imagery Frank Benson created in his earliest interior scenes.

Henry Waters also encouraged the Benson boys to collect antiques. When Frank and his
new bride were on their honeymoon in Portsmouth, New Hampshire, they purchased their first
piece of furniture. "We have found a beautiful old sideboard here," Ellen wrote to her mother,
"which we are satisfied is worth fully what we have paid for it and the dealer was equally pleased to
sell it to us although I came down $15 in his price."[12] When the couple moved into their first home
at 77 Lafayette Street, Salem, in 1888, Frank wrote to Waters, "We shall be very glad to see you
here when you come home and I think you will like my house—it is as cozy as possible and looks
as if it had been lived in for I have bought most of my furniture piece by piece to fit the rooms and
quite a lot of it is old—I dislike so much any sets of [new] furniture that I could afford to buy that I
furnished with old when ever [sic] I could find what I wanted at reasonable prices."[13] Benson's
rooms probably looked very similar to those in his brother Henry's home, for he also collected old
furniture. "All of my purchases have been mahogany except one roundabout chair," Henry wrote
Waters. "I want you to see my furniture. . . . I have two or three good things."[14] A photograph of

FIG. 47. John Robinson's library, 2 Chestnut Street, Salem, Mass., ca. 1876. Phillips Library, Peabody Essex Museum. Benson's first studio was in this building from 1886 to 1888.

FIG. 48. Unknown artist, pair of figures, Japan, late nineteenth century. Glazed Imari porcelain, height, 9¾ inches. Private collection. They were originally owned by Frank W. Benson.

Henry's parlor at 330 Essex Street shows a cluttered interior furnished largely with antiques (FIG. 45). It is interesting to note that at least three of the pieces of furniture in this photograph (a Chippendale side chair, gateleg table, and Federal sofa) and an oval mirror, are similar to props that appear in a number of Benson's interior paintings, such as *The Golden Screen* (FIG. 46). Other artists were just beginning to embrace antiques at this time as well, and one prominent example was close at hand. Frederic Porter Vinton, one of Benson's mentors, included two pieces of old Salem furniture, a late Federal card table and Queen Anne armchair, in his portrait of curator Henry Wheatland that was unveiled at the Essex Institute in 1888.

While the emerging Colonial Revival style was generating much interest in Salem and Boston in the 1880s, Salem was also one of the main centers for the interest in Japanese art and culture. The dazzling display of Japanese goods at the centennial exposition in Philadelphia in 1876 sparked a national mania for all things Japanese. Japan responded by flooding the American market with a wide array of inexpensive Japanese goods including porcelains, bronzes, fans, baskets, and screens. Among those who attended the fair from Salem was John Robinson, who brought home an array of decorative objects and proudly displayed them in the family home at 2 Chestnut Street. It was in the upper floors of this building where Benson rented his first studio with Philip Little in 1886. An image of the Robinson library shows the impact Japanese goods had on upper-class interior decoration on the eve of the launching of Benson's professional career and the painting of his first interior scene (FIG. 47). Local interest in Japanese goods grew even stronger after 1890, when Bunkio Matsuki, a protégé of Salem's distinguished Japanese scholar, Edward S. Morse, became the

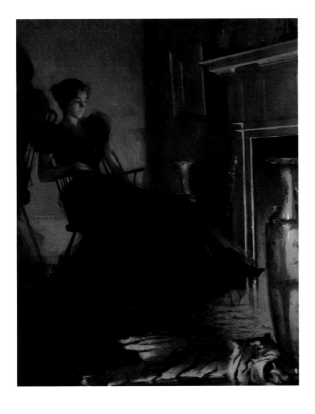

FIG. 49. Frank W. Benson, *By Firelight,* 1889. Oil on canvas, 40 x 31 inches. Private collection. Photograph courtesy of the Schwartz Gallery, Philadelphia.

FIG. 50. "An Artistic Sitting Room," 1889. Illustration from *Home Decorative Art Souvenir Catalogue* by Jordan, Marsh and Company, Boston. Photograph courtesy of the Victoria and Albert Museum, London.

AN ARTISTIC SITTING-ROOM.

primary importer of Japanese goods for Almy's Department Store in Salem. He offered the community a considerable variety of inexpensive wares and may well have sold Benson some of his props, such as the small porcelain figurines that appear in a number of his late works (FIG. 48).[15]

All of these early influences in Benson's life are evident in his first important studio painting, *By Firelight,* completed in 1889, the year after he moved his studio to Boston (FIG. 49). An elegant young woman reclines in an antique Windsor bow-back armchair before a "colonial" mantel, flanked by a pair of enormous Asian export porcelain urns. A Japanese vase rests on the mantel, and a Japanese wood-block print hangs on the wall. Here Benson embraces one of the most popular international trends in art at the end of the nineteenth century: paintings showing modern interiors inhabited by attractive young people in pensive poses.[16] This is among the earliest treatments of this subject by a Boston School painter and is certainly one of the most dramatic and daring in its treatment of firelight. His friend Clarence Cook was among the critics who praised its success in capturing this most difficult effect.[17] Such imagery was familiar to Benson because his family often spent evenings before an open fire. His brother Henry chronicled this in his journal in 1883: "Mr. Waters came in after supper and we sat by the firelight all evening."[18] Benson is also clearly aware of current trends in interior decorating in carefully selecting stylish objects to create a refined ambiance with a distinct colonial feel. Oriental urns flanking a fireplace and a tigerskin on the floor were prized elements of the cluttered and dark interiors associated with the aesthetic movement of the early 1880s in Boston and New York.[19] The emerging interest in colonial architecture, however, soon brought into fashion an entirely new look, rooms with ivory white woodwork and fewer

furnishings. By 1889, this new look was already being promoted by furnishing suppliers, such as Jordan, Marsh and Company in Boston, where they offered suggestions on how to create an "artistic" room using a profusion of pseudocolonial banisters, a few choice antiques, and a wicker armchair (FIG. 50).[20] Benson would also have been exposed to these new ideas firsthand through Arthur Little's work. In the new house Little built for himself at 2 Raleigh Street in Boston in 1890, the style was expressed using newly made architectural details based on colonial prototypes. He also incorporated architectural fragments salvaged from old houses in his designs, being one of the first architects to do so. A photograph of the library taken about 1892, probably under Little's direction, is strikingly similar to the image Benson created in his painting a few years earlier (FIG. 51). An elegant female sits before a Federal-era mantel with a large oriental porcelain urn serving as a focal point. An animal skin on the floor enhances the sense of luxury and sophistication.[21] The mantel in Benson's painting appears to have been inspired by an architectural fragment, a Federal-period mantel dating from about 1805, that may well have been supplied by Little for Benson to use as a studio prop. The mantel appears in the background of three other Benson interiors dating between 1893 and 1910.[22] At some point after 1924, having abandoned painting interior scenes, Benson had the mantel installed in the library of his home at 14 Chestnut Street in Salem, where it remains today (FIG. 72).

 By Firelight and his second interior scene, *Twilight* (FIG. 52), both of which met with great critical acclaim, are also remarkable in that they capture the essence of Salem interiors of this period, evident when one compares the paintings to contemporary photographs. In an image of the

reception room at the Cabot-Endicott-Low House at 365 Essex Street, we find nearly identical pieces of furniture, Japanese porcelains, a Windsor chair, a scrolled-arm sofa, and a new white Colonial Revival mantel (FIG. 53). Benson's primary intent was not to provide a mirror image of a specific room, but to create an attractive compositional arrangement. "A picture is merely an experiment in design," he later told his daughter.[23] This required that he leave out much of the clutter found in an average home of this period (for example, he shows blank walls in *Twilight*), while still retaining enough objects to convey the spirit and essence of the new look. By this reductive process, he achieves a degree of simplicity in these images that was very progressive for the time and would become one of the hallmarks of Colonial Revival interiors in the early twentieth century.

Benson continued to use antique furniture as compositional elements in many of his other interior scenes and portraits painted between 1893 and 1921. Many of the pieces he used may well have been of Salem origin, but it is difficult to say with absolute certainty, for he only shows a detail or two, just enough to convey the item's colonial character and iconographic message. These were symbols of a refined past and an ancestral pedigree. Many of Benson's conservative patrons and supporters were now beginning to collect antiques as a way of holding on to their traditional New England values. Many believed their cherished way of life was being threatened by industrialization and mass immigration. They took comfort in rediscovering objects in the attic and barn that helped establish a personal link to their ancestors and to the moral order, permanence, and stability that marked their society.[24] Benson understood this concept well and was celebrating his own heritage by depicting familiar antique objects. He was also paying homage to interiors that were very

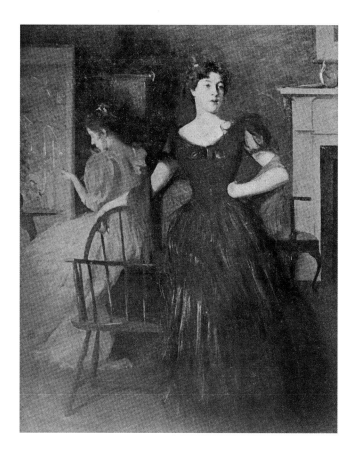

FIG. 54. Frank W. Benson, *Lamplight (Before the Ball)*, 1893. Oil on canvas, 40 x 50 inches. Photograph courtesy of the Frick Art Reference Library, New York.

FIG. 55. Frank W. Benson, *Gertrude*, 1899. Oil on canvas, 50 x 40 inches. Museum of Fine Arts, Boston. Gift of Mrs. William Rodman Fay, 1954.

FIG. 56. Frank W. Benson, *Miss Westinghouse (Young Girl in a White Dress)*, 1899. Oil on canvas, 44 x 36 inches. Private collection. Photograph courtesy of Hirschl and Adler Galleries, New York.

much a part of his own personal experiences and interactions with such people as Henry Waters and Arthur Little.

Benson had a particular fondness for eighteenth-century Salem chairs; several different forms appear in his paintings, including a bow-back Windsor armchair in *Lamplight* (FIG. 54) and a black ladder-back chair with a rushed seat used in many of his Vermeer-period works such as *The Lesson* (1911; private collection). Other forms of seating furniture include a Chippendale side chair with a pierced splat that provides an interesting linear pattern in *The Golden Screen* (FIG. 46) and *Girl with a Veil* (1907; Rainier Club, Seattle, Washington). The mahogany sofa in *Twilight* was a favored form in Salem about 1815 or 1820 because of the graceful scrolled arms. A nearly identical sofa was used in the reception room of the Cabot-Endicott-Low House in Salem (FIG. 53). Tarbell used a similar sofa in many of his later interior scenes. Another favorite Benson device was to show the graceful cabriole leg associated with Queen Anne and Chippendale furniture. The right front edge of a high chest of drawers appears as an almost abstract detail in the background of *Gertrude* (FIG. 55), while part of a leg on an eighteenth-century mahogany tea table appears in the foreground of *Rainy Day* (CAT. 23). In several interiors done after 1911, a small New England candlestand appears with a central turned shaft and three cabriole legs (either a period piece or a reproduction). It is often covered with a small cloth and used to support a ceramic object, as in *Figure in a Room* (FIG. 62). Given the eclectic selection of furniture that appears in the interior scenes of many of his contemporaries, it is surprising how consistent Benson was in his use of traditional pre-1820 pieces from the Salem-Boston area, thereby giving his work a distinct regional character.[25]

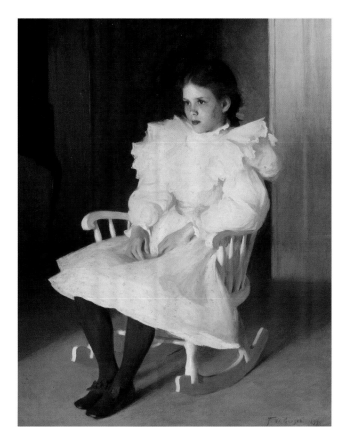
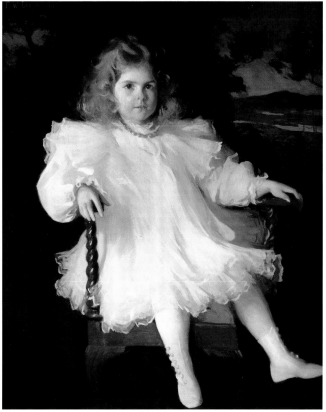

He also pays homage to his Yankee heritage by including a piece of blue-and-white Chinese export porcelain in a number of works. Imported into Salem during the Federal period, these pieces may well have descended from his grandparents, Captain Samuel and Sarah Benson. Chinese export ware was still the standard tableware for many old Salem families during Benson's lifetime. Ginger jars with simply painted blue landscapes were still found in many Salem cupboards where they were used as storage containers. He depicted one as early as 1890 in *Figure in White* (Salem Public Library) and as late as 1934 in *Still Life—Azaleas* (CAT. 36). He also used a Nanking porcelain covered jug or punch pot with strap handles (ca. 1800) in several works, including *Rainy Day* (CAT. 23) and *Peonies in Blue China* (CAT. 32). A covered custard cup in the same pattern appears in several late still life paintings such as *Tabletop, Still Life with Golden Screen* (1936; private collection).

Benson also used new pieces of furniture as props in his paintings, but most were still colonial in character. Architects were among the first to study pieces of old furniture in order to make new designs. Arthur Little created several new pieces for the Emmerton house in Salem in 1885 and may well have influenced some of Benson's selections. In his 1899 *Miss Westinghouse (Young Girl in a White Dress)* (FIG. 56), Benson introduces a new version of a traditional corner chair. Clarence Cook extols the virtues of the colonial elbow chair in his book, noting that it is suitable for modern use because of its comfort and beauty of design. He identified several manufacturers who offered new versions based on antique originals.[26] The spiral twist arm posts of Benson's chair betray its modern origin since true colonial examples never had this type of detail. The cabriole legs with carved knees are more faithful to original versions. It was also probably through Little's

FIG. 57. Music room, Emmerton House, 328 Essex Street, Salem, Mass., ca. 1886. Phillips Library, Peabody Essex Museum.

FIG. 58. A room at Wooster Farm showing wicker armchairs owned by the Benson family. Photograph courtesy of Faith Andrews Bedford.

FIG. 59. Item no. 6220c, large armchair from the *Heywood Brothers and Wakefield Company Classic Wicker Furniture: The Complete 1898–1899 Illustrated Catalogue* (New York: Dover, 1982), 47.

FIG. 60. Mahogany gateleg table, between 1910 and 1930. Private collection. This was originally owned by Frank W. Benson

influence that Benson was aware of the other popular trends in decorating, including the use of white enameled furniture. "Occasional" chairs, either repainted old chairs or new versions, were particularly popular as accent pieces. The white Windsor rocking chair used in his portrait *Gertrude* (FIG. 55) is similar to a chair Arthur Little used in his redecoration of the music room in the Emmerton House in 1885 (FIG. 57). Benson also used a white Louis XVI revival armchair (Arthur Little's favorite style at that time) in several of his late portraits and interiors, including *Reflections* (CAT. 30).[27]

The only modern pieces of furniture found in Benson's images are two examples of seating furniture that were used at Wooster Farm. An enormous white slat-back bench in the "Craftsman" style championed by reform furniture maker Gustave Stickley of New York appears in several outdoor scenes including *Sunshine and Shadow* (CAT. 21). Any number of manufacturers offered furniture in this popular Arts and Crafts style, which was also a favorite style with amateur home woodworkers because of its straightforward construction. The enormous size of the bench at North Haven suggests it was custom-made to fit the needs of the large Benson family. The bench is also reminiscent of the simple but elegant white painted chair with gilded-ball finials that Benson used in his 1889 *Portrait in White* (National Portrait Gallery, Washington, D.C.). The other contemporary example was a wicker or rattan armchair that appears in four of his North Haven paintings. Benson acquired several of the chairs soon after renting the farm in 1901, and they often appear in the background of family photographs taken during this era (FIG. 58). The Heywood Brothers and Wakefield Company in Gardner, Massachusetts, the largest manufacturer of furniture for summer

6220 C
Large Arm Chair

cottages, verandas, and seasonal rooms, manufactured the chairs (FIG. 59). The dramatic increase in outdoor leisure activities by the end of the century created a demand for lightweight furniture that could be easily moved about. In works such as *My Daughter Elisabeth,* the chair becomes the perfect symbol of the carefree, easy lifestyle the Benson family enjoyed during their summers in Maine (CAT. 22). The natural yellow of the rattan vine used to make the chair echoes the soft yellow of the floppy straw sunbonnet. Inspired by a Chinese chair with an hourglass base introduced at the Philadelphia exposition in 1876, this adaptation was a favorite prop with other artists as well and appears in paintings by William Merritt Chase, Edmund Tarbell, and Charles Hawthorne.[28]

 Of all the furniture forms that appear in turn-of-the-century Boston-area interiors, the oval gateleg or drop-leaf table appeared the most often and became one of the real icons of the Colonial Revival movement. Edmund Tarbell first used an eight-legged table as a prop in his paintings around 1904; Benson adopted it around 1911. It is clear that, between them, they owned several different versions in various sizes (FIG. 60). Some may have been antique originals, but most were probably modern adaptations. This form of table, popular during the first half of the eighteenth century, regained prominence at the Philadelphia centennial exposition in 1876, where a large gateleg table served as the focal point of the very popular New England kitchen exhibit.[29] It became a favorite of interior decorators by the 1880s. Arthur Little used gateleg tables in his redecoration of the Emmerton and Little houses in Salem, where they added "integrity and character" to the rooms.[30] The A. C. Titus Furniture Company in Salem offered gateleg tables among their line of antique reproductions "in rich dull finished mahogany" based on "some of the notewor-

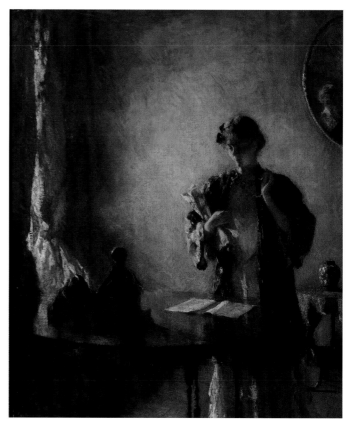

FIG. 61. *Antique Reproduction Furniture Offered by A. C. Titus Company* (Salem, Mass., ca. 1915). Phillips Library, Peabody Essex Museum.

FIG. 62. Frank W. Benson, *Figure in a Room,* 1912. Oil on canvas, 30 x 25 inches. New Britain (Conn.) Museum of American Art. Alix W. Stanley Fund.

thy types of Colonial furniture which so charmingly adorn the interiors of many ancestral homes in old Salem (FIG. 61)."[31] Mary Northend, one of the early Salem writers on antiques, identified one of the chief reasons the gateleg table was so popular: "its polished surface brings out to advantage the articles resting on it."[32] Indeed, it was this reflective quality of the polished surface that made the table a favorite prop for artists. John Singleton Copley used a polished table effectively in a number of his most successful portraits painted in the 1770s.[33] During Benson's Vermeer period between 1911 and 1921, the table was a prominent feature. In *Figure in a Room* (FIG. 62), he places the table in the foreground and uses the polished surface to reflect the light coming in through the window. The tabletop blends into the rich, dappled yellow-and-blue tones of the background. Inspired by Vermeer's masterpiece *Young Lady Adorning Herself with a Pearl Necklace* (FIG. 63), Benson creates a similar vertical composition and also uses an object in deep shadow in the foreground to create a greater sense of depth and drama. Vermeer silhouettes an arrangement of loosely gathered fabric with a covered porcelain urn, while Benson employs a bronze statue of Artemis, the Greek virgin goddess of the hunt and the moon and twin sister of Apollo, sculpted by his friend Bela Pratt (FIG. 64). Typical of Benson's creative process, he uses the table again in the same position in *The Gray Room* of 1913 (FIG. 65), but changes to a horizontal composition using different objects. He employs a linear arrangement using a Japanese oil lamp and a French porcelain basket (ca. 1830) filled with fruit to balance two framed pictures on the opposite side of the central seated female figure. His interest in light led him to try various color harmonies to suggest a different time of day. As in a number of Vermeer's works, Benson uses a predominately blue-gray palette with white

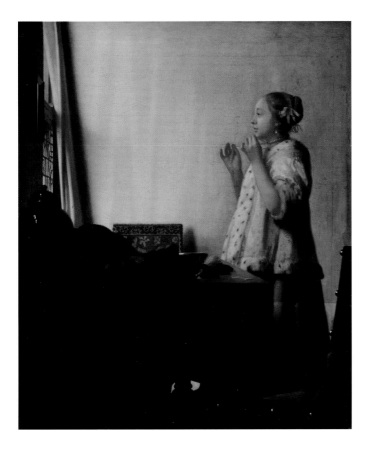

FIG. 63. Jan Vermeer (1632–75), *Young Lady Adorning Herself with a Pearl Necklace,* 1660–65. Oil on canvas. Staatliche Museen zu Berlin-Preubischer Kulturbestiz Gemaldegalerie. Photograph by Jorg P. Anders.

FIG. 64. Bela Lyon Pratt, *Artemis,* ca. 1909. Bronze, 13⅛ x 17⅝ inches. New Britain (Conn.) Museum of American Art. Stephen B. Lawrence Fund. Bela Pratt gave Benson the cast of Artemis, and he used this in at least two paintings.

and pale yellow accents to suggest a cool early morning light that creates a monochromatic atmospheric haze that envelops the entire image.

Equally important to the colonial objects in Benson's interiors and still lifes were such oriental objects as painted screens, porcelain urns, figurines, and embroidered silk textiles. Most were a legacy of the Japan craze that swept the country in the 1880s, rather than being drawn from objects descending from the family's China trade heritage. As we have seen, by the time Benson took up painting interiors, these objects were a popular part of the eclectic upper-class aesthetic decor. They helped create the exotic and cosmopolitan look that was so highly prized by the country's first generation of interior decorators. James McNeill Whistler was among the first American artists to appreciate the decorative quality of Japanese porcelains and textiles and featured them in a number of his paintings done in the 1860s. It was during the 1880s, however, when they became an almost mandatory element for any American interior scene. In John Singer Sargent's well-known 1882 portrait of the *Daughters of Edward D. Boit* (Museum of Fine Arts, Boston), he juxtaposed monumental Japanese urns with the beguiling figures of four girls, creating an image that may well have inspired Benson's use of large urns in his first interior, *By Firelight* (FIG. 49). The blue-and-white Japanese vase (ca. 1875) on the mantel in this same work reappears in a number of later paintings, including *Twilight* (FIG. 52) and *The Black Hat* (FIG. 66). The latter painting is Benson's most important exploration of the Japanese theme. In addition to the vase, he includes a Japanese print on the wall and shows a traditional Japanese storage chest in the background. The chest was featured in Clarence Cook's *The House Beautiful,* where he praised it as a model of con-

89

FIG. 65. Frank W. Benson, *The Gray Room,* 1913. Oil on canvas, 25¼ x 30¾ inches. Private collection. Photograph courtesy of Christie's, New York.

FIG. 66. Frank W. Benson, *The Black Hat (Lady Trying on a Hat),* 1904. Oil on canvas, 40 x 32 inches. Museum of Art, Rhode Island School of Design, Providence. Gift of Walter Callendar, Henry D. Sharpe, Howard L. Clark, William Gammell, and Isaac C. Bates.

FIG. 67. Illustration of a Japanese chest in Clarence Cook's *The House Beautiful,* 1877. Phillips Library, Peabody Essex Museum.

venience suitable for a modern bedroom (FIG. 67).[34]

Cook also advocated the use of folding screens as a way of breaking up large rooms and providing privacy.[35] One finds them in countless photographs and paintings dating from the last quarter of the nineteenth century, including many from Salem. Suppliers such as N. M. Hatch in Boston offered a full line of Japanese paper screens "in a great variety of styles."[36] Other importers, such as Bunkio Matsuki, offered Chinese examples. Oriental screens became a favorite prop for Boston School painters, and Benson owned several different versions. His earliest representations are rather nondescript in nature, such as the plain screen found in the background of his *Figure in White* (1890; Salem Public Library). Around 1900, he acquired several that were more decorative in nature with more exotic details, the perfect solution for creating an interesting background in a sterile studio environment. The multiple folding panels also allowed him to show one panel in bright light, another set in shadow to enhance the sense of depth within the overall image. This arrangement is used in *The Golden Screen* (FIG. 46), where a flowering tree painted on two panels adds an elegant landscape element. In his *Portrait of Mary Sullivan,* a large crane on the screen adds a sense of exotic wonder and introduces a landscape theme that is echoed in the Chinese porcelain garden seat (1902; private collection).

Screens were a dominant element in Benson's still life paintings after 1921, where they provide background color and texture. In *The Silver Screen,* he uses a relatively plain example with four luminous silver panels to create a remarkable reflective light that intensifies the three-dimensional quality of the objects set on a gateleg table directly in front of it. Like most of the screens in

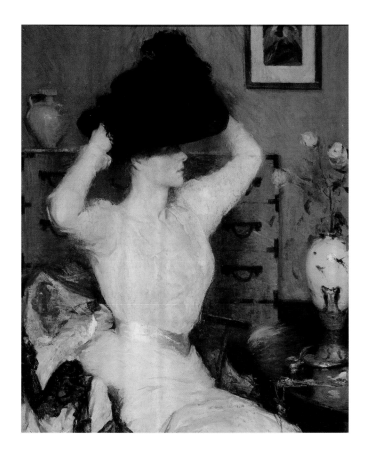

Benson's work, there are not enough details to say with any certainty if it is of Chinese or Japanese origin. The same is true for the more colorful Asian textiles that often appear as table coverings.

Benson's interest in Asian textiles developed during his Vermeer period, starting in 1911, in part to emulate the Dutch master's superb rendering of costumes and lush furnishing textiles that are such an appealing aspect of his work. Benson briefly experimented using fabric as a background element in *The Lesson* where a large panel of golden brocade fabric is simply tacked onto the wall behind his subjects (1911; private collection). He quickly abandoned this practice in favor of having his female subject wear a brightly colored informal Chinese robe to convey the same sense of luxury but also to add areas of bright color against the more subdued background. Reminiscent of Vermeer's richly attired female in *Young Lady Adorning Herself with a Pearl Necklace* (FIG. 63), he used a yellow silk robe with an embroidered white-and-black trim that forms a scrolling lotus pattern at the neck and sides in a number of works, including *Young Girl by a Window (Woman near Window, Maid in Waiting)* (CAT. 25). An embroidered blue Chinese robe with a contrasting orange fabric lining the interior of the wide sleeves appears in *Figure in a Room* (FIG. 62). The robes are also used as props in several still lifes done in the 1920s. By far, the most effective use of textiles is seen in *The Silver Screen* (CAT. 31), where three different fabrics create a symphony of color. A flat rectangular piece of blue silk embroidered with accents of yellow and orange and bound with a vibrant yellow border covers most of the gateleg table. To the left, a loosely draped Chinese robe in yellow with a white trim cascades down from the bowl of fruit, covering a piece of lavender fabric with black trim. In teaching his daughter to paint, Benson gave her these instruc-

FIG. 68. Unknown artist, figure of a man, Shiwan, China, mid-nineteenth century. Glazed stoneware, height, 20 inches. The statue appears in Benson's painting *Confucius* (CAT. 35). Collection of Mrs. Richard D. Reitz. Photograph by Laura Worsham.

FIG. 69. Unknown artist, jar, China, ca. 1650. Porcelain with a teak cover and stand, 19½ x 11 inches. Private collection. The jar appears in several of Benson's works, including *The Silver Screen* (CAT. 31).

FIG. 70. A detail of the porcelain jar in *The Silver Screen* (CAT. 31).

tions: "Describe the lights and shadows of drapery in masses. Pay special attention to the directions of the folds in relation to the design. Invent if necessary . . . Where the edge of the table disappears into shadow, don't make it plain. The light on the edge of the table is important because it describes the kind of material that covers the table."[37] Here Benson succeeds brilliantly, not only in capturing the rich mottled color and texture of the fabrics, but also in using the contrasting trims to create a dynamic linear pattern that adds great energy to the overall composition.

Benson's rekindled interest in still lifes that emerges around 1920 also brings a wide array of new props into his studio. Inanimate objects range from delicate pieces of contemporary table glass (a fruit bowl, candy dish, and goblet) to figural pieces including a bronze statue of a walking man. Flora and fauna are introduced, including plants, cut flowers, fruit, and several exotic parrots. The objects were selected for their color, shape, and surface texture. Their eclectic nature is indicative of Benson's constant search for the right combination of objects to produce the perfect still life composition. "The important part of a still-life is the design," Benson always stressed to his students, followed by the need "to paint the atmosphere, in which all the objects are and in which they have their relations to one another. . . . at all times observe minutely the delicate variations of value between one thing and another or between light and shadow—paint the light and shade and interrelating values of the whole thing" and your picture will be a success.[38] As a group of objects, these later additions to Benson's repertoire of props certainly lack any kind of coherent iconographic message. There are still echoes of the colonial theme so prominent in his pre-1917 work in his use of brass candlesticks, the occasional piece of China trade porcelain, a pewter cream pitcher,

and a gateleg table. More prominent is his continued interest in oriental objects. A screen, porcelain bowl, jar, or figurine of Asian manufacture appear in all but a handful of his late still lifes.

Figurines were the most evocative objects in the group. Benson owned several including a pair of inexpensive late nineteenth-century Japanese Imari porcelain figurines, each depicting a lady playing a drum (FIG. 48). One was used for the first time in 1900 in *The Golden Screen* (FIG. 46), while its mate in red attire figures prominently in the watercolor *Still Life—Azaleas* (CAT. 36). In the large painting *Confucius* (CAT. 35), a solitary statue of the ancient Chinese man wearing a red and green robe (FIG. 68) stands against a mottled white background surrounded at the base by white dogwood blossoms. Porcelain bowls and jars appear regularly, often as containers for potted plants. A delicate blue-and-white porcelain bowl resting on a tall teak stand is used with a miniature orange tree in *Oriental Figurine* (1930; private collection). His favorite ceramic piece was a Chinese porcelain ginger jar with a deep blue background covered with white flowers. It was most likely a late nineteenth-century copy of a form that had been popular during the early eighteenth century.[39] Benson used it in half a dozen works, including several interior scenes such as *Figure in a Room* (FIG. 62). It also appears in the background of the *Portrait of Richard Saltonstall* (CAT. 12) where it forms a still life vignette with a brass candlestick that enhances the colonial theme reflected in the Chippendale-revival armchair. The oriental theme is also reinforced in the hand-carved Walfred Thulin frame where Japanese motifs in the central panels are painted red and black to imitate oriental lacquerware.

While Benson may well have taken artistic license in representing some of the objects (one

93

recalls his dictum to his daughter to "invent if necessary"), most props appear to have been faithfully rendered. This is evident when one compares the image of the large Chinese porcelain jar in *The Silver Screen* (CAT. 31) with the actual object (FIG. 69) that happily survives in the Benson family. Dating from the Qing dynasty, the jar (ca. 1650) has carefully drawn figures and landscape details that are brightly colored in a primary palette of red, blue, and green. The irregular areas of color are perfectly captured in Benson's rendering (FIG. 70). The jar has a carved teak stand and cover that were probably added later by the dealer who sold it to Benson around 1920. This may have been the well-known Boston importer Yamanaka who is known to have sold other Japanese and Chinese antiquities to Benson.[40]

In working with these disparate objects, Benson created some of the most vibrant and luminous American still life paintings. One critic summed up his success: "he takes insensate things and gives them artistic life. . . . he finds aesthetic beauty in a cluster of fruit or a porcelain vase. . . . he sees and feels in the manner of a true artist expressing a personal emotion and arriving at a personal style. . . . [he] has invented his own hypothesis. But he achieves beauty because he is faithful to an immemorial tradition, because he is not only sensitive, exquisite in his feelings for the sensuousness in form, color and decoration, but because he upholds the integrity of honest craftsmanship."[41] By 1936, Benson had painted his last still life and was enjoying more and more the quiet solitude of his Salem home.

The Colonial Revival movement influenced many aspects of American life. Interiors with ivory woodwork, polished hardwood floors, and orderly revival-style furnishings were the most

common expression throughout the country by 1915.[42] Frank Benson was an early advocate and embraced aspects of the style not only in his early interior scenes and later still life compositions, but also gave it a voice in the home he purchased at 14 Chestnut Street in Salem in 1924. Like most new homeowners, Benson remodeled and redecorated the 1834 Greek Revival house to make it his own. Two views of the library in the southeast room on the first floor, one taken about 1890 during the Lee family occupancy (FIG. 71), and another taken from the exact same vantage point after Benson's redecoration (FIG. 72), show the dramatic shift that had taken place in terms of aesthetic sensibilities during the early twentieth century. Benson swept away most of the trappings of the Victorian era, the wall-to-wall carpeting, over-stuffed furniture, and dark walnut woodwork. He replaced the massive marble mantel with a painted, Federal-period mantel that he had used as a prop in his studio. He retained the rococo overmantel mirror but simplified it by removing its elaborate crest. He then furnished the room with icons of the era, an almost encyclopedic array of objects and furnishings that echo the props that appear in many of his interiors and still lifes. To the right is a gateleg table draped with an oriental textile, next to an eighteenth-century Chippendale rush-bottomed side chair. On the opposite side is a seventeenth-century English armchair (very probably given by his friend Henry F. G. Waters) and a Federal-period sewing table. Carefully arranged across the top of the white bookcases is an array of objects and pictures, including the porcelain bowl on a stand (seen in several late watercolors), a glass bowl of fruit, and several oriental vases. A biographical note is struck with the photograph of Benson with his daughter Eleanor taken on her wedding day in 1913, a sculpture of Benson's own image by Bela Pratt, and several of his own works of art, including *The Lone Pine* (CAT. 78). Reflected in the mirror is the oriental folding screen used in the background of several works including *Peonies in Blue China* (CAT. 32). These objects reflect a lifetime of interests, influences, and memories, drawn together to create a highly personalized Colonial Revival room. Remarkably, the scene is reminiscent of the imaginary room Benson depicted in his first interior, *By Firelight* (FIG. 49), painted nearly a half-century before. In that work, he began the quest to redefine his own sense of elegance and beauty using colonial and oriental props. Developing a superb sense of design, color, and light along the way, he went on to create some of the most memorable interiors and compelling still life compositions of his generation.

Dean T. Lahikainen is the curator of American Decorative Arts at the Peabody Essex Museum.

Notes

1. See William Hosley, *The Japan Idea: Art and Life in Victorian America* (Hartford, Conn., 1990).

2. Frank Benson cited in "Advice on Painting from F. W. B. Notes Taken after Criticisms by E. B. L.," entry for 17 February 1939, unpublished manuscript, Benson Papers, Phillips Library, Peabody Essex Museum, Salem, Mass.

3. James Homer, "Henry Fitz Gilbert Waters," *The New England Historic and Genealogical Register* 67 (1914): 8. See also Richard H. Saunders, "Collecting American Decorative Arts in New England," Part I: 1793–1879, *Antiques* 109 (1976): 998–99; Part II: 1876–1910, *Antiques* 110 (1976): 754–55.

4. It is unclear how formal Waters's role was in teaching the Benson boys. Henry Benson signs several letters to Waters as "friend and pupil." Waters is often mentioned in the family journals as being in their classroom and frequently in their home. Typical is Henry's entry for 18 September 1882: "Mr. Waters was in for the evening with some architectural drawings." Another entry for 23 January 1882 states that "Mr. Waters up at the Drawing School" where Frank served as the instructor. The journals make it clear he took a keen interest in all of the boys' varied activities. Benson Family Journals, private collection.

5. Elizabeth Benson to Henry Fitz Gilbert Waters, 6 November 1883, Waters Collection, Phillips Library, Peabody Essex Museum. Hereafter, Waters is cited as HFGW.

6. Arthur Little to HFGW, 13 August 1876, Waters Collection.

7. Clarence Cook, *The House Beautiful Essays on Beds and Tables, Stools and Candlesticks* (1878; reprint, New York: Dover, 1995), 163.

8. Arthur Little, *Early New England Interiors: Sketches in Salem, Marblehead, Portsmouth and Kittery* (Boston, 1878), preface.

9. See Walter K. Sturgis, "Arthur Little and the Colonial Revival," *Journal of the Society of Architectural Historians* 32 (1973): 147–63. See also Kevin D. Murphy, "A Stroll Thru the Past: Three Architects of the Colonial Revival" (master's thesis, Boston University Graduate School of Arts and Sciences, 1985).

10. John P. Benson to HFGW, 15 April 1884, Waters Collection. John Benson left Little's employ in 1886 and went on to design several Colonial Revival houses in Salem, including 30 Chestnut Street in 1896

and a house for his brother Henry at 7 Hamilton Street in 1898.

11. Bryant F. Tolles, *Architecture in Salem: An Illustrated Guide* (Salem, Mass.: Essex Institute, 1983), 175–76, 191. Photographs of both commissions are in the collection of the Society for the Preservation of New England Antiquities (SPNEA), Boston.

12. Ellen Peirson Benson to Ellen Perry Benson, 21 October 1888, quoted in Faith Andrews Bedford, *Frank W. Benson: American Impressionist* (New York, 1994), 42.

13. Frank Benson to HFGW, 18 December 1888, Waters Collection.

14. Henry Benson to HFGW, 27 August 1896, Waters Collection.

15. See *"A Pleasing Novelty": Bunkio Matsuki and the Japan Craze in Victorian Salem* (Salem, Mass.: Peabody Essex Museum, 1993), 88–103.

16. See Trevor J. Fairbrother et al., *The Bostonians: Painters of an Elegant Age, 1870–1930* (Boston, 1986), 69–78.

17. Faith Andrews Bedford, *Frank W. Benson: American Impressionist*, 59. Cook, an early advocate of Impressionism, praised Benson's work in print as early as 1888 in "The Society of American Artists," *Studio*, n.s., 3 (1888): 95.

18. Benson Family Journals, 8 April 1883, private collection.

19. Benjamin Blom, *Artistic Houses: Being a Series of Interior Views of a Number of the Most Beautiful and Celebrated Homes in the United States* (New York, 1883), 122. See also Peter Thornton, *Authentic Decor: The Domestic Interior, 1620–1920* (New York, 1984), 330–41.

20. Peter Thornton, *Authentic Decor*, 341.

21. A photograph in the SPNEA collection shows another room in the Little house with a tigerskin rug identical to the one depicted in Benson's painting.

22. Other works include *Lamplight* (1893), *Young Girl in Profile* (1898), and *Examining the Lace* (1910).

23. Benson, "Advice on Painting," 22 February 1939, p. 5.

24. For a broader discussion of this aspect of collecting, see Celia Betsky, "Inside the Past: The Interior and the Colonial Revival in American Art and Literature, 1860–1914," in *The Colonial Revival in America*, ed. Alan Axelrod (New York, 1985), 241–77.

25. For examples, see H. Barbara Weinberg et al., *American Impressionism and Realism: The Painting of Modern Life, 1885–1915* (New York, 1994), 44–46, 306–7.

26. Cook, *The House Beautiful*, 71–72.

27. Many of Arthur Little's original furniture designs are in the collection of SPNEA, Boston.

28. The chair is discussed in *Heywood Brothers and Wakefield Company Classic Wicker Furniture: The Complete 1898–1899 Illustrated Catalogue* (New York: Dover, 1982), ii. Chase's painting *In the Studio* (1892) is reproduced in Weinberg, *American Impressionism*, 103; Tarbell's *My Family* (1914) appears in Fairbrother et al., *The Bostonians*, 162; and Hawthorne's *Morning Sunlight* (n.d.) is reproduced in Richard Muhlberger, *Charles Webster Hawthorne* (Chesterfield, Mass., 1999), 23.

29. Axelrod, *The Colonial Revival*, 176.

30. William H. Truettner and Roger B. Stein, eds., *Picturing Old New England: Image and Memory* (New Haven, Conn., 1999), 89.

31. Advertising flyer, A. C. Titus and Company, Salem, Mass., ca. 1915, Phillips Library, Peabody Essex Museum.

32. Mary H. Northend, *Memories of Old Salem* (New York, 1917), 236.

33. See examples in Carrie Rebora et al., *John Singleton Copley in America* (New York, 1995), 271–72.

34. Cook, *The House Beautiful*, 290.

35. Ibid., 181–82.

36. Advertising pamphlet, *Catalogue of Japanese Screens, from the Japanese Parlors of N. M. Hatch*, 283 Tremont St., Boston, ca. 1890, Phillips Library, Peabody Essex Museum.

37. Benson, "Advice on Painting," spring 1940, p. 9.

38. Benson, "Advice on Painting," 1 February 1939, p. 5.

39. The author would like to thank William R. Sargent and Dr. H. Crosby Forbes for helping to identify the ceramics in the various works of art discussed in this essay.

40. Bedford, *Frank W. Benson: American Impressionist*, 150.

41. Unidentified critic, "Workmanship: Its Role in Sustaining Current American Painting," *New York Herald Tribune*, 28 November 1916, Benson Papers.

42. For a broader discussion of this style, see William Seale, *The Tasteful Interlude: American Interiors through the Camera's Eye, 1860–1917* (New York, 1975), 20–27.

Benson as Naturalist and Sportsman

BY JANE M. WINCHELL

Frank Benson was not only a master painter and legendary etcher, but also a distinguished naturalist and passionate outdoorsman. Benson expressed these qualities through his groundbreaking artwork and longstanding commitment to conservation and bird study. His enduring interests in natural science, wildfowl hunting, and fishing clearly laid the foundation for the title later bestowed upon him as the father of American sporting art.[1]

Salem, the city that was to be Benson's lifelong home base, nurtured his earliest boyhood curiosity in nature study and discovery. Salem had become a mecca for scientific and cultural explorations, dating back to the late 1700s with the establishment of the East India Marine Society. Benson's grandfather, Captain Samuel Benson, had become one of the members of the prestigious East India Marine Society in 1822 upon successfully sailing a vessel around both the Cape of Good Hope and Cape Horn. The society started a museum, the precursor to the Peabody Museum of Salem, to display "natural and artificial curiosities" from around the world. Benson carried on his grandfather's association with the Peabody Academy of Science and later the Peabody Museum of Salem where he served as a trustee for thirty-seven years, as well as the museum's honorary curator of ornithology. He produced the seal for the museum in 1919 (FIG. 73) and painted portraits of several of the museum's prominent scientists and trustees. Concurrently, Benson established a relationship with the Essex Institute, which also incorporated natural science and cultural studies. He was elected to be a member in 1894 and remained so until his death in 1951.

In the days of Benson's youth, Salem was surrounded by open, rolling country and miles of seashore. Further to the north lay the extensive estuaries and vast salt marshes behind Plum Island near Newbury and Rowley. It was in these wild fields, marshes, and waterways that Benson explored, fished, and later hunted. His father taught him to hunt waterfowl and shorebirds and bought him his first shotgun at the age of twelve. His accounts of hunting excursions with family and friends reflect the deep love of the out-of-doors that became almost palpable in his later works of waterfowl and sporting art.

Benson spent innumerable hours studying the myriad birds that abounded in the environs

FIG. 73. Frank W. Benson, seal of the Peabody Museum of Salem, 1919.
Etching on paper, 9⅞ x 7⅞ inches. Peabody Essex Museum.

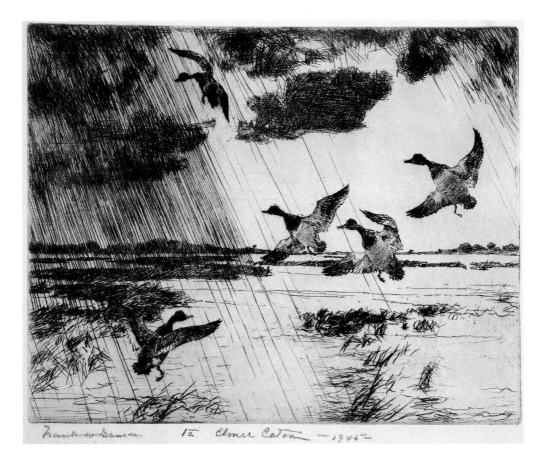

of Salem and the North Shore. "Birds were a passion of my youth," Benson once said, and they continued to be throughout his life.[2] His earliest oil paintings, done at age sixteen, were of a snipe and a rail he had shot (FIG. 2). Somewhat surprisingly, a long hiatus from wildlife and sporting art ensued. He was nearly fifty before he began seriously sketching wildlife again. Nevertheless, during all the intervening years while he built his reputation as a painter of portraits and landscapes, he had never ceased hunting birds, watching them, studying their habits, and sketching them in his mind's eye.

Perhaps it is not so surprising then that, from the moment Benson put some of his sporting art sketches into a show in 1913, the images were an instant success. From that day forward, Benson's focus became wild game and sporting art, and his etching career took off. Benson became particularly identified with images that depicted a flock of waterfowl in flight. He often portrayed weather and light in these scenes with remarkable realism (FIG. 74 and CATS. 47, 48, and 56). To capture his waterfowl images, Benson would lie in a blind, watching thousands of birds fly overhead. He would then go home and draw the scene from memory, returning to the field repeatedly to observe and then revisit his sketch to correct errors.[3]

The "wildness" that Benson captured in his wildfowl images, and the life he breathed into his feathered subjects drew acclaim from connoisseurs of art, sportsmen, and bird watchers alike. As noted ornithologist Roger Tory Peterson remarked in a 1995 interview, "I truly admired Frank Benson and feel that he was the best painter of birds I have ever known. . . . It was clear that he had been observing birds all his life by the time he finally began painting pictures of them for they appear so incredibly real, frozen in time."[4]

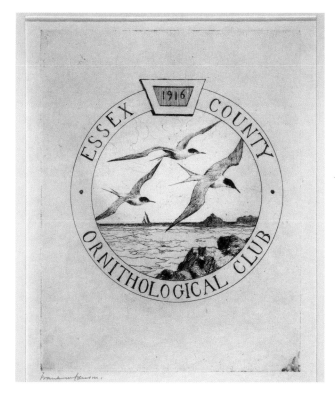 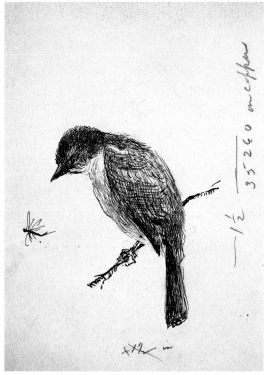

Art critics regularly commented on Benson's singular mastery in the realm of sporting art: "It would be difficult to conceive of more perfect interpretation of the wildlife of the marshes. . . . These birds are caught with more truth than any camera, with more art than has ever fallen to their lot before."[5] Anthony Philpott gave Benson a particularly sweeping compliment in an evaluation of his work: "To the great ornithological work that Wilson and Audubon did in America 100 years ago Frank W. Benson had added something imperishable—an artist's dream they knew not; a knowledge of bird flight which places him in a class by himself."[6]

As he grew older, Benson increasingly turned his attention to the conservation and study of birds rather than the hunting of them. He regularly participated in bird counts, reporting his findings to the Audubon Society. Benson also became a charter member of the Bay State Ducks Unlimited chapter in 1938. He produced original art for Ducks Unlimited and granted the group publication rights to other images, thereby starting a long tradition of artist support for the organization that is continued by wildfowl artists to the present day.

One organization in which Benson became particularly active was the Essex County Ornithological Club (ECOC), for which he created the seal that is still used by the group today (FIG. 75). Benson served as the club's first president in 1916, and continued in that capacity until he became honorary president in 1935. At the time, the ECOC was composed of a rather exclusive group of noted ornithologists and naturalists. Members convened monthly, usually around a large wooden table at the Peabody Museum, to compare notes on field identifications, photographs, and recent sightings.

AROUND THE BIG TABLE

The club published an annual bulletin from 1919 through 1938. Benson provided original artwork for these publications and fulfilled his boyhood dream of illustrating ornithological texts (FIG. 76). A regular column of the bulletin, "Around the Big Table," featured sightings of rarities and behavioral notes on birds. Benson produced an accompanying pen-and-ink sketch of the table itself, replete with an assemblage of bird mounts, field journals, and other items typical of the monthly meeting (FIG. 77). Benson regularly participated in the club's annual Ipswich River bird trip in May, a bird-tallying event in the region that has continued right up to the present.

Benson contributed to wildfowl preservation at a national level with his 1935 Federal duck stamp design that generated monetary support for national waterfowl habitat enhancement and conservation through stamp sales to hunters and others (FIG. 78). Jay "Ding" Darling, designer of the first stamp in 1934, solicited Benson to produce the 1935 stamp shortly before the program became an open competition. Benson's subsequent etching of the stamp design, which featured a trio of canvasbacks above a marsh, remains the most valuable of all the Federal duck stamp prints, with only one hundred proofs ever made (FIG. 79). Although it is the rarest and one of the best known of all the Federal duck stamp prints, it seems Benson was never personally satisfied with it. So one could conclude, anyway, from remarks made by his daughter Sylvia Lawson and the fact that Benson waited about seven years before making the plate of the wash painting, from which prints were made.[7] Interestingly, this etching, made by Benson in 1942 at the age of eighty, was his last.

Wildfowl continue to benefit from the energy and talent this singular artist dedicated to conservation and habitat restoration efforts, both regionally and nationally. Benson successfully

passed on his love and enthusiasm for nature to his children, who themselves participated in many of the outdoor activities and studies in which Benson engaged, such as bird counts, ECOC outings, and fishing excursions on the North Shore and in Maine. Perhaps, in the end, his example will have been his greatest contribution to conservation.

No artist, before or since Benson, has portrayed the activities and behaviors of birds more accurately and perceptively than he did. His legacy lives on in the hundreds of original wildfowl paintings, etchings, and drypoints he produced over his lifetime, some of the best of which are displayed in this exhibition. In addition to founding American sporting art, Benson continues to be its leader as no other artist has traveled further along that path than he did himself.

Jane M. Winchell is the curator of the Natural History Department at the Peabody Essex Museum.

Notes

1. John Ordeman, *Frank W. Benson's Etchings, Drypoints and Lithographs* (Summit, N.J.: Hickok-Bockus, 1994), 18.

2. Ibid., 11.

3. Lucien Price, *Frank W. Benson, 1862–1951: A Joint Retrospective Exhibition* (Salem, Mass.: Essex Institute and Peabody Museum, 6 June–30 September 1956), 8–9.

4. Faith Andrews Bedford, *The Sporting Art of Frank W. Benson* (Boston: David R. Godine, 2000). Roger Tory Peterson, interview with the author, Warrenton, Va., 22 April 1995.

5. Unidentified newspaper clipping, no date (probably from the mid-1920s), regarding a Benson exhibition of etchings, drypoints, and watercolors at the Kennedy Galleries in New York, archives of the Peabody Essex Museum.

6. Newspaper clipping, November 1936 (probably the *Boston Globe* for which Anthony Philpott wrote), artist's scrapbook, Benson Papers, Peabody Essex Museum.

7. Correspondence files, Natural History Department, Peabody Essex Museum.

I. Studio Portraits

"As with portraits, I've been doing a great variety, and so each helps the other by changing my point of view. Benny's [portrait] was done quickly, but it has a quality of life about it that I like. I am especially glad, as no photograph ever was like him to me and this is very much the way I see him."

FRANK W. BENSON

1. *My Sister (Portrait of Betty)*, 1885

Oil on canvas, 35½ x 29½ inches. Private collection.
Benson's portrait of his youngest sister was done the year he returned from art school in Paris.
Photograph courtesy of Berry-Hill Galleries, New York.

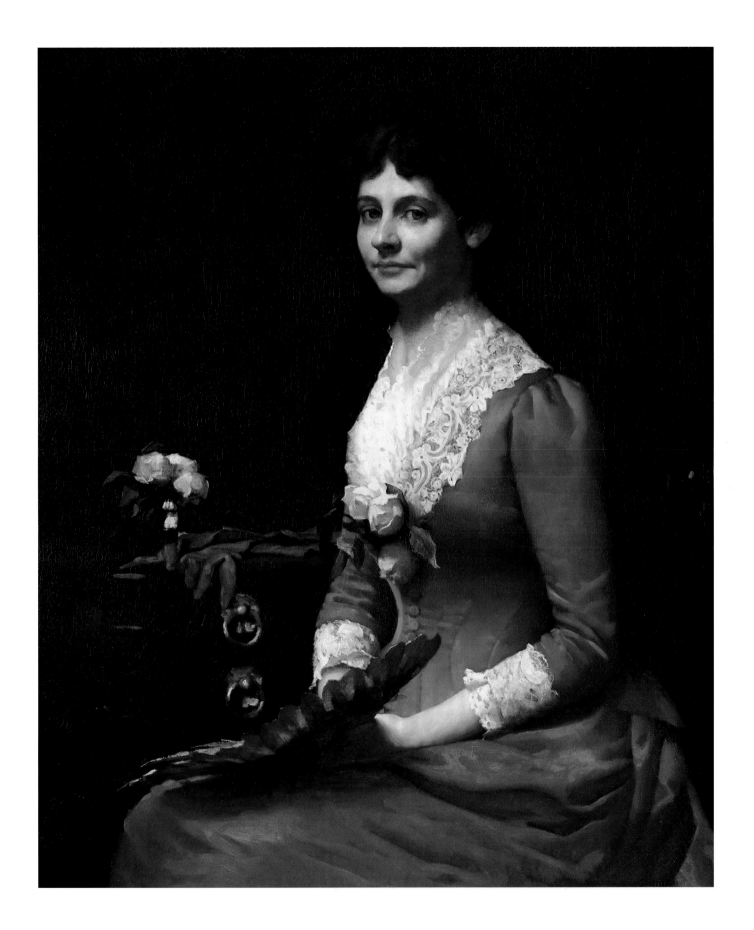

2. *Portrait of Margaret Washburn Walker,* 1886

Oil on canvas, 43 x 36½ inches. Collection of a descendant.
This was Benson's second commissioned portrait.

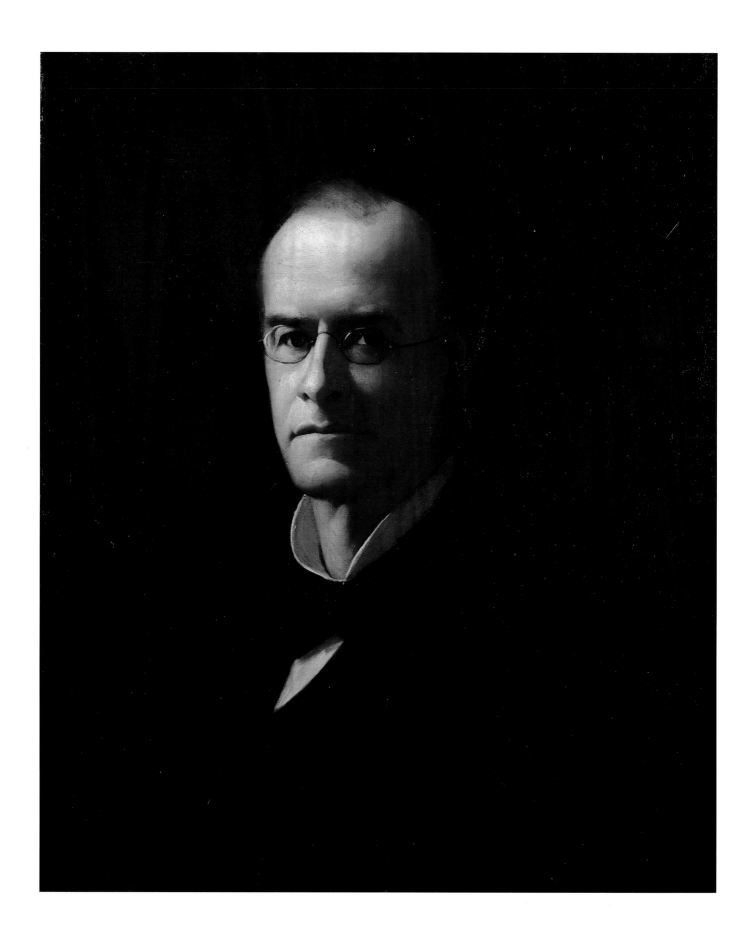

3. *Portrait of Charles Hamlin,* 1887

Oil on canvas, 28 x 21½ inches. Private collection.
Charles Hamlin was a lawyer, scientist, philosopher, and a professor at Colby College in Maine.

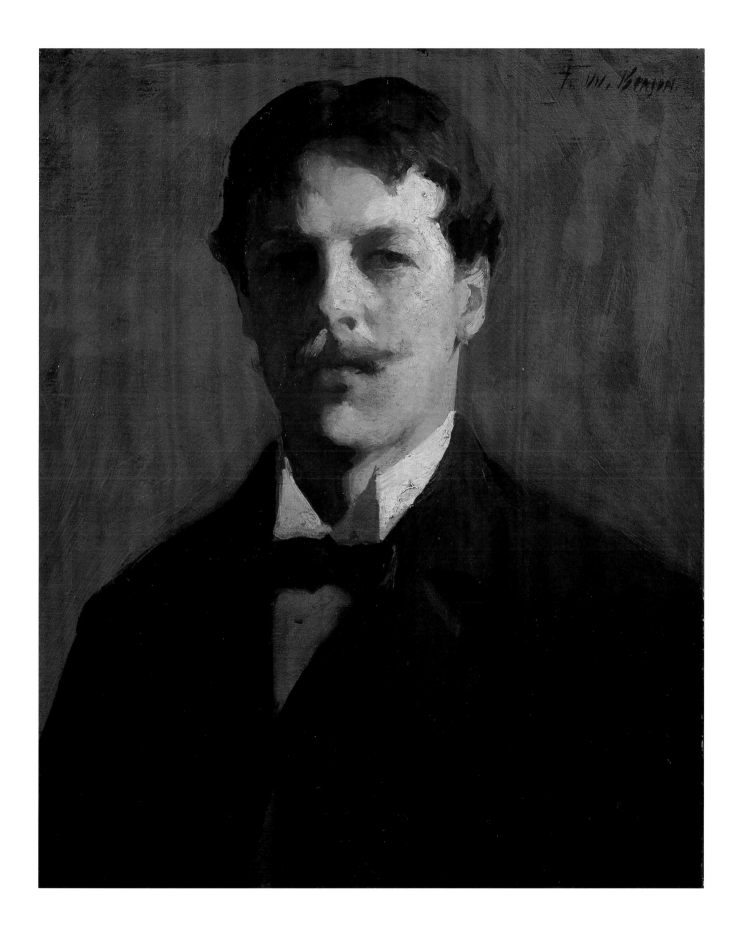

4. *Self-Portrait,* 1898

 Oil on canvas, 21 x 17 inches. National Academy of Design, New York.
 Upon being elected an associate of the National Academy of Design in New York, an artist was
 expected to present the academy with a self-portrait.

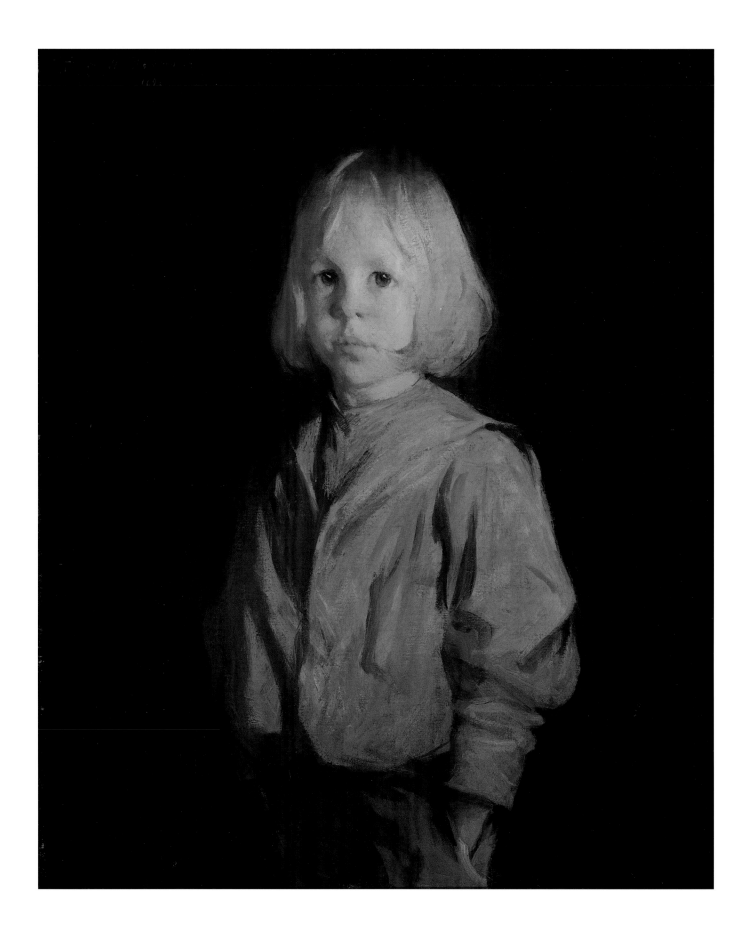

5. *Portrait of a Boy,* 1896

 Oil on canvas, 30 x 26½ inches. Carnegie Museum of Art, Pittsburgh. Museum purchase, 1897.
 Benson's charming portrait of his son was done when George was five. An active little boy, George appears
 rarely in his father's works.

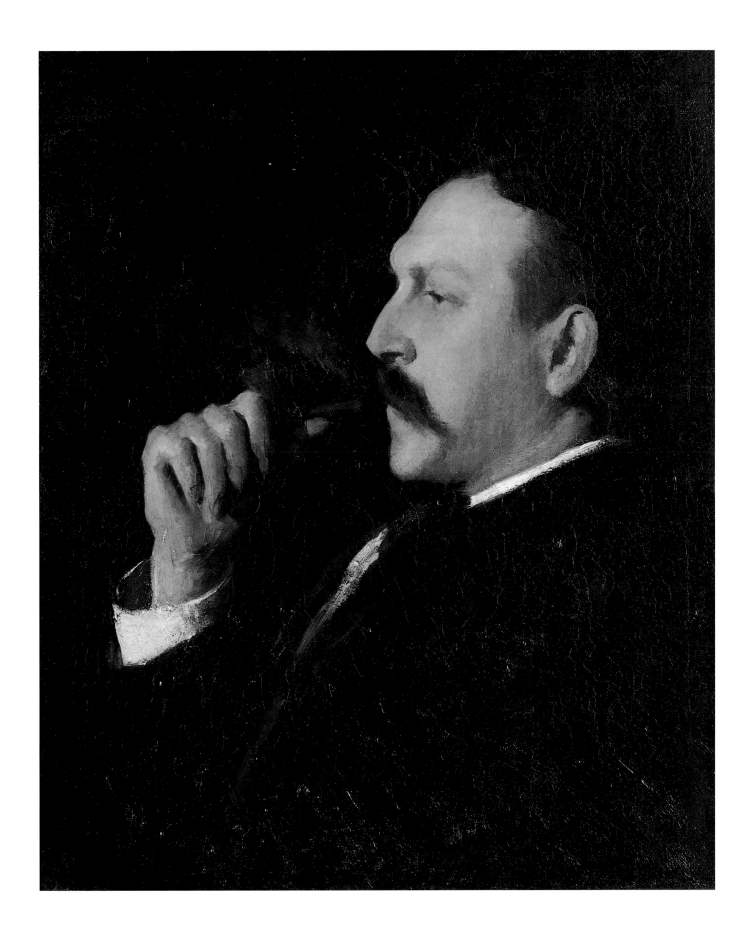

6. *Portrait of Alexander Pope,* 1892

Oil on canvas, 22½ x 19¼ inches. Collection of Natalie Fielding.
At the time Benson painted this informal portrait of his friend, Pope was a painter of trompe l'oeil still lifes and a carver of wooden models of animals and game birds. By 1912, he had turned chiefly to portrait painting. The two shared a love of wildfowl, and Pope's book, *Upland Game Birds and Water Fowl of the United States,* undoubtedly had a place of honor on Benson's shelves.

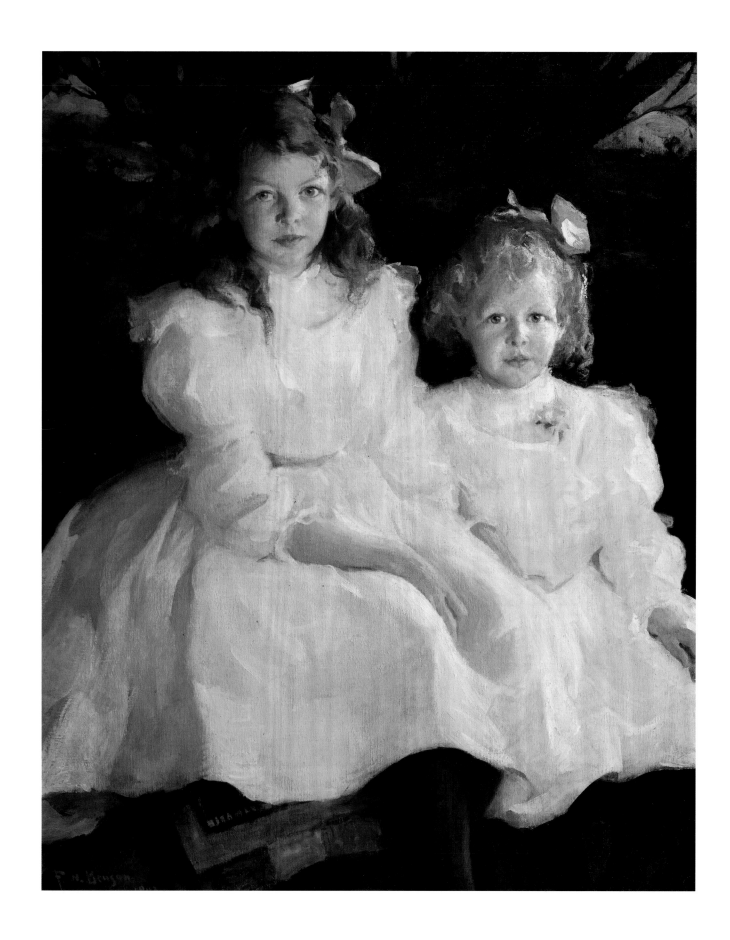

7. *Two Little Girls,* 1903

Oil on canvas, 40 x 32 inches. Private collection.

Rosamund and Ruth Benson, daughters of Benson's brother Harry, are depicted in this charming portrait.

Photograph courtesy of Berry-Hill Galleries, New York.

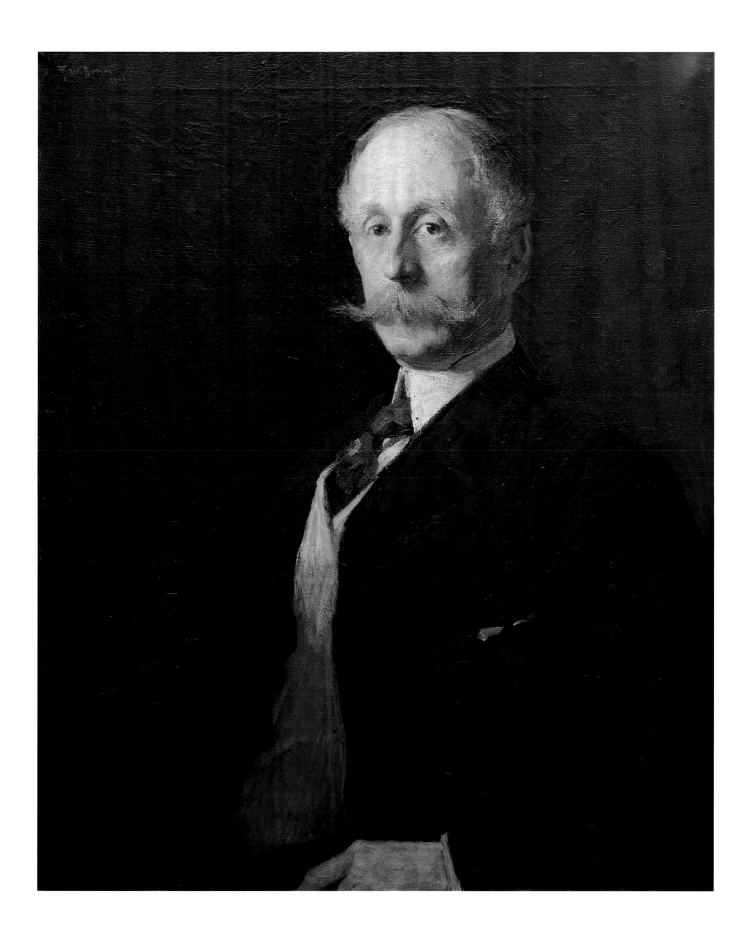

8.　*Portrait of Philip Little,* 1906

Oil on canvas, 30 x 25 inches. Peabody Essex Museum.
Philip Little was a childhood friend of Benson's and a fellow classmate at the Museum School in Boston.
They shared their first studio together in Salem and, later, were neighbors on Chestnut Street.

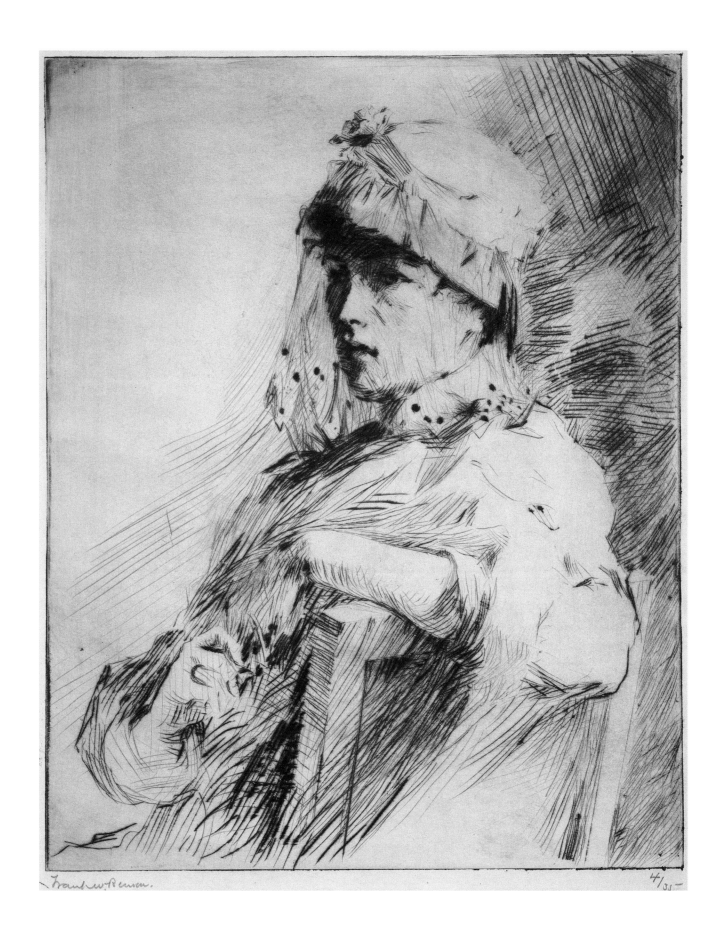

9. *Nan,* 1915

Drypoint on paper, 9⅞ x 8 inches. (Paff no. 43, ed. 28.) Print Department, Boston Public Library. Gift of the artist.
This drypoint portrait was drawn on the plate directly from life. Benson intended to print the usual number of editions that he ran while in his experimental phase—thirty-five—but, after twenty-eight proofs had been taken, the plate showed signs of wear and was destroyed.

10. *Portrait of Augustus Hemenway, 1919*

Etching on paper, 9 x 7 inches. (Paff no. 157, ed. 19.) Print Department, Boston Public Library. Gift of the artist.
Benson etched only twelve portraits, but this genre earned him high praise from critics who compared his portrait work to
that of Anders Zorn, a Scandinavian painter and etcher who was considered the master of the etched portrait at the time.
Hemenway was one of Benson's closest friends and a companion on most of his hunting and fishing trips.

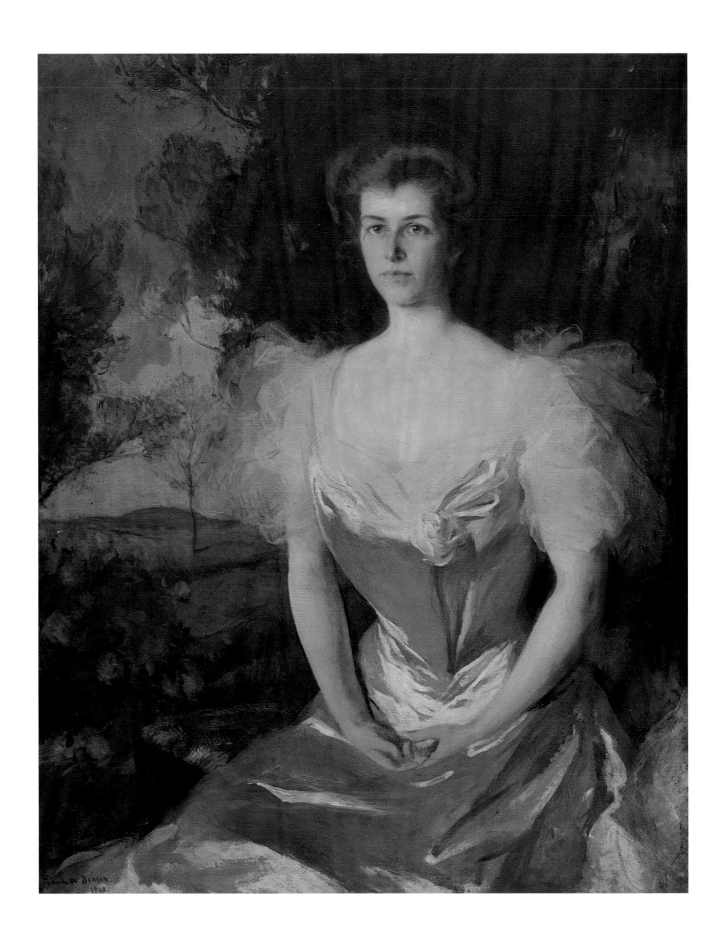

11. *Portrait of Mrs. Hathaway, 1907*

Oil on canvas, 47¼ x 37¼ inches. Peabody Essex Museum.
Benson painted both Mabel Hathaway and her husband, Horatio, and included a study of their daughter
Anna in his well-known plein air painting *Summer, 1909,* in the collections of the Museum of Art at the
Rhode Island School of Design.

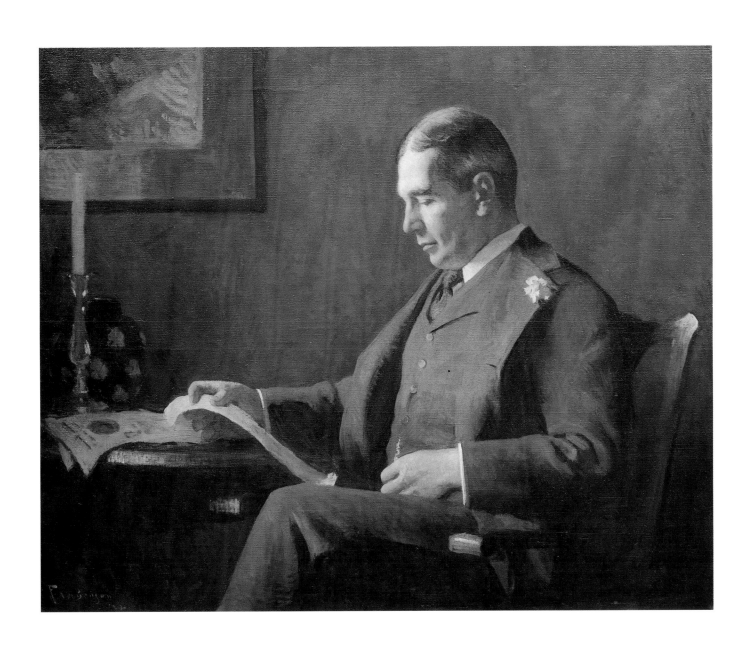

12. *Portrait of Richard Saltonstall, 1924*

Oil on canvas, 36 x 44 inches. Peabody Essex Museum.
By the time Benson painted this portrait of Richard Saltonstall, he had all but given up accepting portrait commissions.
It was probably only their close friendship that caused Benson to take up this genre once again to paint this posthumous
portrait of Mr. Saltonstall, who died in 1922.

II. Plein Air Works

*"There is a certain inspiration which comes when
you work quickly and surely and are enthusiastic about
the beauty of light."*

FRANK W. BENSON

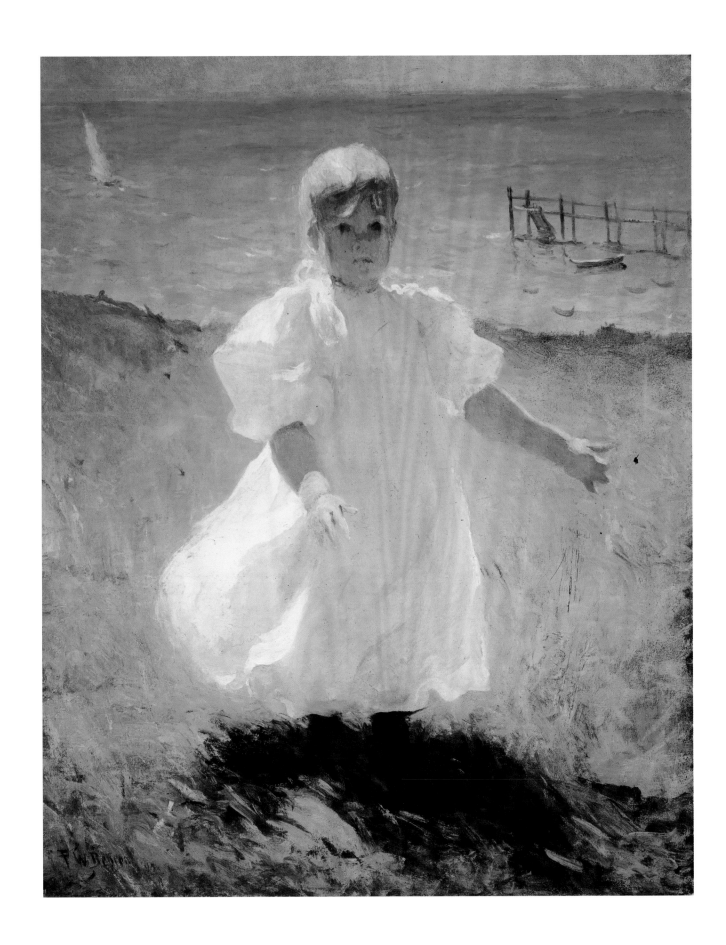

13. *Child in Sunlight,* 1899

Oil on canvas, 30 x 24⅛ inches. Private collection.
Drawn from a larger work, *The Sisters,* this portrait of Benson's youngest child,
Sylvia, hung on the living room wall of his house on Salem's Chestnut Street.
Photograph courtesy of Christie's, New York.

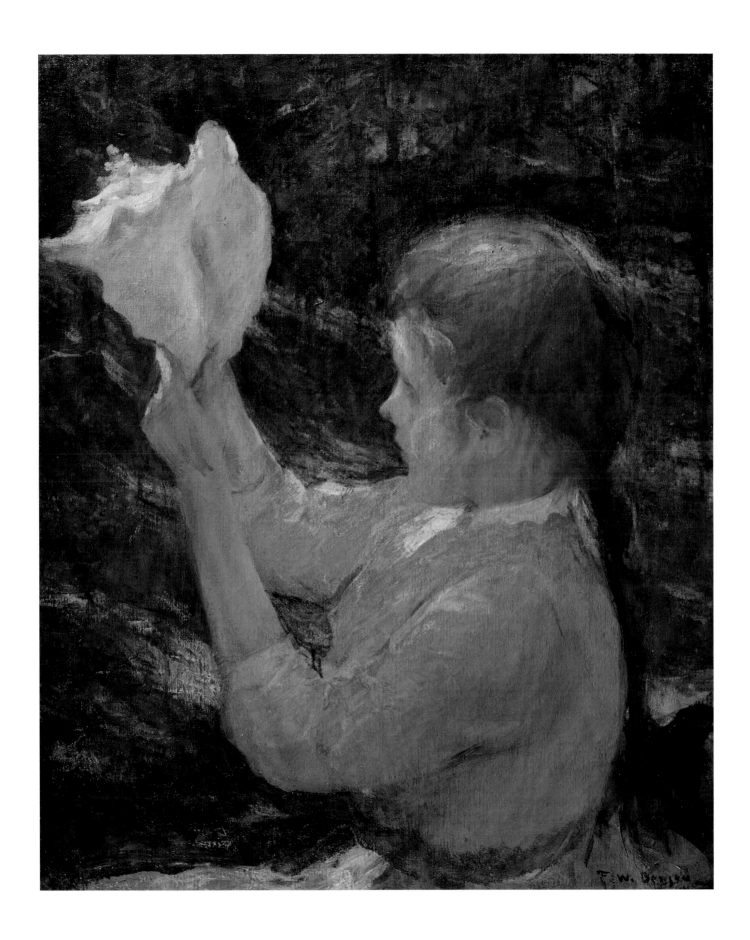

14. *Child with a Seashell,* 1902

Oil on canvas, 30 x 25 inches. Private collection.
Benson painted two versions of Eleanor holding a shell in the spruce woods behind Wooster Farm.
In the second interpretation of this theme, Eleanor gazes down at the shell.
Photograph courtesy of Berry-Hill Galleries, New York.

15. *The Fishermen,* 1915

Etching on paper, 7⅞ x 6 inches. (Paff no. 50, ed. 18.) Peabody Essex Museum.
This etching is a reversed image of an oil painting Benson completed in 1904 entitled *Calm Morning.* That work is now in the collections of the Museum of Fine Arts, Boston; there is a study for it hanging in this exhibition.

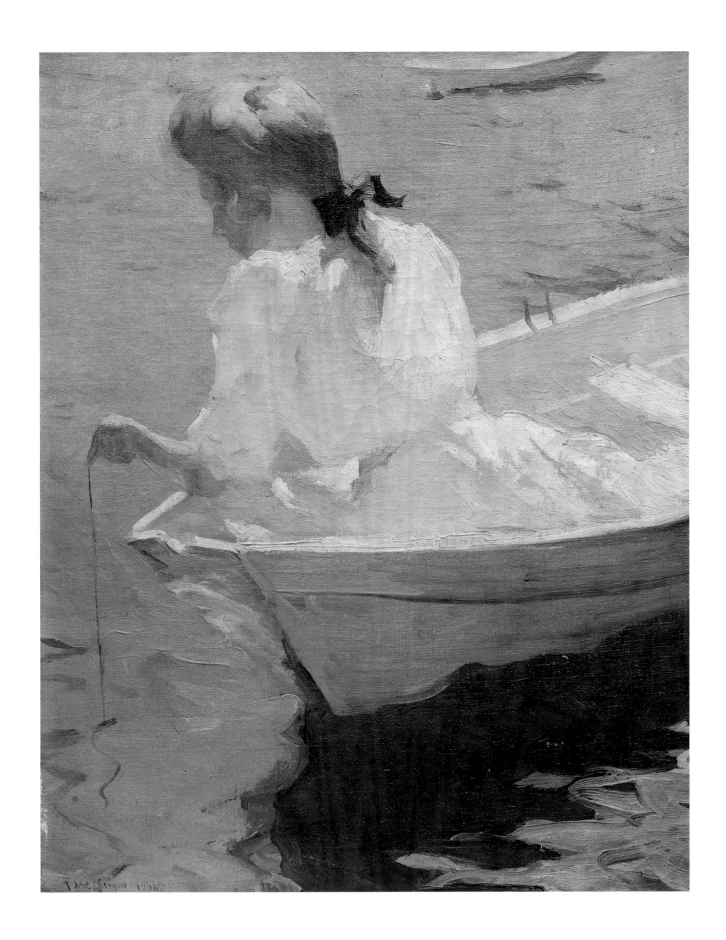

16. *Eleanor in the Dory* (former title: *Study for Calm Morning*), 1904

Oil on canvas, 20 x 16 inches. Private collection.
This is one of at least three studies that Benson painted for *Calm Morning* (Museum of Fine Arts, Boston).
Photograph courtesy of Berry-Hill Galleries, New York.

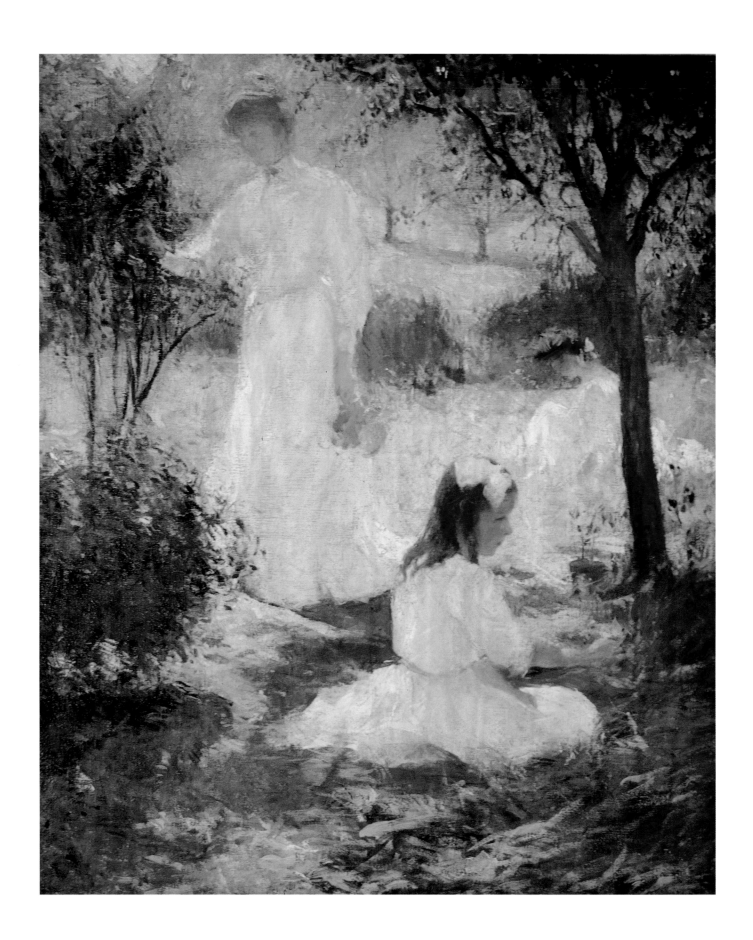

17. *Girls in the Garden*, ca. 1906

Oil on canvas, 30 x 24¾ inches. Private collection.
This charming study of Benson's three daughters is not known to have been translated into a finished work.
Photograph courtesy of Berry-Hill Galleries, New York.

18. *Afternoon,* 1915

Etching and drypoint on paper, 7⅞ x 6 inches. (Paff no. 63, ed. 2.) Print Department, Boston Public Library.
Gift of the artist.

Benson created this etching of his three daughters and the family dog, Toto, from an oil painting done in 1914.
The painting was never exhibited and is now unlocated.

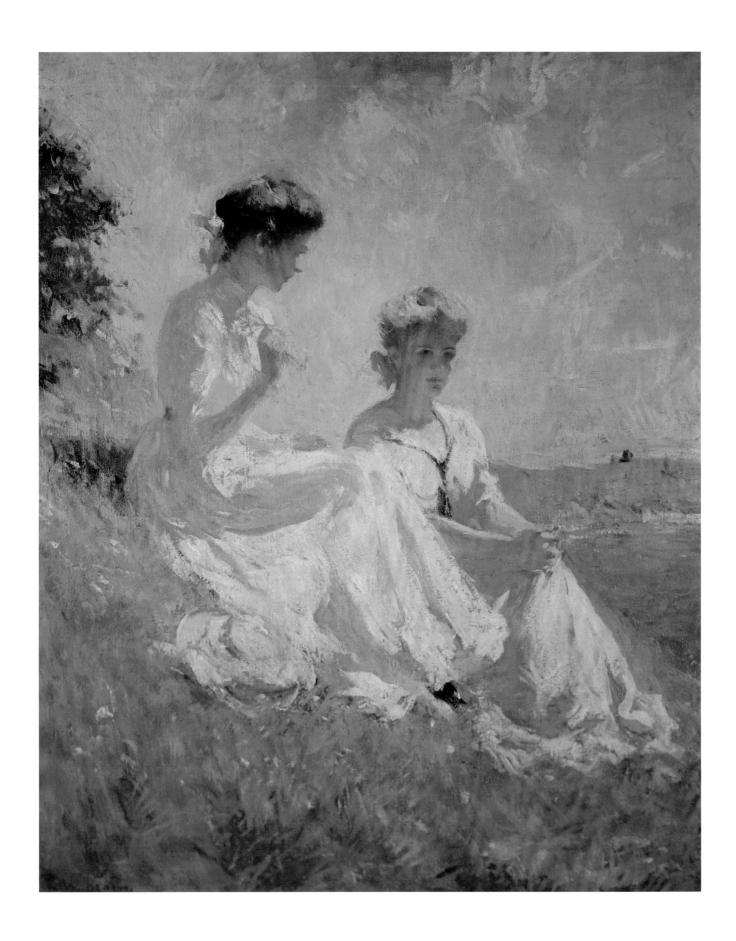

19. *In Summer*, ca. 1909

Oil on canvas, 32 x 25 inches. Collection of Marie and Hugh Halff.
These two girls are Elisabeth Benson and her friend Anna Hathaway. Anna can also be seen in the left portion of *Summer*, 1909, in the collections of the Museum of Art at the Rhode Island School of Design.

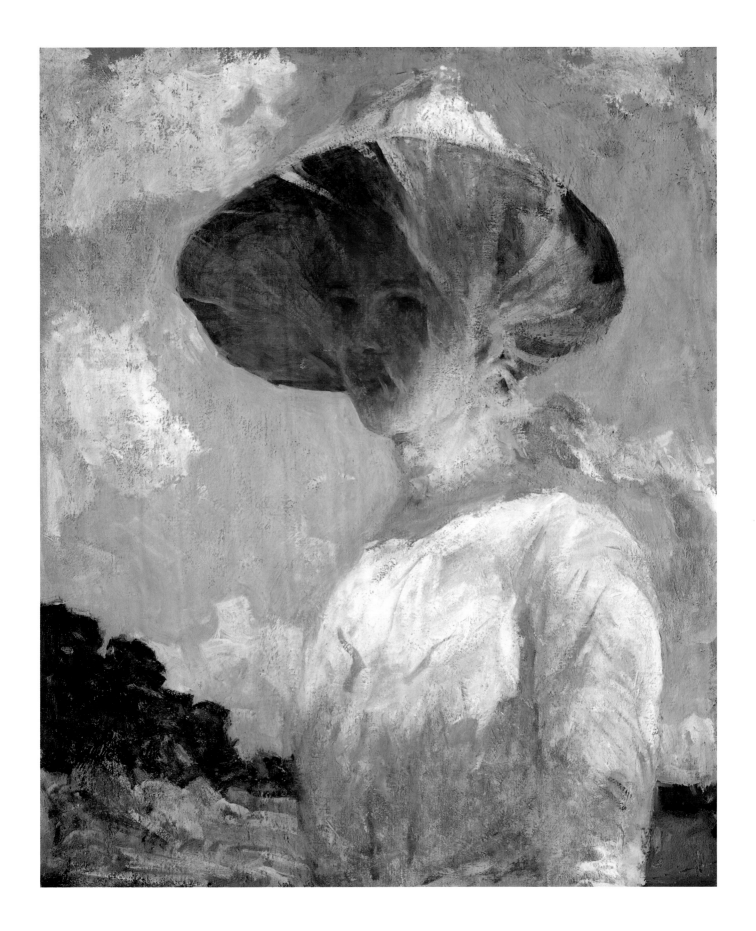

20. *Study for Young Girl with a Veil*, ca. 1912

Oil on canvas, 30 x 24¾ inches. Private collection.
The location of the final version of this unsigned work, first exhibited in 1912, is unknown. This painting of
Benson's eldest daughter, Eleanor, hung in his home until he bequeathed it to her.

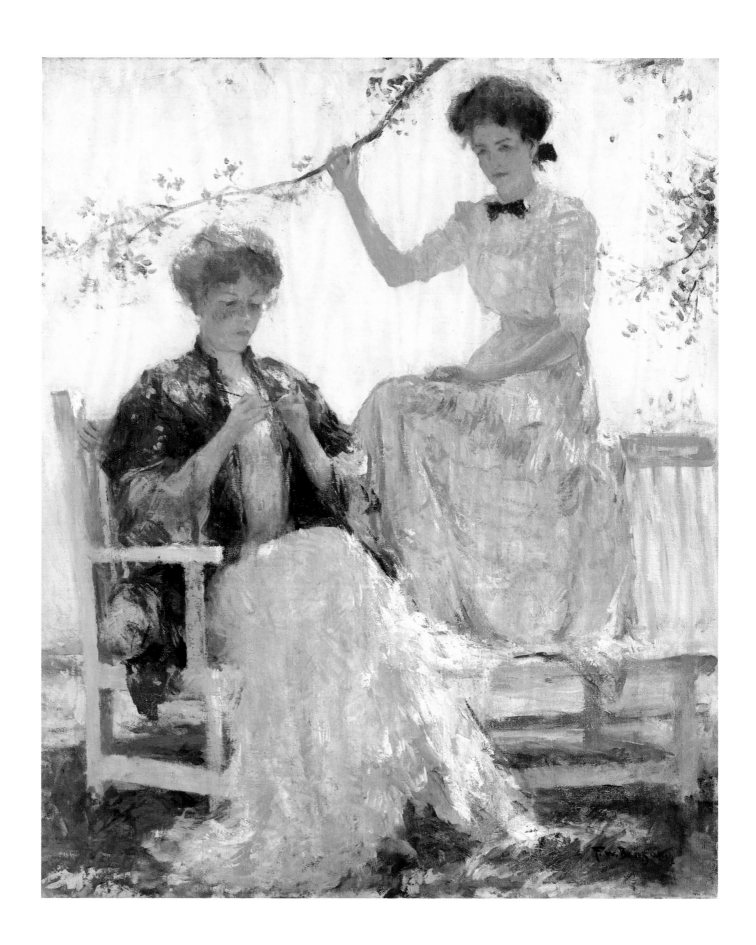

21. *Sunshine and Shadow,* ca. 1911

Oil on canvas, 30¼ x 25¼ inches. Private collection.
Benson painted another work, *Sun and Shadow,* based on this study of two of his daughters,
Eleanor and Elisabeth. The location of that painting is unknown.
Photograph courtesy of Christie's, New York.

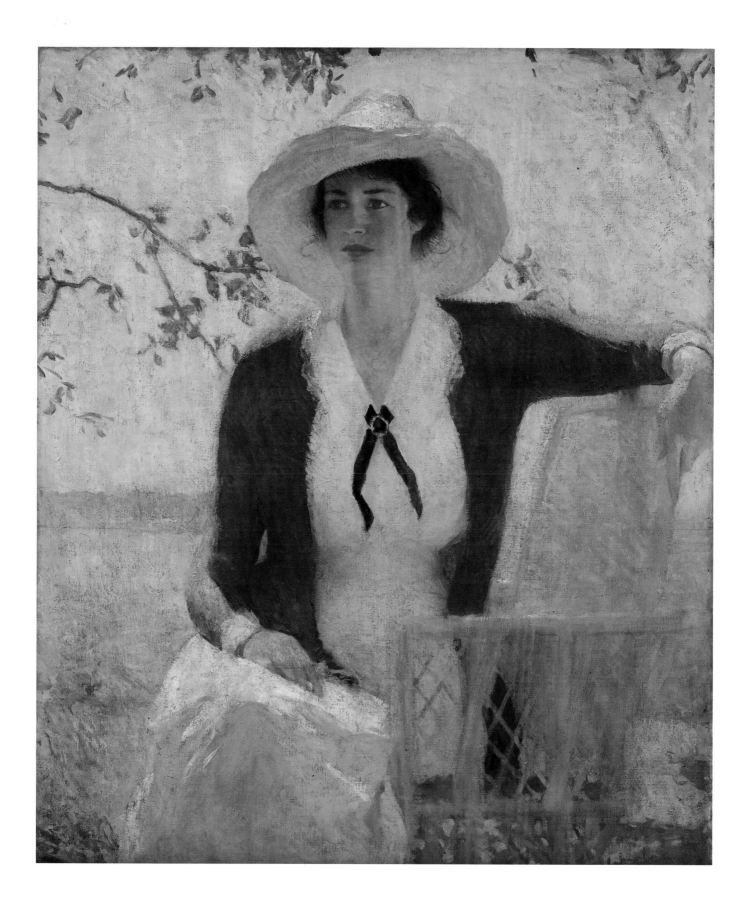

22. *My Daughter Elisabeth,* ca. 1915

Oil on canvas, 44 x 37 inches. The Detroit Institute of Arts, Detroit Museum of Art purchase. Special Membership and Donations Fund with contributions from Philip, David, and Paul R. Gray, and their sister Mrs. William R. Kales. It is interesting to note Benson's use of this rattan chair in two other North Haven works hanging in this exhibition: *Rainy Day* and *Young Girl by a Window.*

III. Interiors and Still Lifes

"Design makes the picture. Good painting can never save the picture if the composition is bad. Good painting—representation of objects—is utterly useless unless there is a good design. That is the whole object of painting."

FRANK W. BENSON

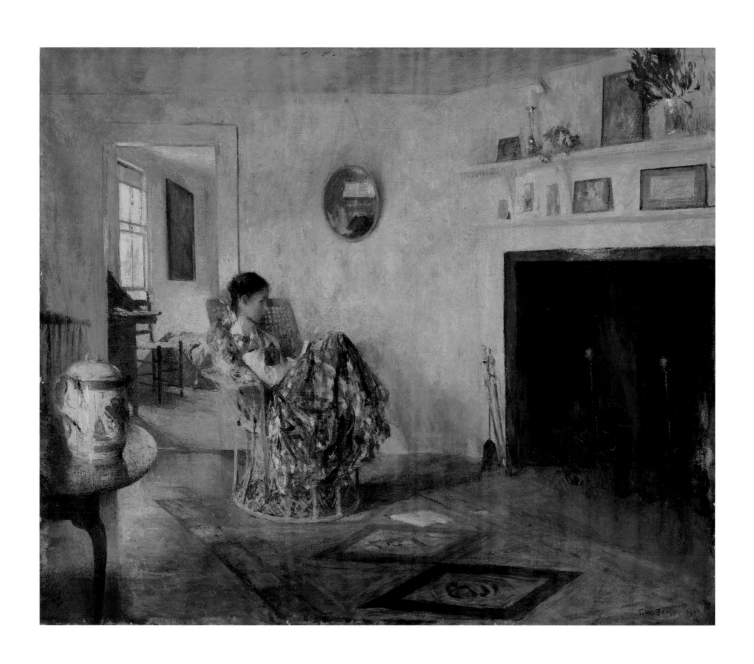

23. *Rainy Day,* 1906

Oil on canvas, 25 x 30 inches. Art Institute of Chicago. Gift of the Friends of American Art.
Benson did few interiors while he was on North Haven. This is the earliest known example of such a work.

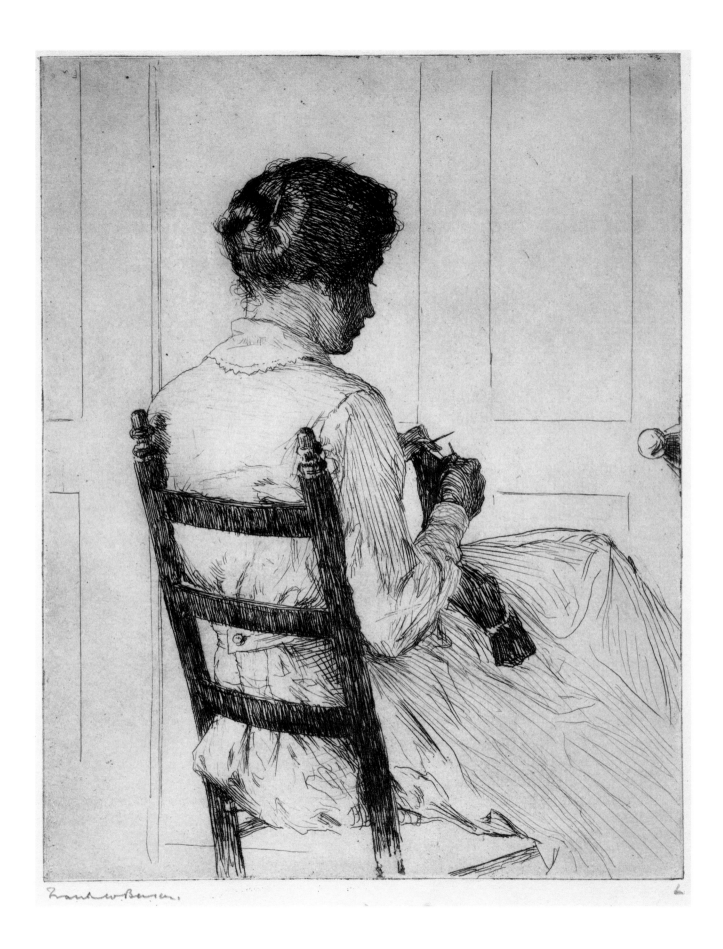

24. *Elisabeth,* 1918

 Etching on paper, 10 x 8 inches. (Paff no. 150, ed. 13.) Print Department, Boston Public Library.
 Gift of Albert H. Wiggin.
 Benson's etchings of women are rare. This etching of his daughter knitting is one
 of only twenty prints that feature women.

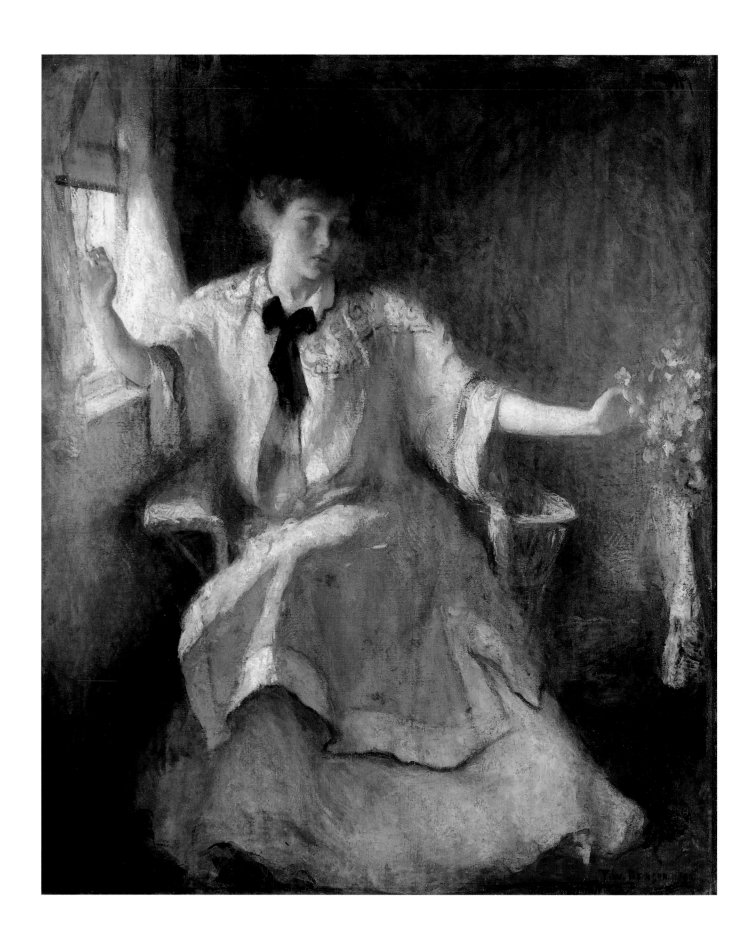

25. *Young Girl by a Window (Woman near Window, Maid in Waiting)*, 1911

Oil on canvas, 30 x 24 inches. Eva Underhill Holbrook Memorial Collection of American Art, Georgia Museum of Art, University of Georgia. Gift of Alfred H. Holbrook, 1945.
The model for this work is Eleanor Benson. It is another example of Benson's rare North Haven interiors.

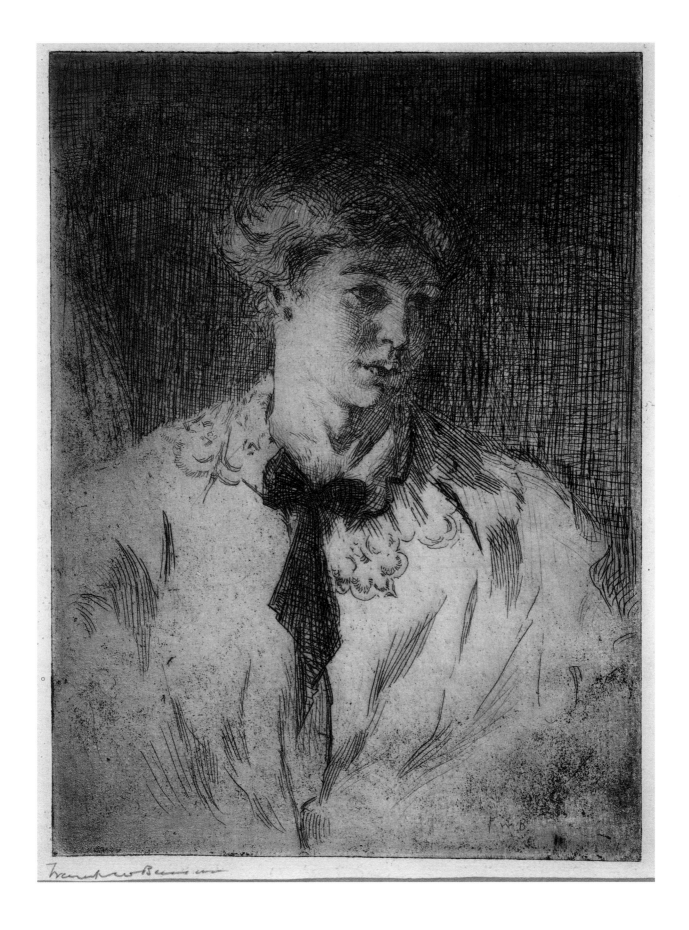

26. *Head of a Young Girl* (second plate), 1913

Etching on paper, 8 x 6 inches. (Paff no. 15, ed. 2.) Print Department, Boston Public Library.
Gift of Louis Black.

This etching of Eleanor Benson is very similar to her father's portrait of her in *Young Girl by a Window,* which is also hanging in this exhibition.

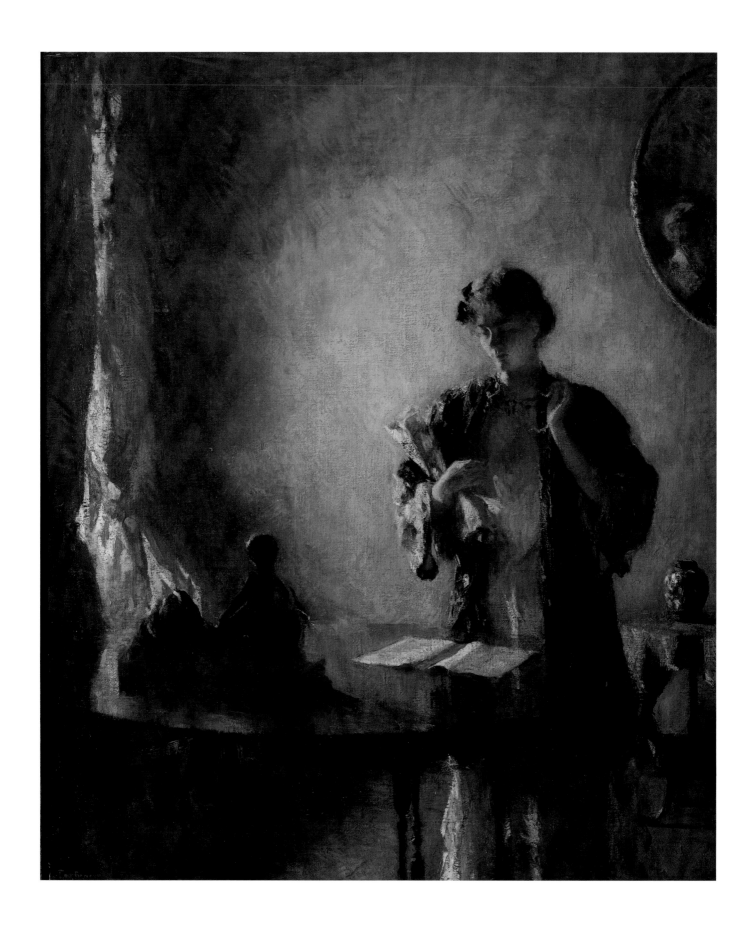

27. *Figure in a Room*, 1912

Oil on canvas, 30 x 25 inches. New Britain (Conn.) Museum of American Art. Alix W. Stanley Fund.
The statue of Artemis used in this work was given to Benson by Bela Pratt, his close friend and fellow instructor at the Museum School.

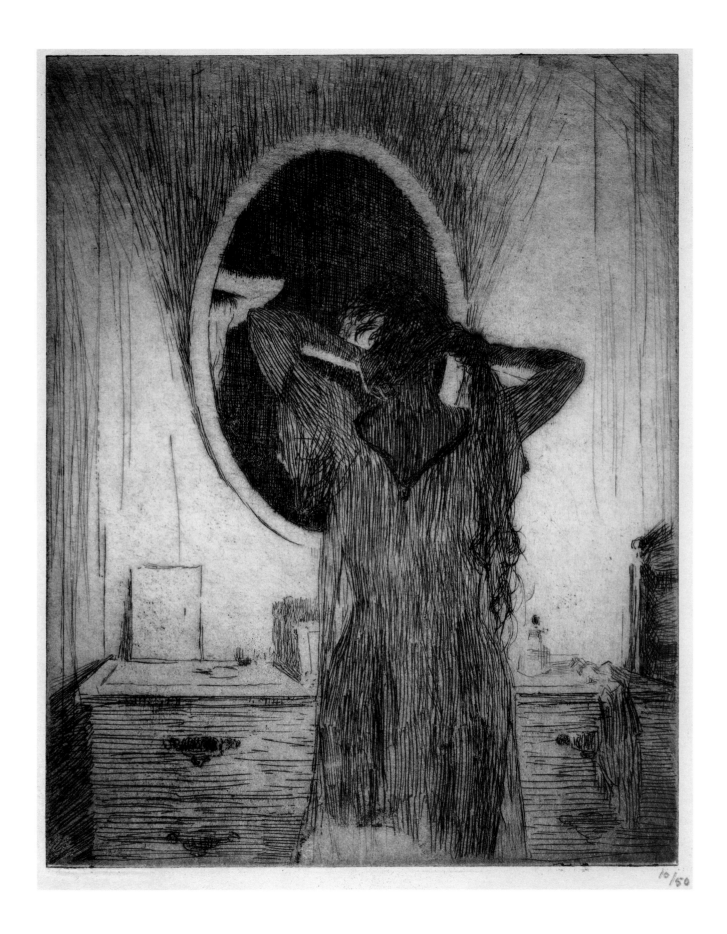

10/50

28. *Candlelight,* 1915

 Etching on paper, 9⅞ x 7⅞ inches. (Paff no. 62, ed. 50.) Print Department, Boston Public Library.
 Gift of Albert H. Wiggin.
 Perhaps one of Benson's loveliest etched figures is a study of his wife, Ellen. A candle stands atop her bureau at
 Wooster Farm, but all we see of it is the halo it casts around Ellen's figure.

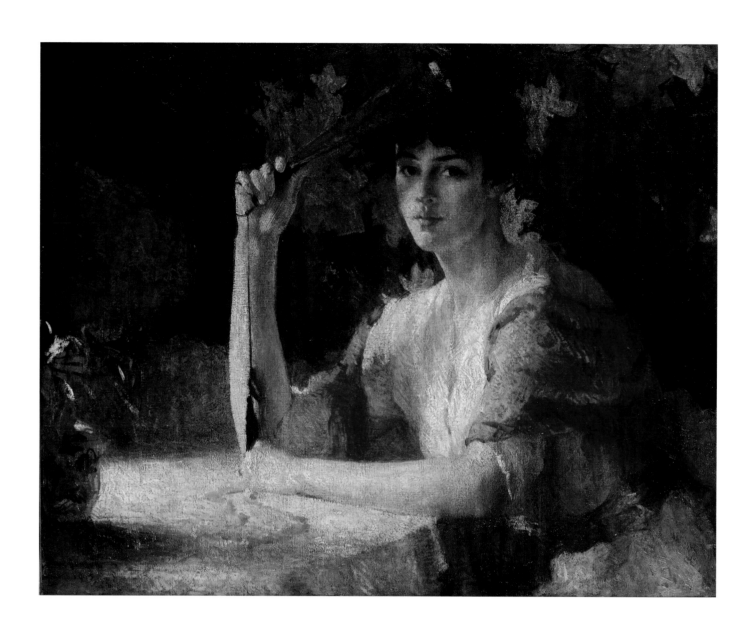

29. *Red and Gold,* 1915

Oil on canvas, 31 x 39 inches. Collection of the Butler Institute of American Art, Youngstown, Ohio. Museum purchase, 1919. Joseph G. Butler Jr. of Ohio saw this work when it was exhibited at the last show of the Ten, held at the Corcoran Gallery in Washington, D.C., in 1919. He bought it for the inaugural exhibition of the small public gallery he had recently established in Youngstown. The Butler Institute, designed by the renowned firm of McKim, Mead and White, is the first structure in the United States built specifically to house a collection of American art.

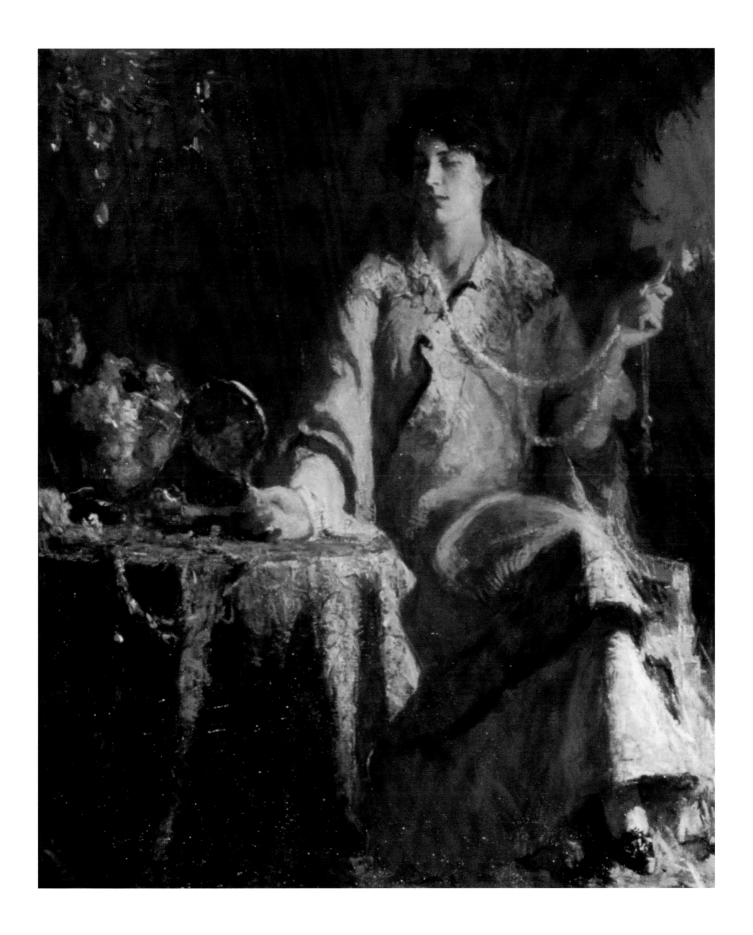

30. *Reflections,* 1921

Oil on canvas, 43¼ x 35½ inches. Private collection.
Benson's daughter Elisabeth probably posed for this, his last interior with a figure.

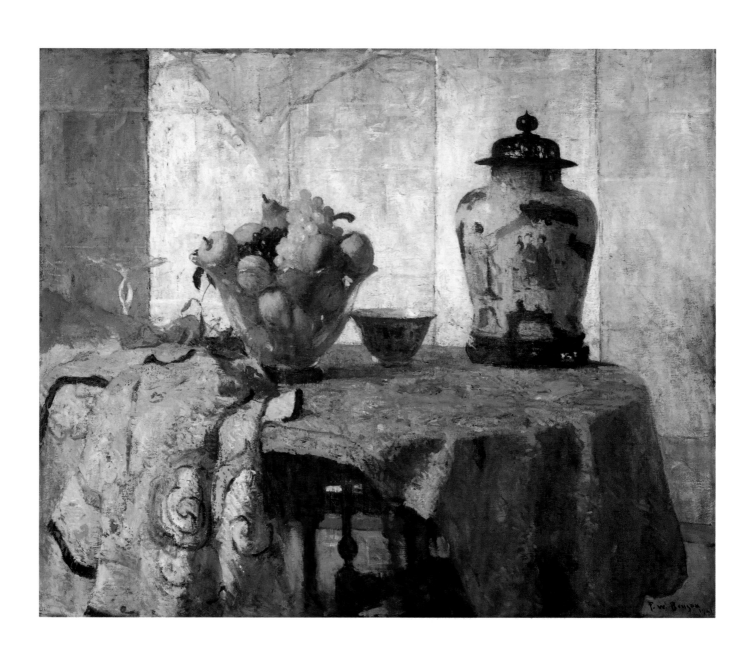

31. *The Silver Screen,* 1921

Oil on canvas, 36¼ x 44⅛ inches. A. Shuman Collection, Museum of Fine Arts, Boston.
This handsome still life was given by Benson to his tailor, F. L. Dunne, in exchange for a lifetime of hand-tailored suits.
The Dunne family, known as the finest tailors in Boston, eventually became Benson collectors.

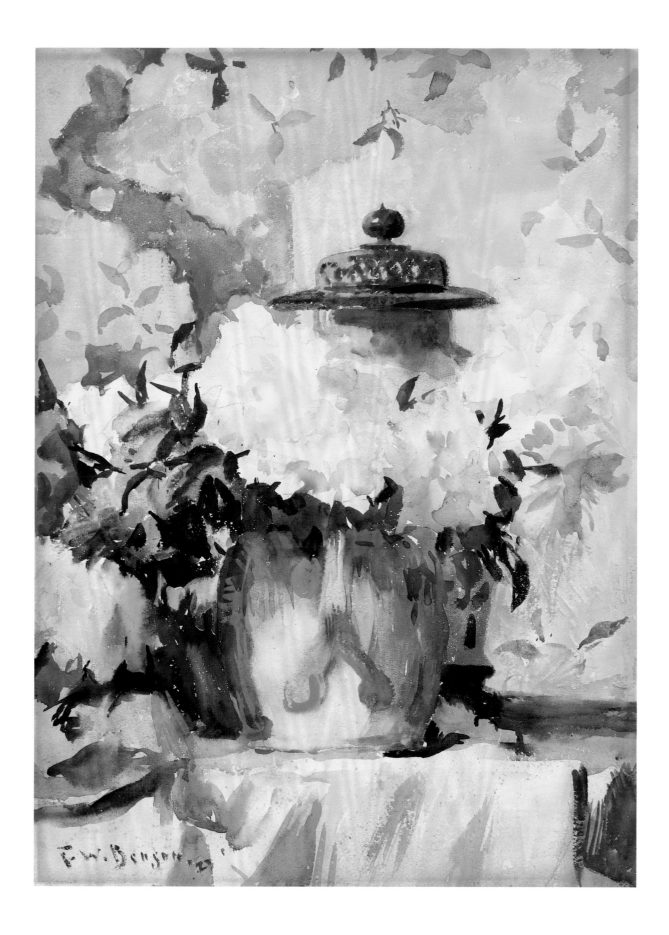

32. *Peonies in Blue China*, 1923

Watercolors on paper, 25 x 19 inches. Private collection.
The blue-and-white porcelain china jug in which the peonies were arranged was also seen in the foreground of Benson's North Haven interior *Rainy Day* (CAT. 23).

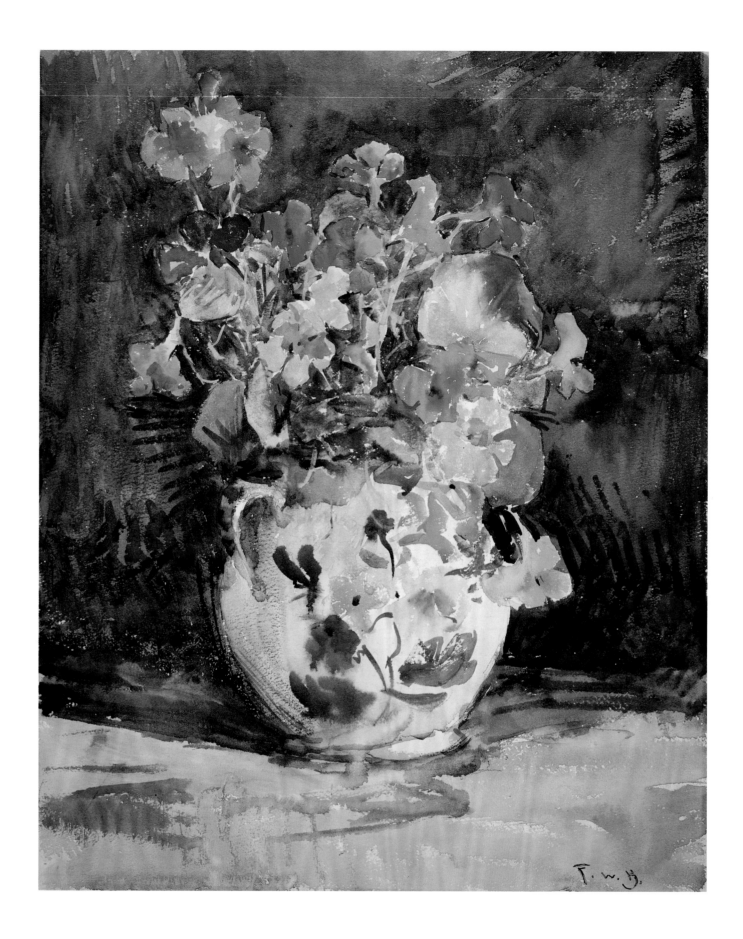

33. *Nasturtiums in a Vase,* 1926

 Watercolors on paper, 21¾ x 17⅝ inches. Private collection.
 This charming watercolor is an example of the collaboration between Benson and his wife, Ellen.
 She grew the flowers and arranged them; he painted her creations.
 Photograph courtesy of Berry-Hill Galleries, New York.

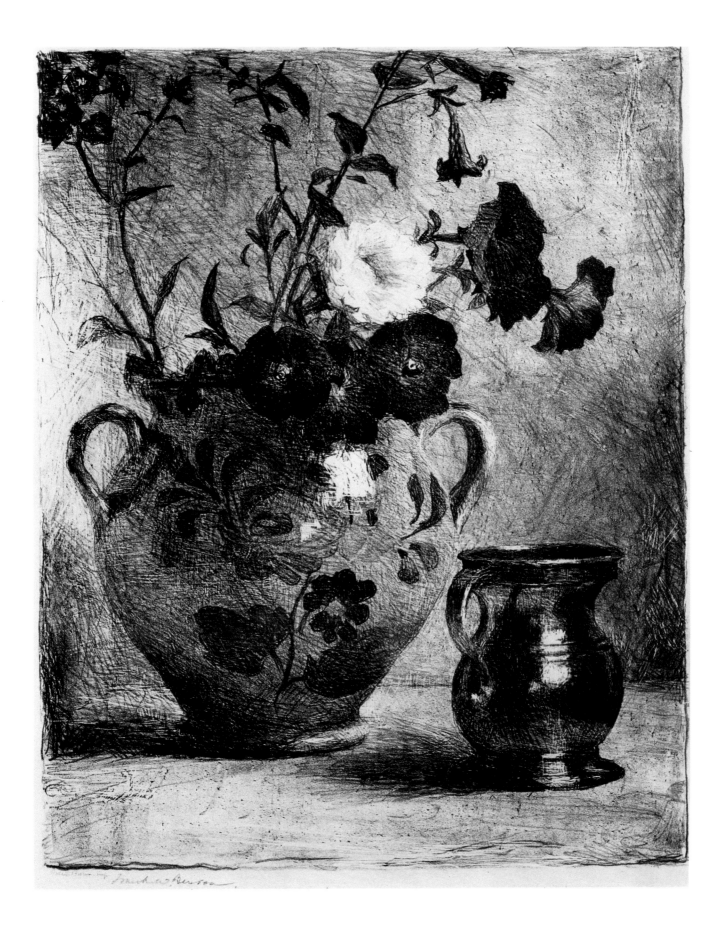

34. *Still Life,* 1927

Lithograph on paper, 22 x 18 inches. Private collection.
This was Benson's first experiment with lithography. He produced only seven works in this medium.

35. *Confucius,* ca. 1930

Oil on canvas, 38¼ x 32½ inches. Collection of Mrs. Richard D. Reitz.

Benson often featured oriental figurines in his still lifes. While several can be seen in numerous works,
this is the only known instance of this figure being used in a painting.

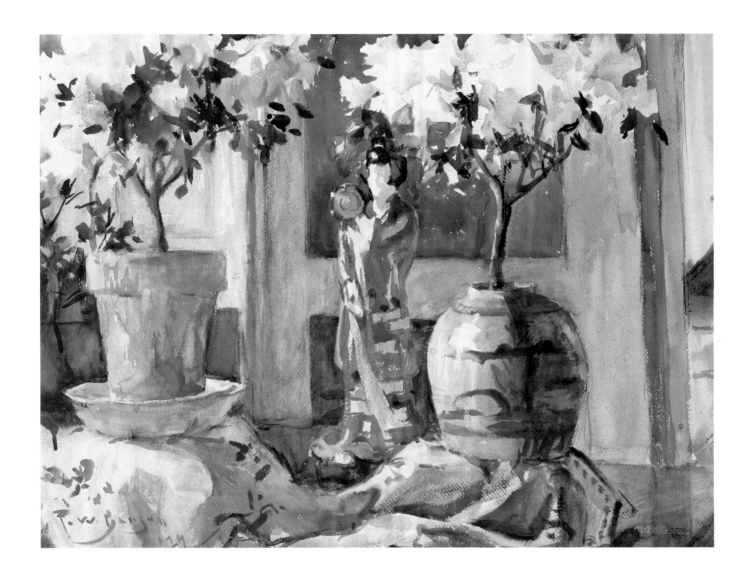

36. *Still Life—Azaleas (Azaleas),* 1934

Watercolors on paper, 21 x 28 inches. The Stephen Phillips Memorial Trust House.
When Benson's new neighbor, Mrs. Stephen Phillips, came for tea at his home on Chestnut Street,
she greatly admired this painting. Ever the gracious host, he presented it to her as a gift.

IV. Landscapes and Sporting Life

"Every artist must see things in his own way. He will do as the Japanese have done it for centuries—study some object in nature until he can draw it from memory by repeated practice. In that way I learned how birds appear in flight, watching them by the hour, returning to the studio to make drawings, then back to the birds to make corrections."

FRANK W. BENSON

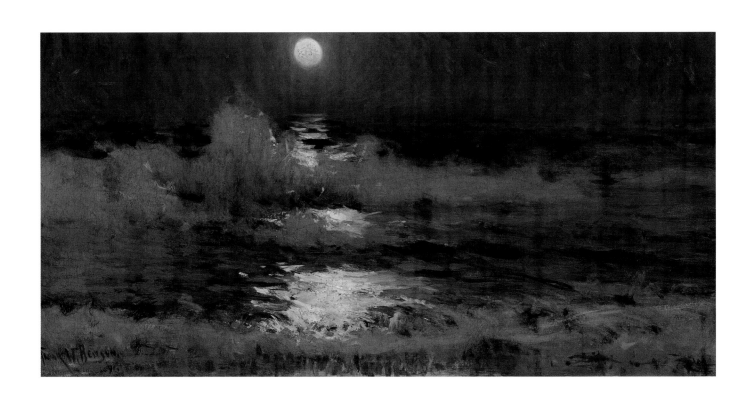

37. *Moonlight (Moonlight on the Waters)*, 1891

Oil on lined canvas, 15 x 30 inches. Private collection.
When this painting was first exhibited at the Chase Gallery in Boston, it was listed as No. 4, *Moonlight (on Sea Waves)*.
This was Benson's first private show, and it was done jointly with Edmund C. Tarbell, his close friend and fellow instructor at the Museum School.
Photograph courtesy of Joan Whalen Fine Arts, New York.

38. *Moonlight,* 1914

> Etching on paper, touched with drypoint, 7 x 8⅞ inches. (Paff no. 31, ed. 50.) Print Department,
> Boston Public Library. Gift of Albert H. Wiggin.
> The original pencil sketch, of the same size as the etching, was made during a cruise in the Caribbean Sea.

39. *Hunter in a Boat,* 1915

Oil on canvas, 33¼ x 66 inches. Private collection.
Benson placed this coot shooter and his boat in the waters off Blackledge Rock, located near Salem Harbor.

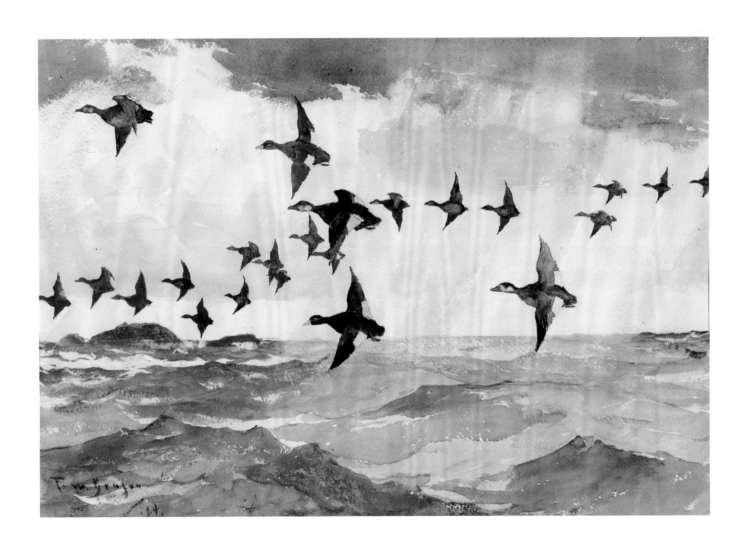

40. *Scoters over Water*, 1924

Watercolors on paper, 13¼ x 19½ inches. Private collection.
As a child, Benson enjoyed watching the scoters skim over the tops of the waves off Salem and Marblehead.

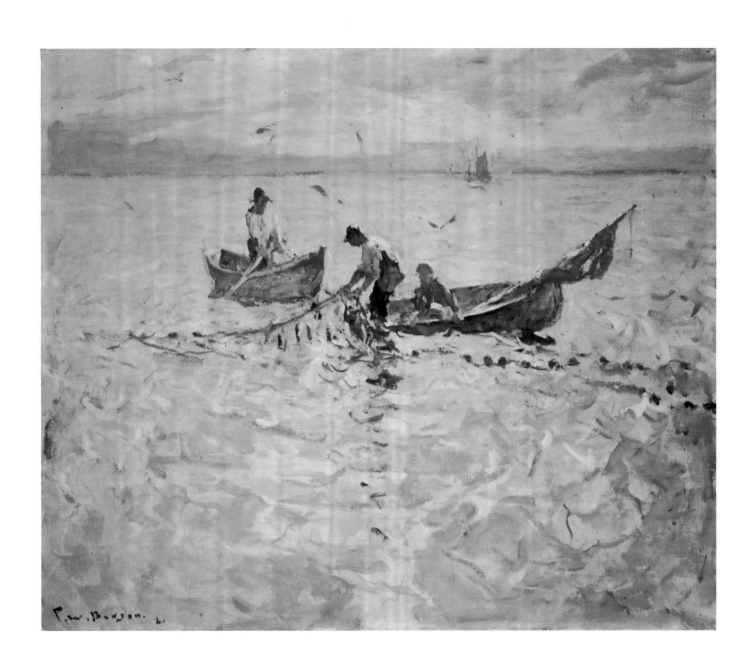

41. *Dory Fishermen,* 1941

Oil on canvas, 25 x 30 inches. Private collection.
The Wooster Farm log records catches of hundreds of mackerel in the family's nets. They smoked them in North
Haven and shipped them home to Salem where the family enjoyed them all winter. This painting has long been believed to
be of Benson and his son, George, with one of their hired men, perhaps Irwin Dyer, in the second boat.

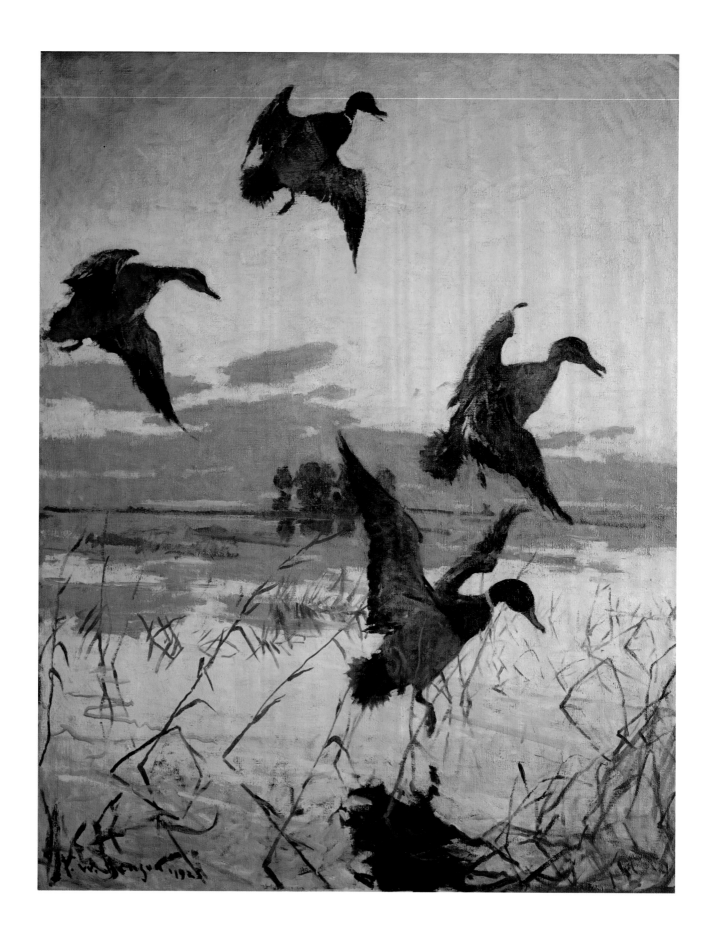

42. *Long Point Sunset*, 1923

Oil on canvas, 50 x 40 inches. Private collection.

Ten years after this painting was completed, Benson used the same image to create an etching entitled
Sunset at Long Point. (Paff no. 333, ed. 150.)

Photograph courtesy of the Vose Galleries, Boston.

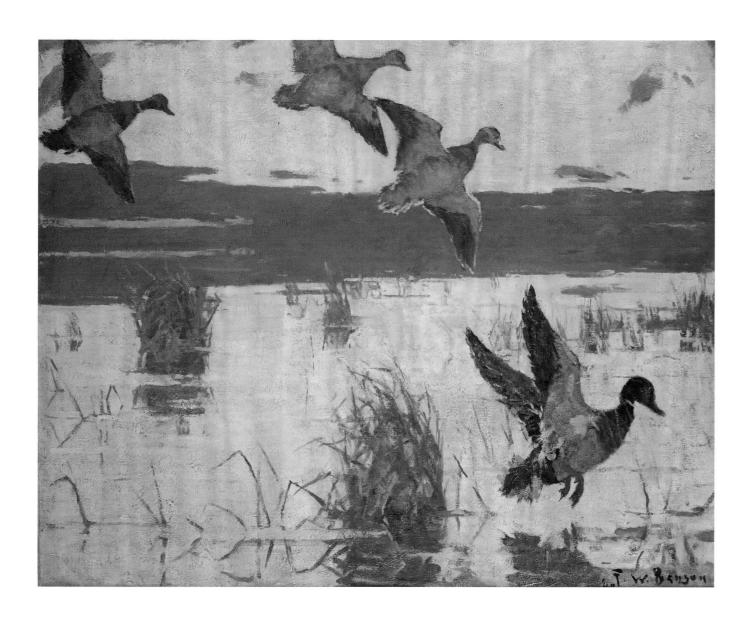

43. *Ducks at Dawn,* 1940

Oil on canvas, 28½ x 35 inches. Collection of Robert C. Vose III.
Benson seemed to prefer painting wildfowl in the early morning light or at dusk.

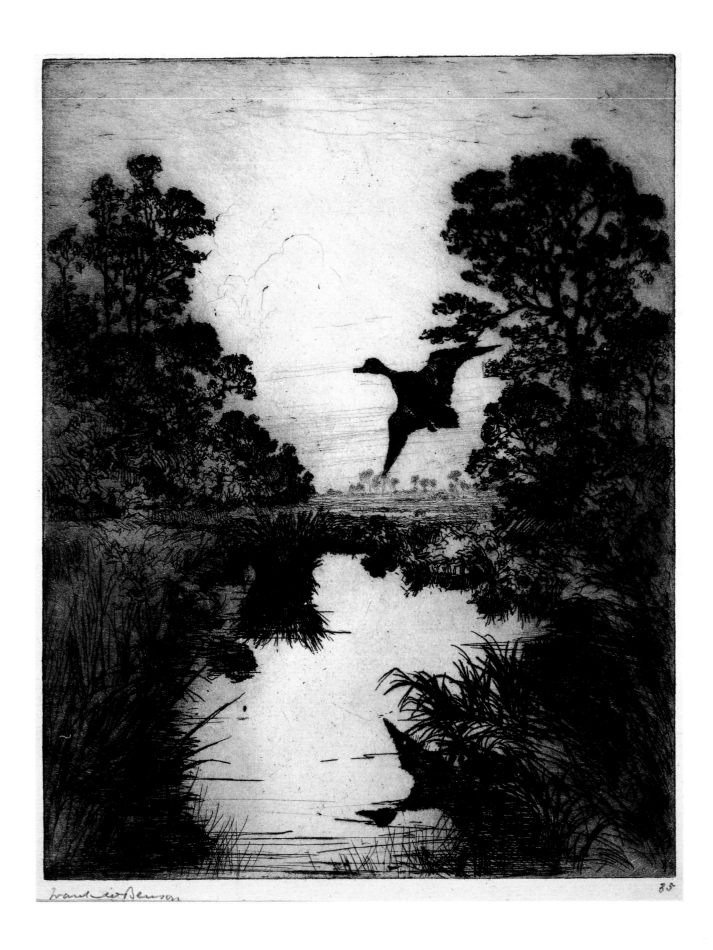

44. *Evening,* 1916

> Etching on paper, 10 x 7⅞ inches. (Paff no. 103, ed. 37.) Print Department,
> Boston Public Library. Gift of the artist.
> As evening approaches, a lone duck comes in for a landing in a silvery pool.

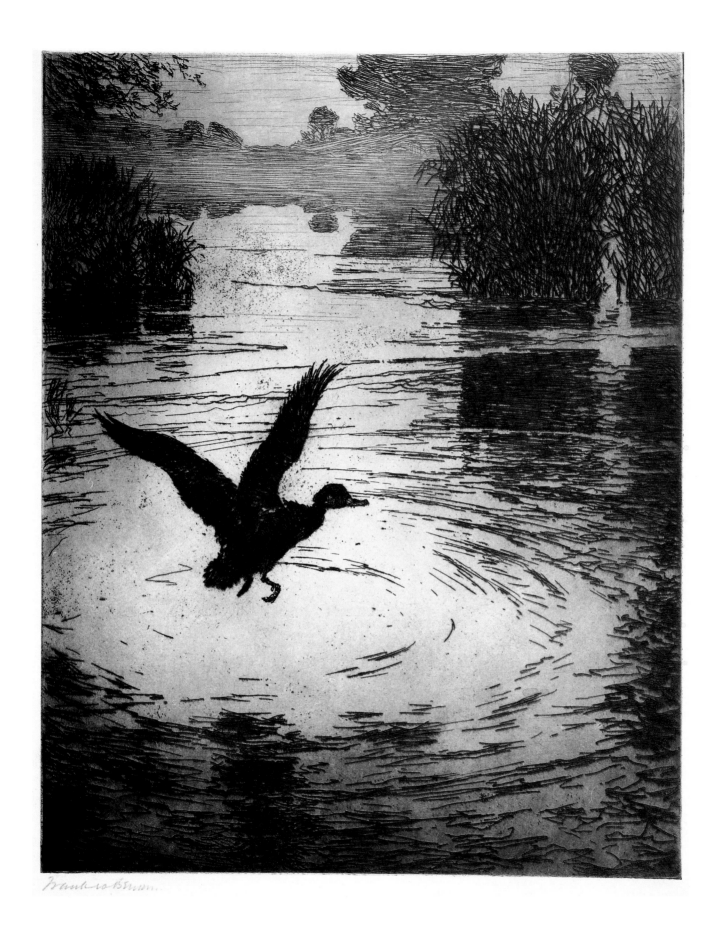

45. *Rippling Water,* 1920

 Etching on zinc, 9¾ x 7⅞ inches. (Paff no. 174, ed. 150.) Print Department,
 Boston Public Library. Gift of Sherburne Prescott.
 This is one of Benson's rare etchings on a zinc plate.

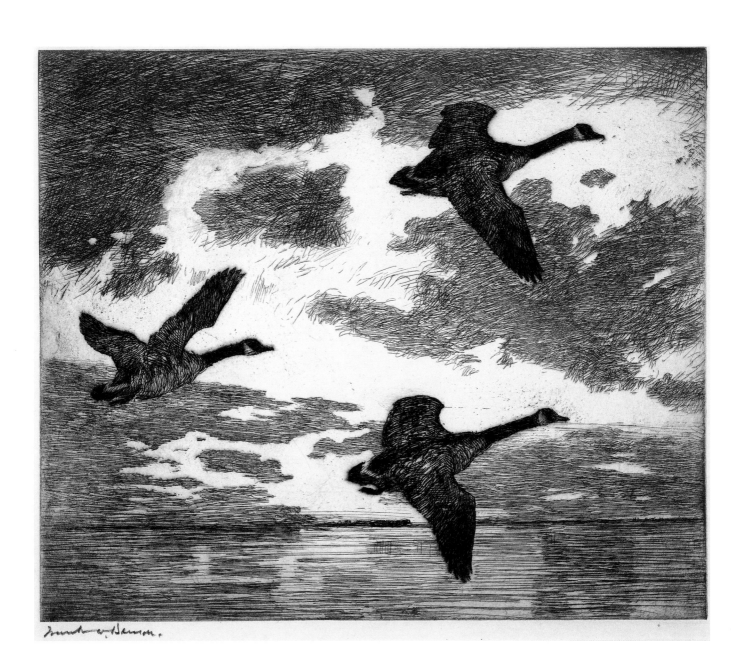

46. *Cloudy Dawn,* 1922

 Drypoint on paper, 9⅞ x 11⅞ inches. (Paff no. 215, ed. 150.) Print Department,
 Boston Public Library. Gift of the artist.
 Benson's elegant composition of three geese is offset by the first light of morning.

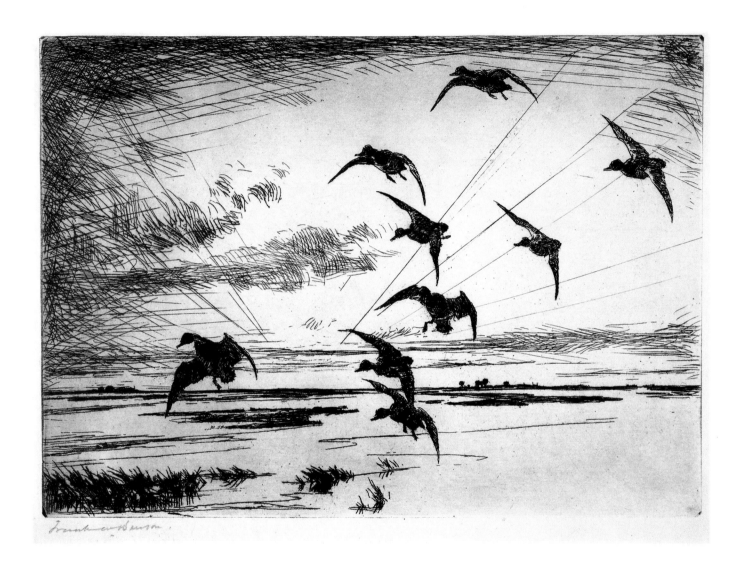

47. *Dawn,* 1924

Etching on paper, 6⅞ x 9⅞ inches. (Paff no. 232, ed. 271.) Print Department, Boston Public Library.
Gift of Albert H. Wiggin.
This plate was made for the Cleveland Print Club, and two hundred and fifty proofs were given to the club for distribution to its members.

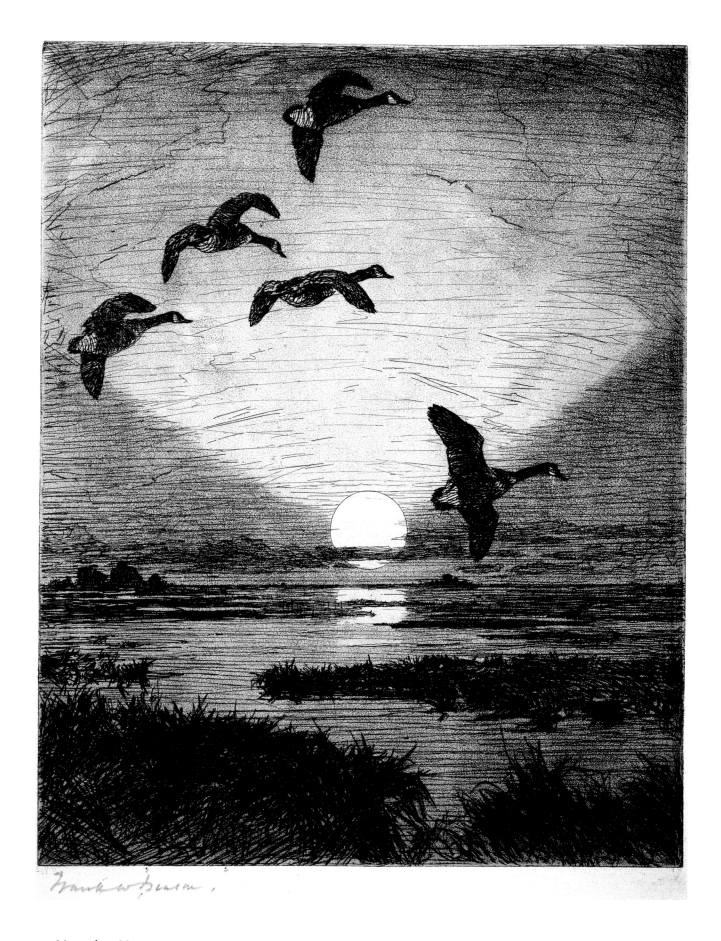

48. *November Moon*, 1931

Etching and aquatint on paper, 9⅞ x 8 inches. (Paff no. 316, ed. 150.) Peabody Essex Museum.
This dramatic work of five geese gliding across the silvery glow of a November moon is one of Benson's
rare experiments with aquatint.

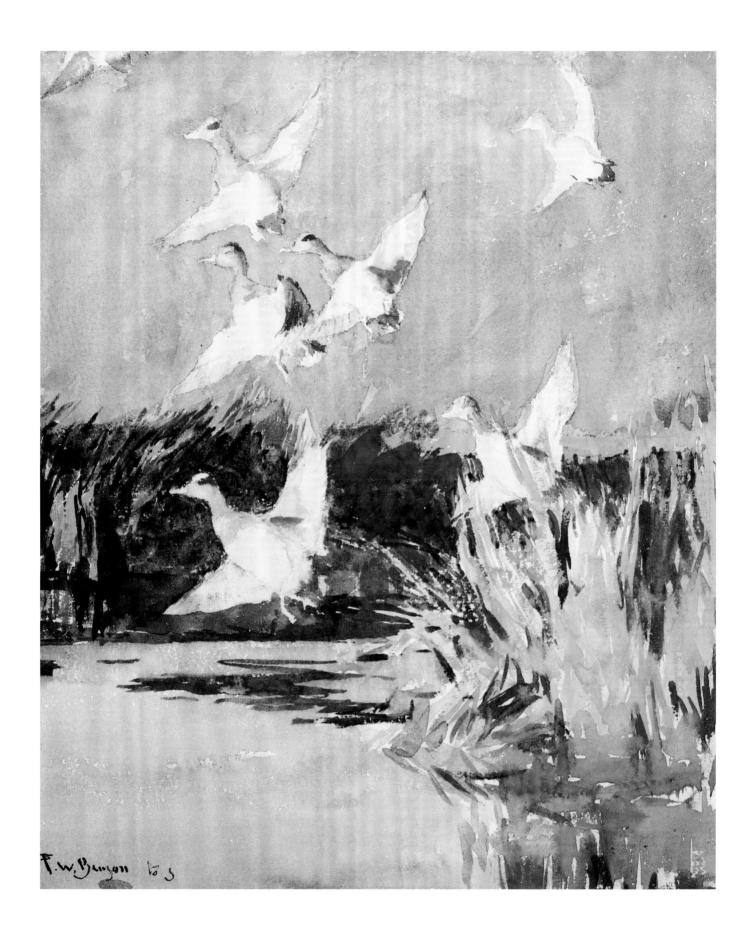

49. *Ducks with Purple Sky (Ducks in Flight)*, 1941

Watercolors on paper, 14 x 12 inches. Private collection.
Frightened ducks rise into the air before an oncoming storm, making
striking patterns against the threatening sky.

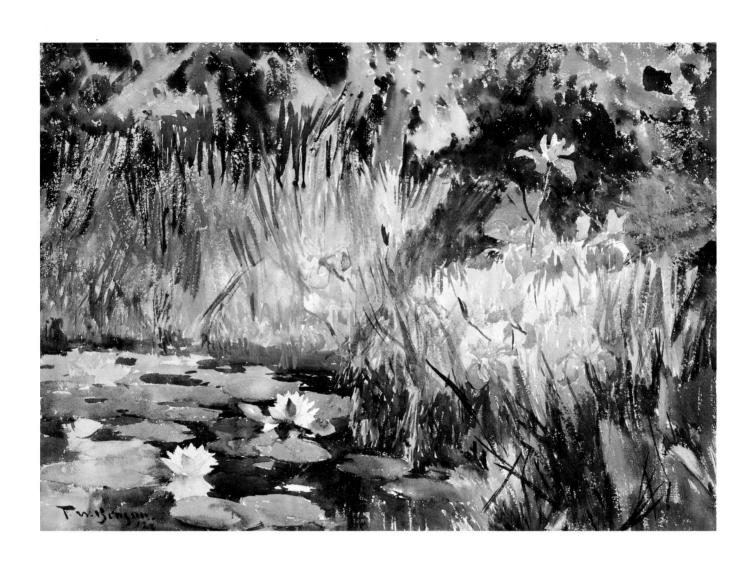

50. *Iris and Lilies,* 1922

Watercolors on paper, 14⅛ x 20⅝ inches. Private collection.

Behind Benson's summer home, Wooster Farm, lay a deep spruce woods. At the edge of this woods
was a small pond in which Ellen Benson planted water lilies and iris. Benson painted it often.

Photograph courtesy of Berry-Hill Galleries, New York.

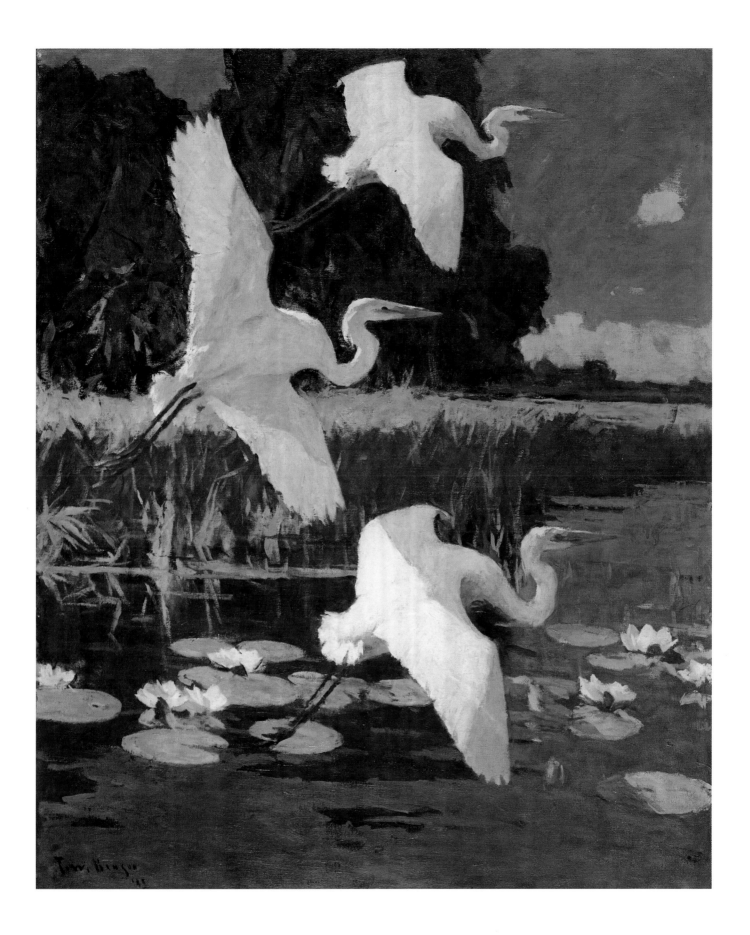

51. *Great White Herons,* 1933

 Oil on canvas, 44 x 36⅛ inches. Pennsylvania Academy of the Fine Arts, Philadelphia.

 Joseph E. Temple Fund.

 This painting won the Temple Fund Purchase Prize when it was exhibited at the Pennsylvania Academy

 of the Fine Arts in 1934.

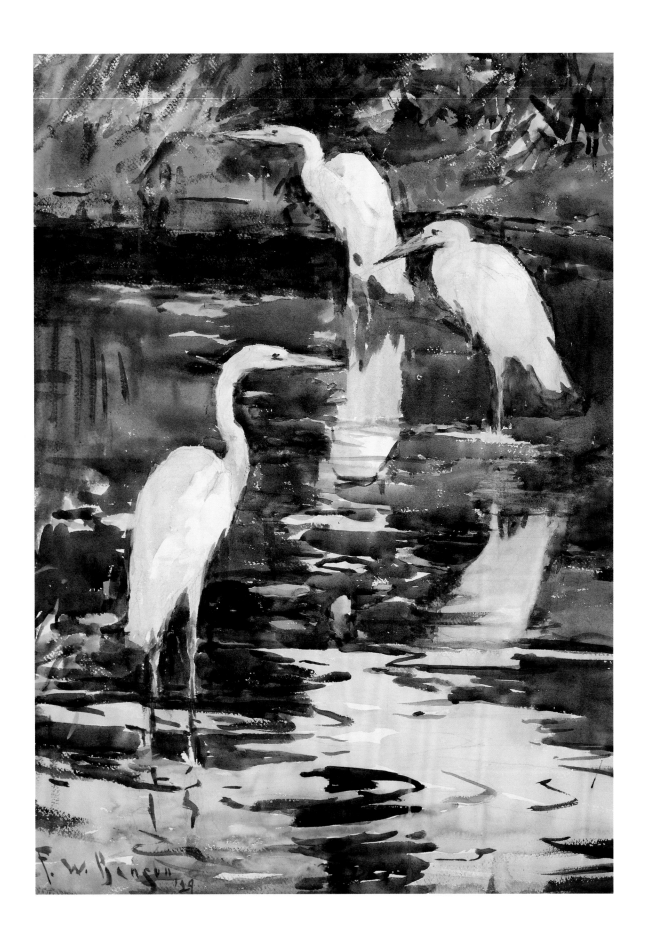

52. *White Herons,* 1929

Watercolors on paper, 29 x 21 inches. Private collection.
Benson created a series of paintings of herons and egrets both in watercolors and oil. Obviously enjoying the combination of ruffled white water lilies and the pure white plumage of these exotic birds, he frequently placed these birds in a lily pond.

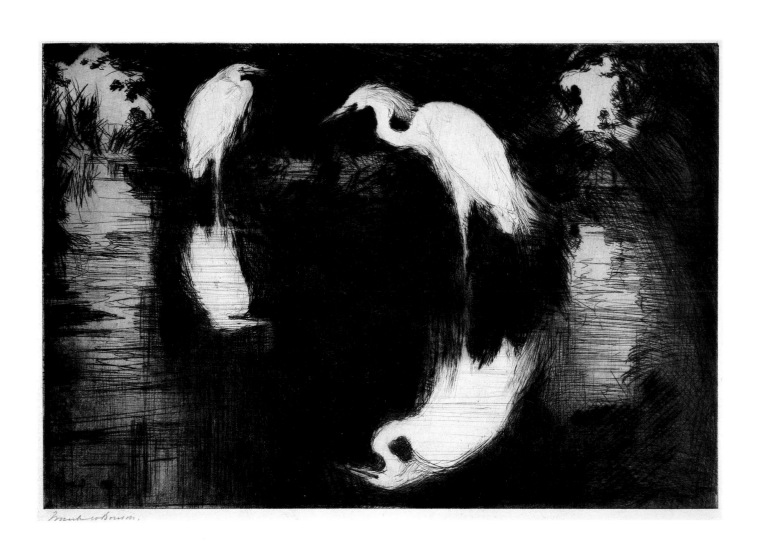

53. *Dark Pool,* 1920

Drypoint on zinc, 8 x 11⅞ inches. (Paff no. 189, ed. 150.) Peabody Essex Museum.
Benson did not often sign his etched work on the plate. This print is an exception; "F. W. B. 1920"
is etched in the lower left corner.

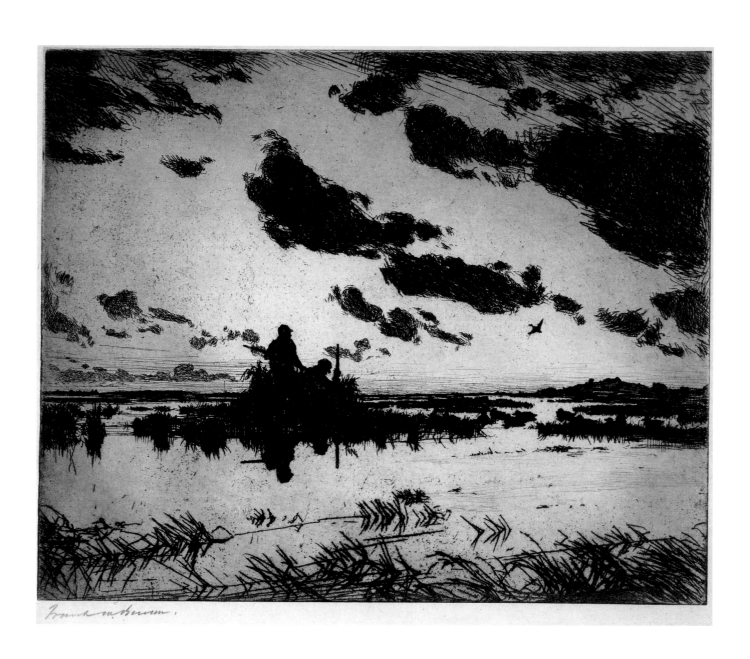

54. *The Gunner's Blind, 1921*

Etching on paper, 7⅞ x 9¾ inches. (Paff no. 204, ed. 150.) Peabody Essex Museum.

Of this magnificent plate of gunners standing out in sharp relief against a dramatic sky, a friend made this comment: "I see you are etching in color now."

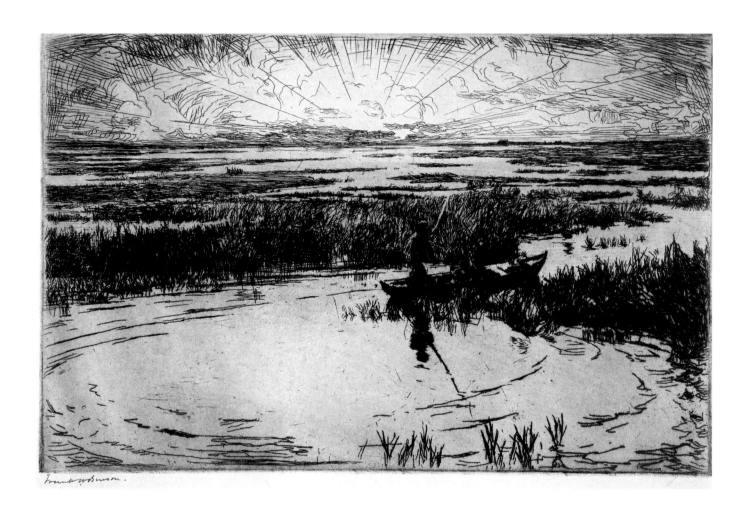

55. *Sunrise,* 1920

Etching on paper, 6⅞ x 10¾ inches. (Paff no. 180, ed. 150.) Print Department, Boston Public Library.
Gift of Albert H. Wiggin.

Although Benson once told his students that sunset and sunrise were the most difficult times of day to represent accurately,
he was able to capture dawn and twilight wonderfully in his etched work as well as in his watercolors and oils.

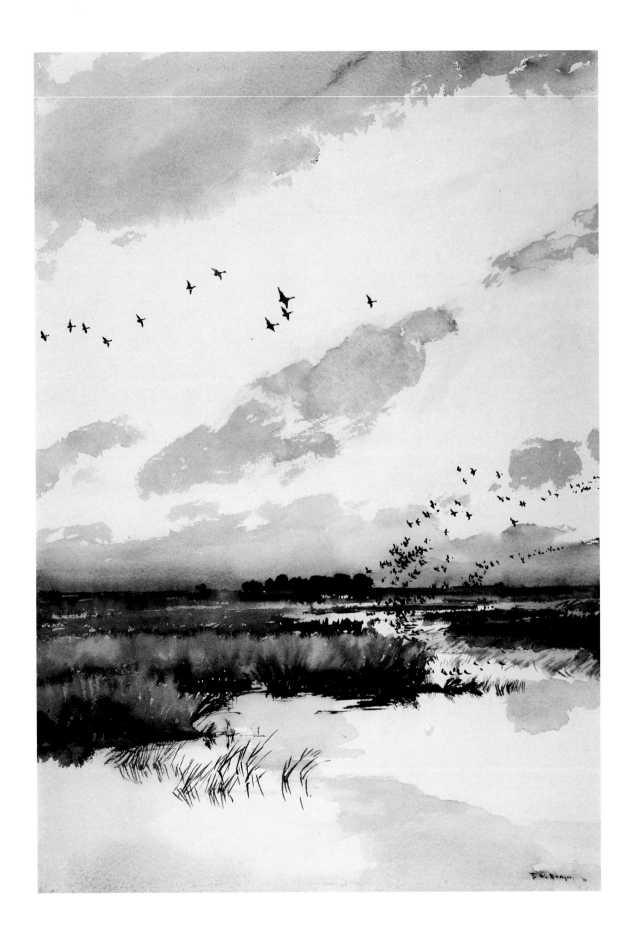

56. *Ducks Coming off the Marsh*, 1914?

 Ink wash on paper, 19¾ x 13¾ inches. Private collection.
 This wash drawing is an excellent example of the black-and-white watercolors that Benson first exhibited in 1912.
 They became so popular that, to keep up with the demand, Benson authorized the Elson Art Publication Company to print reproductions of eight of his drawings. Four other wash drawings have been similarly reproduced.

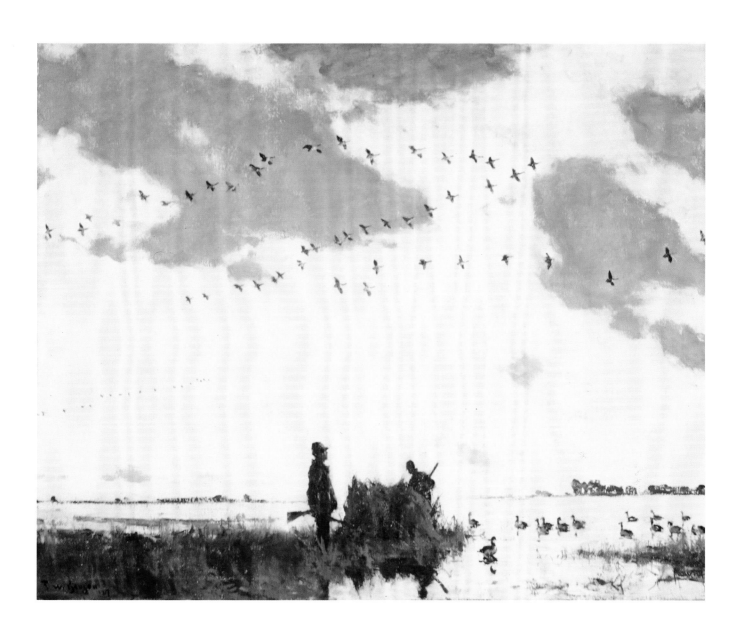

57. *Goose Blind*, 1927

Oil on canvas, 32 x 40 inches. Private collection.
The landscape of this painting suggests it was inspired by scenes Benson saw while hunting
at the Long Point Hunting Club in Canada.

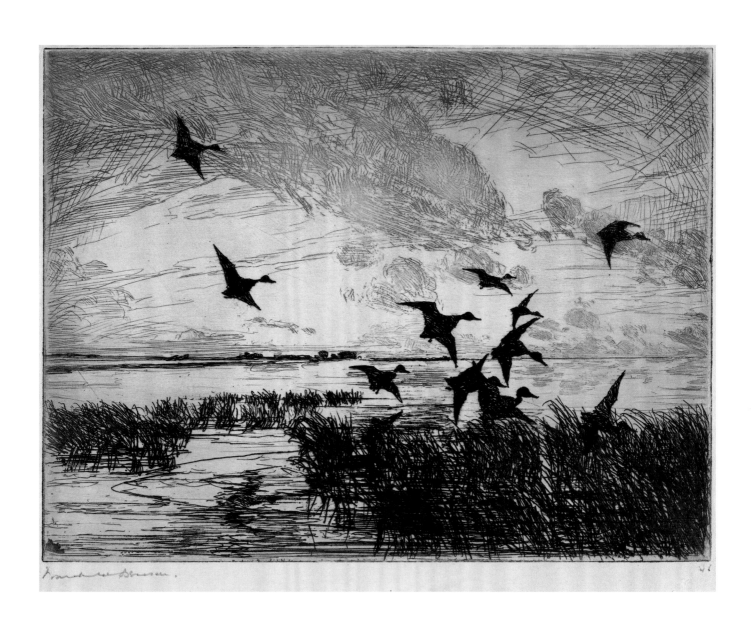

58. *After Sunset,* 1917

Etching on paper, 6 x 8 inches. (Paff no. 113, ed. 152.) Print Department, Boston Public Library.
Gift of Sherburne Prescott.
Benson did two trial proofs before running off his usual edition of one hundred and fifty etchings from this plate.

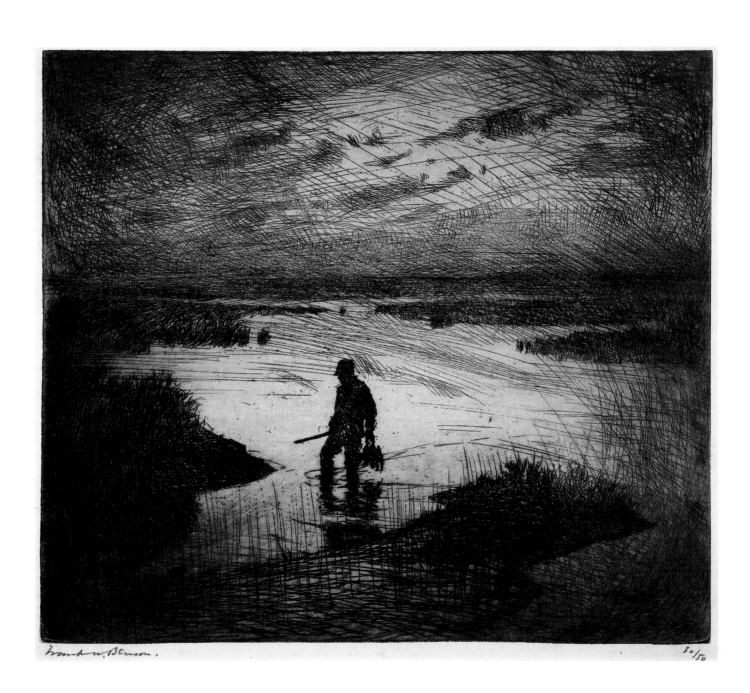

59. *Dusk,* 1914

Etching on zinc, 9¼ x 10⅞ inches. (Paff no. 34, ed. 50.) Print Department, Boston Public Library.
Gift of Albert H. Wiggin.
This etching, made in Benson's North Haven studio, required only one proof.

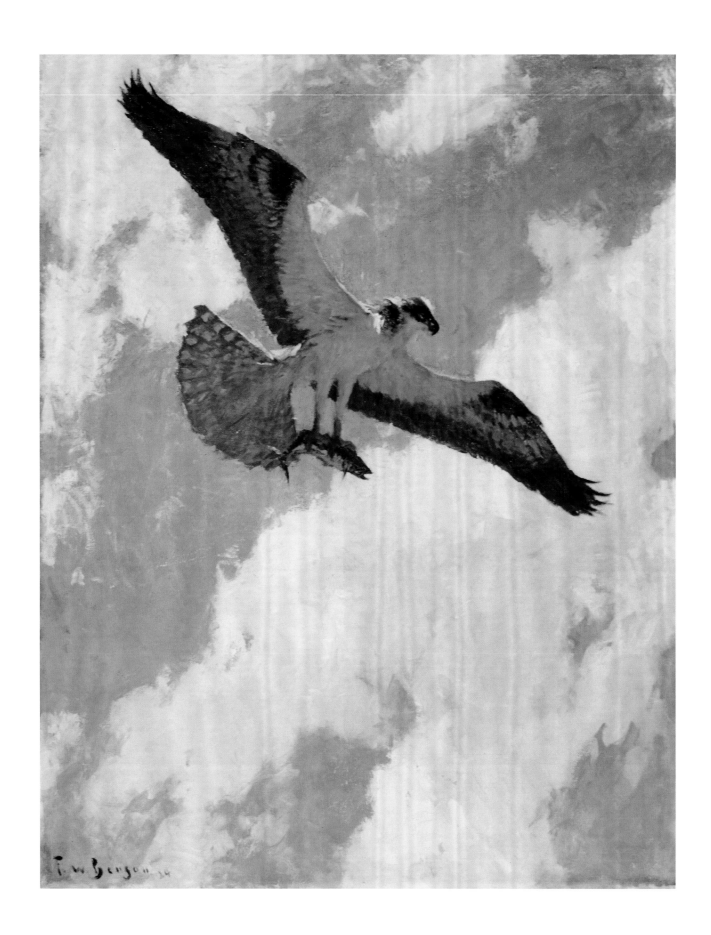

60. *Osprey and Fish,* 1924

Oil on canvas, 60 x 45 inches. Collection of Charles Sterling.
The waters of Penobscot Bay were rich fishing grounds for osprey.

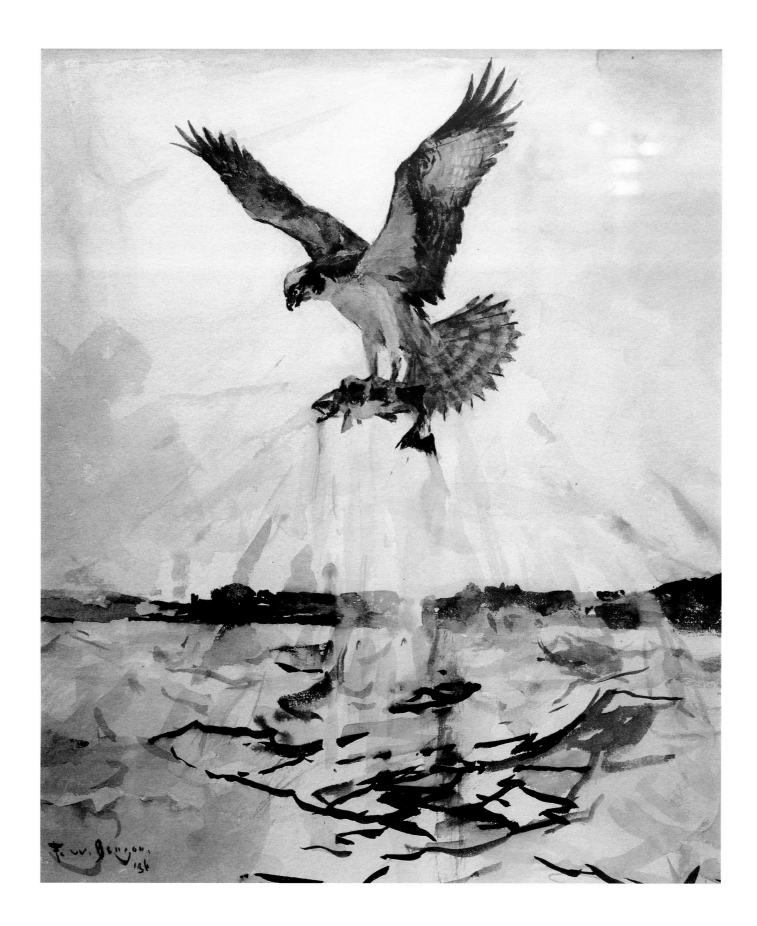

61. *Hawk and Fish,* 1936

Ink wash on paper, 13½ x 11½ inches. Peabody Essex Museum.
Fish hawks were seen often above the waters off North Haven.

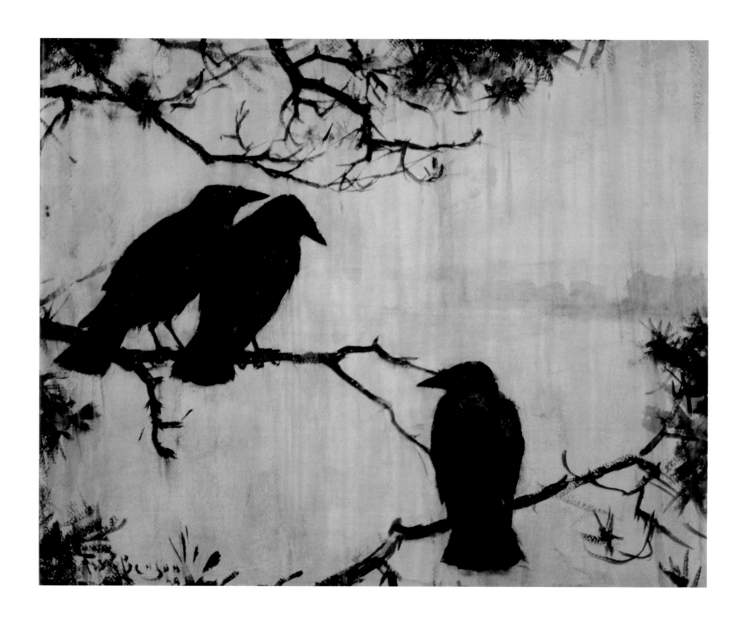

62. *Crows in the Rain, 1929*

Watercolors on paper, 19¼ x 24 inches. Collection of Lisa K. Dreyer and Javier Romero Dominguez-Roqueta.
Benson rarely depicted crows in his works. When he did, as in this stunning watercolor, the results were often dramatic.
Photograph courtesy of the Marine Art Gallery, Salem, Mass.

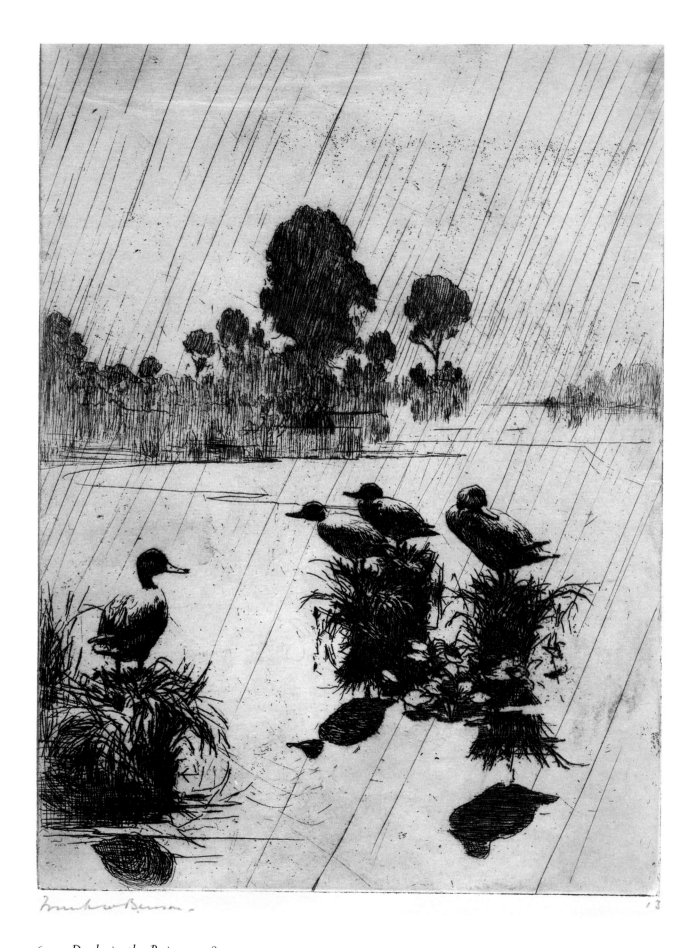

63. *Ducks in the Rain,* 1918

Etching on paper, 8 x 6 inches. (Paff no. 147, ed. 45.) Print Department, Boston Public Library.
Gift of Albert H. Wiggin.

After two trial proofs, Benson added lines of rain in the immediate central and right foreground and defined the distant shore with a few additional lines of shading before pulling one hundred proofs.

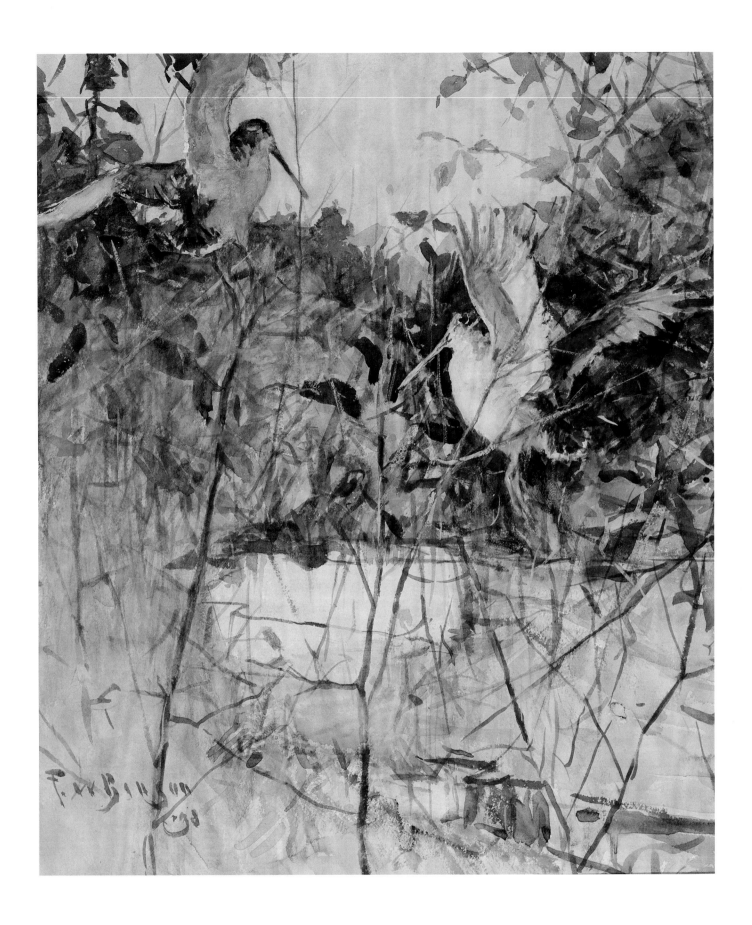

64. *Sighting,* 1938

Watercolors on paper, 23 x 19½ inches. Private collection.
Benson and an early mentor, Abbott Handerson Thayer, shared an interest in the protective coloration
of animals and birds. Benson painted numerous works that illustrate this fascination.

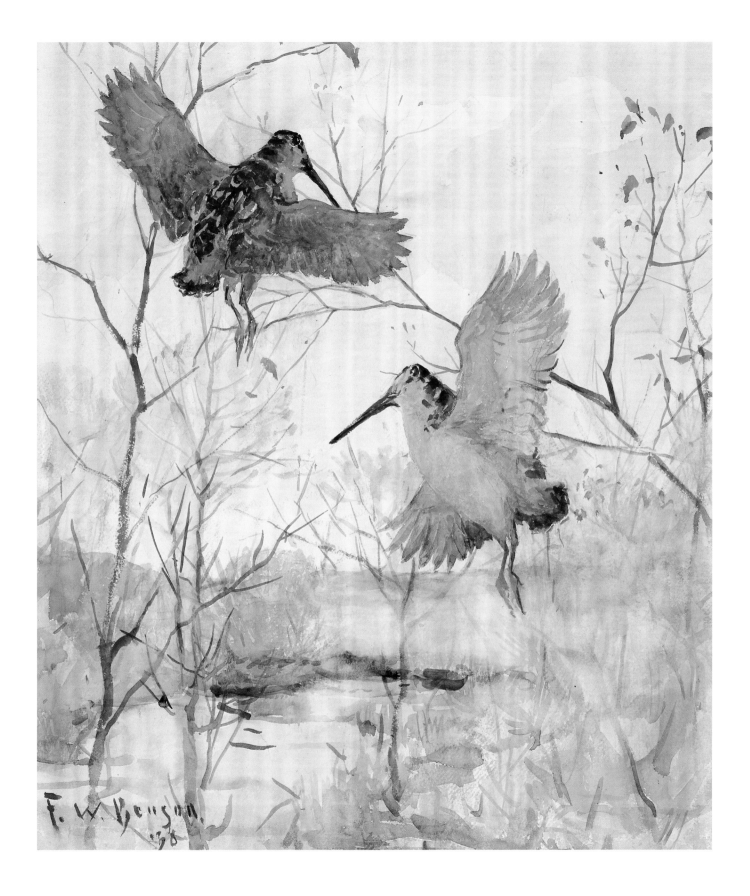

65. *Misty Morning, 1938*

Watercolors on paper, 23 x 19¾ inches. Private collection.
In the boggy thickets near upland streams, Benson often came across woodcocks, so perfectly camouflaged that they seemed to vanish in the undergrowth. Their explosive way of taking off and streaking through the woods made these little birds challenging targets. In his watercolors and etchings of these game birds, he often depicted them in mid-flight.

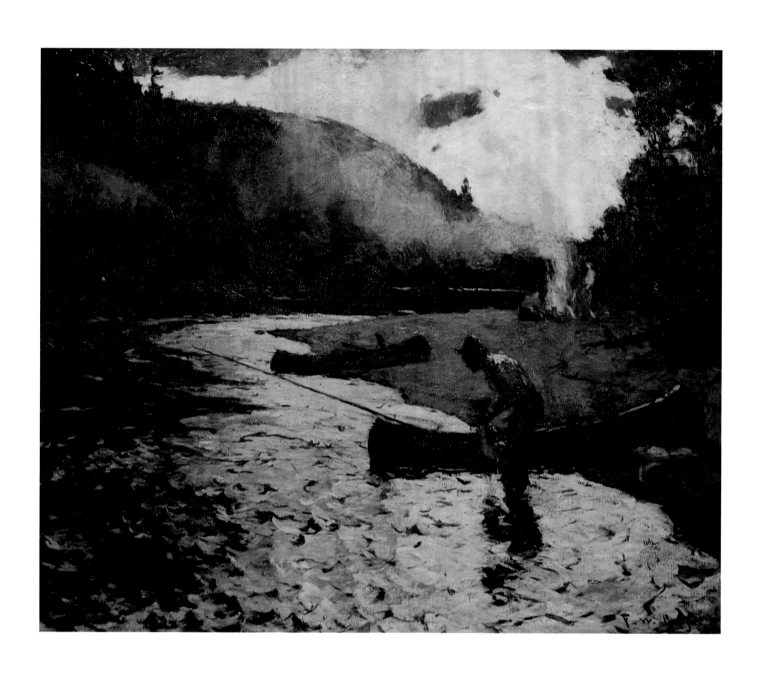

66. *The Campfire (Fire on the Beach), 1925*

Oil on canvas, 30¼ x 36¼ inches. Private collection.

This painting captures well the sense of camaraderie that Benson so enjoyed on his fishing and hunting expeditions.

Photograph courtesy of Alfred J. Walker Fine Arts, Boston.

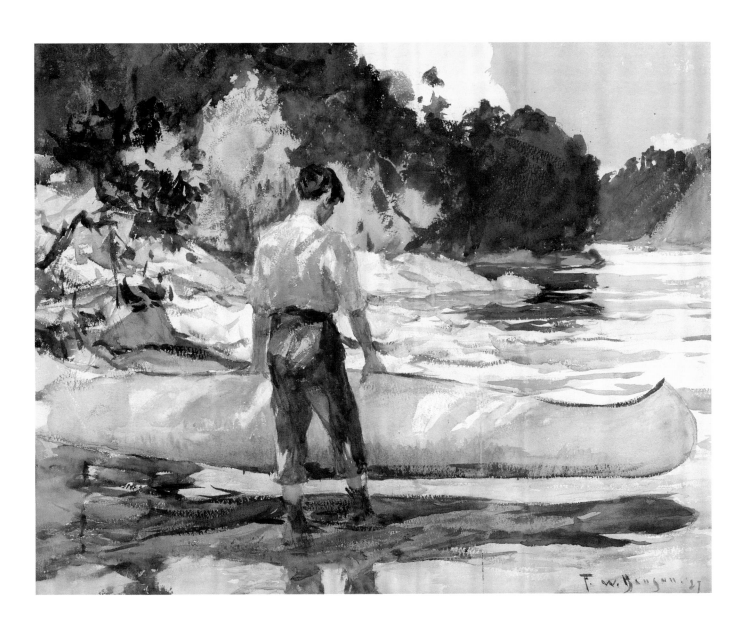

67. *Morning Sunlight*, 1927

Watercolors on paper, 19 x 24 inches. Private collection.
Canoes figure prominently in a number of Benson's watercolors. He painted guides poling them, portaging them around falls, pushing them into streams, and paddling them down calm stretches of water.

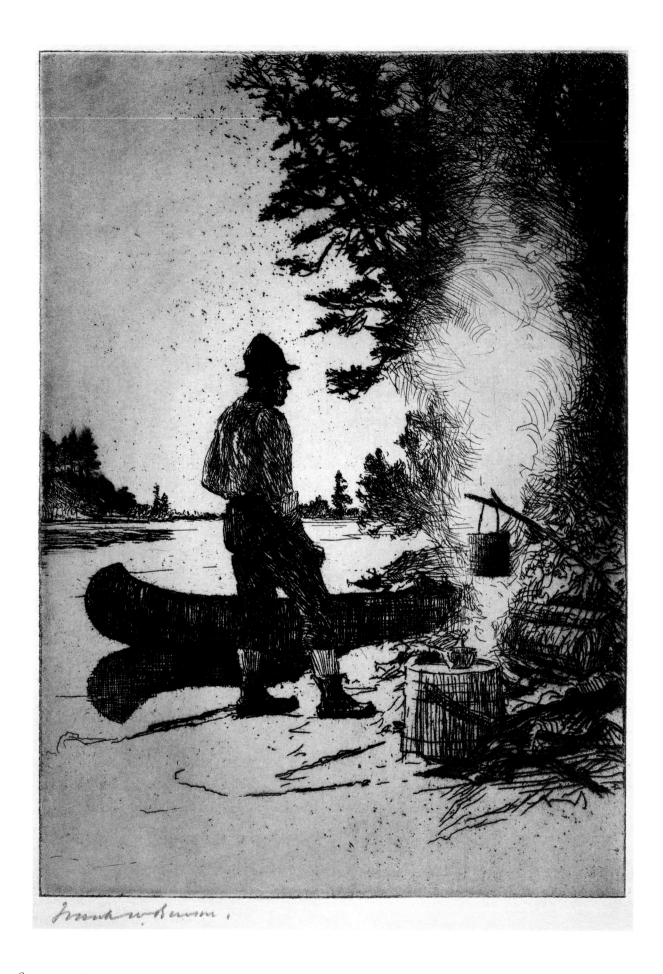

68. *Supper*, 1920

 Etching on paper, 6⅞ x 4⅞ inches. (Paff no. 182, ed. 150.) Peabody Essex Museum.

 Makeshift camps were often set up by the shores of the salmon rivers of Canada's Gaspé Peninsula.

 This end-of-the-day scene captures one of the guides preparing the fishing party's dinner.

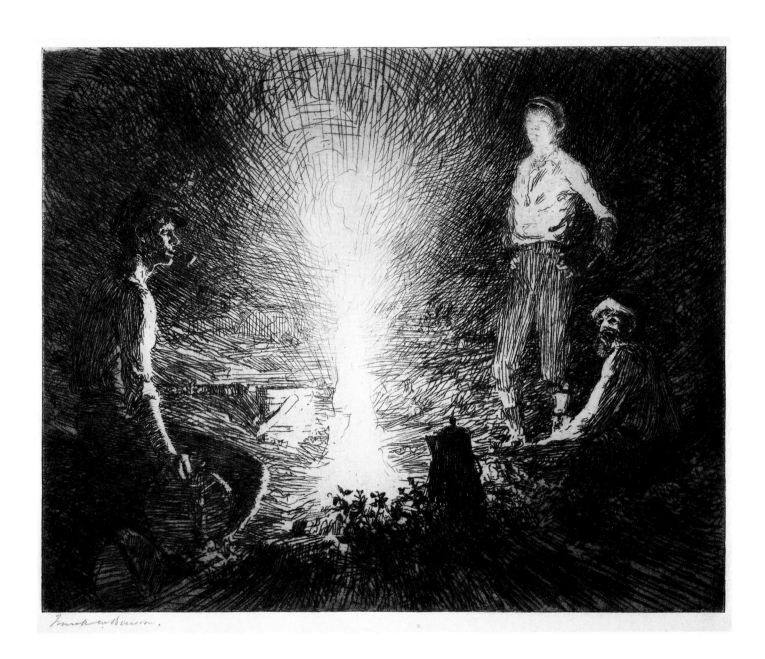

69. *Camp-Fire,* 1920

Etching on paper, 7⅞ x 9⅞ inches. (Paff no. 194, ed. 150.) Print Department, Boston Public Library.
Gift of Albert H. Wiggin.
Despite the perceived limitations of the black and white of etching, Benson was able to capture perfectly
the white-hot heat of an evening campfire.

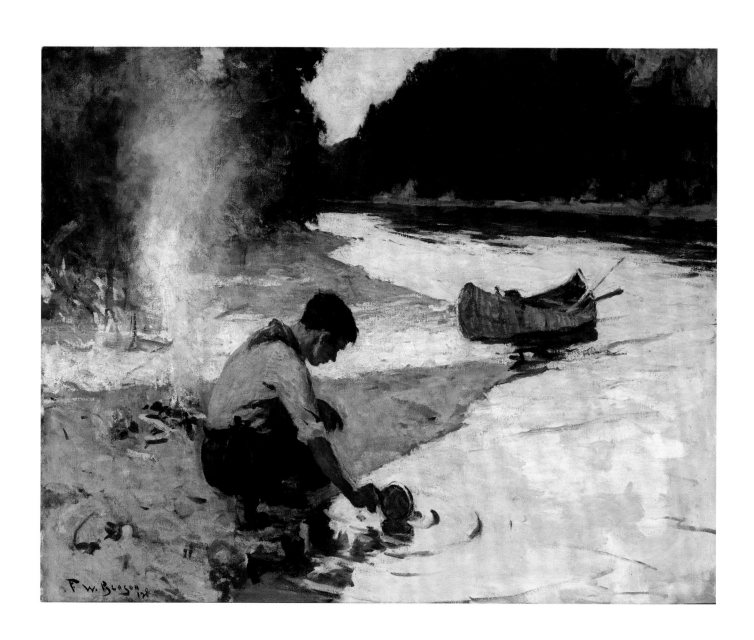

70. *Cup of Water,* 1928

Oil on canvas, 32 x 40 inches. Collection of Mr. and Mrs. Abbot W. Vose.
Benson undoubtedly based this painting on a study made while salmon fishing on one of the many rivers
and streams of Canada's Gaspé Peninsula.

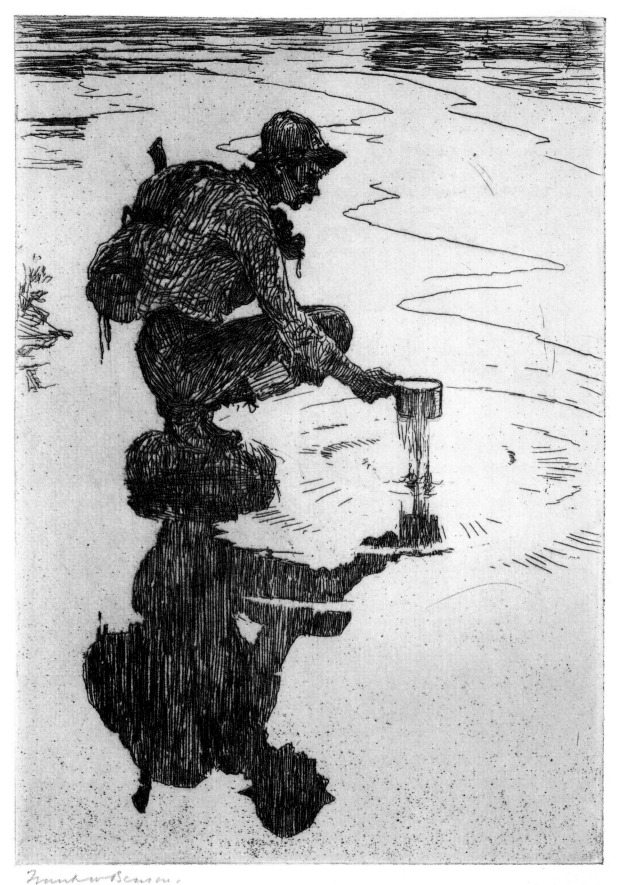

Frank W. Benson.

71. *A Cup of Water,* 1928

Etching on paper, 6⅞ x 4⅞ inches. (Paff no. 196, ed. 150.) Peabody Essex Museum.
The same year that this etching was created, Benson painted a handsome oil of a very similar subject.

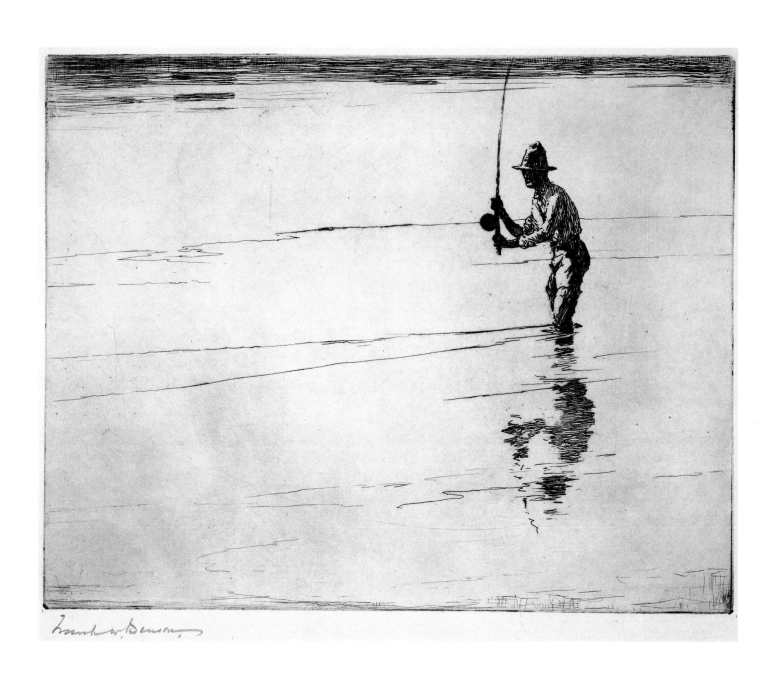

72. *Casting for Salmon, 1929*

Etching on paper, 7¾ x 10 inches. (Paff no. 288, ed. 150.) Peabody Essex Museum.
Strong parallels to the work of the Japanese ukiyo-e masters can be seen in this spare composition of a lone fisherman.

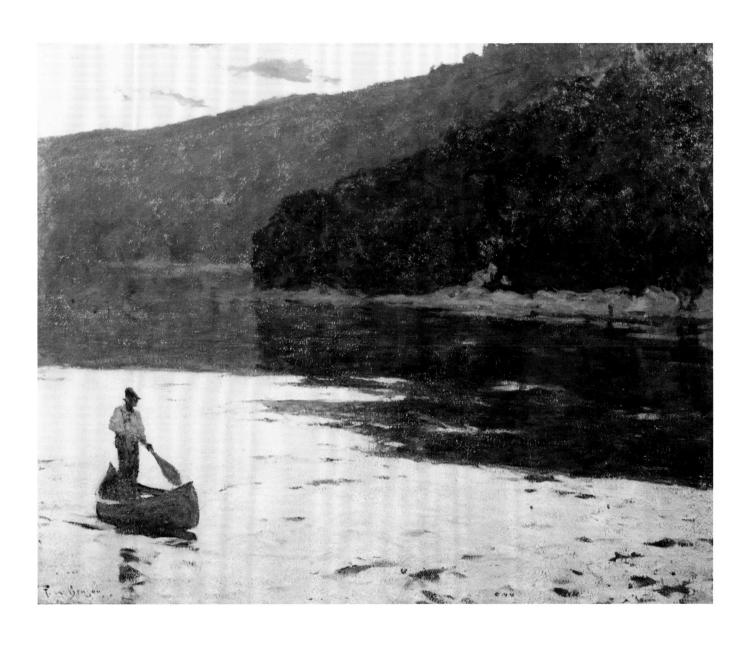

73. *Twilight,* 1930

Oil on canvas, 40 x 50 inches. Collection of Giuseppe Waltoni.

The tranquility of twilight pervades this work. The sun has set behind the deep blue hills, and their shadows reach across the water towards the lone figure of a fisherman standing in the stern of his canoe.

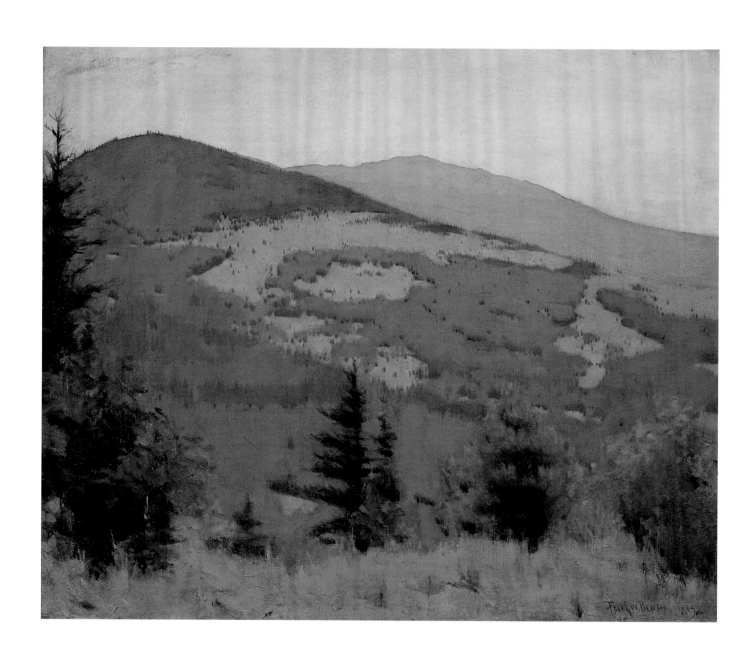

74. *Spring Hillside, Mount Monadnock, N.H.*, 1889

Oil on canvas, 20 x 24 inches. Collection of Mr. and Mrs. Thomas A. Rosse.

Benson summered in Dublin, New Hampshire, from 1889 to 1893. There, in the company of Abbott Handerson Thayer, he painted numerous landscapes. However, only one known portrait, that of Thomas Wentworth Higginson, was painted by Benson during this period.

75. *The Squall,* 1915

Etching on paper, 7⅞ x 9⅞ inches. (Paff no. 77, ed. 4.) Print Department, Boston Public Library.
Gift of Albert H. Wiggin.

This etching is a view toward Beacon Street from Benson's studio in the Riverway Building near The Fenway in Boston.
Benson and several artist friends contracted to have this built specifically to provide affordable studios for young artists.

76. *Sunlight in the Woods,* 1924

Watercolors on paper, 14⅛ x 20 inches. Private collection.

When Benson's watercolors were first exhibited, a critic acknowledged his mastery of the medium: "He has great knowledge of the limitations of aquarelle, knowing when to stress his medium or to have respect for the beauty of the white surface on which he is working, or with a brush full of color, express a brilliant note of sunlight through foliage" (see note 79).

77. *Fox Island Thoroughfare,* 1923

Watercolors on paper, 14½ x 20¼ inches. Private collection.
This watercolor captures one of the views from Benson's summer home.

78. *The Lone Pine,* 1935

Watercolors on paper, 23 x 18¾ inches. Private collection.

This watercolor is a good example of one of Benson's artistic convictions: "If a landscape is not worth painting purely as a design in light and shade, it is not worth painting at all."

79. *Snowy Hill,* 1946

Watercolors on paper, 16½ x 24½ inches. Private collection.

One of Benson's latest watercolors, this work was done when he was eighty-four.

Selected Bibliography

Books

Allison, Henry. *Dublin Days, Old and New: New Hampshire Fact and Fancy*. New York: Exposition Press, 1952.

Bedford, Faith Andrews. *Frank W. Benson: American Impressionist*. New York: Rizzoli International Publications, 1994.

Baedeker, Karl. *Baedeker's Paris and Environs, with Routes from London to Paris, Handbook for Travelers*. Leipzig: Karl Baedeker, 1899.

Burke, Doreen Bolger. *American Paintings in the Metropolitan Museum of Art*. New York: Metropolitan Museum of Art, 1980.

Caffin, Charles H. *American Masters of Painting*. New York: Doubleday, 1902.

————. *The Story of American Painting*. New York: Frederick A. Stokes, 1907.

Chamberlain, Samuel. *A Stroll through Historic Salem*. New York: Hastings House Publishers, 1969.

D.O.C. *Etching since Nineteen Hundred*. Philadelphia: Charles Sessler, 1930.

Fox, James Shirley. *An Art Student's Reminiscences of Paris in the Eighties*. London: Mills and Boon, 1909.

Gammell, R. H. Ives. *The Boston Painters, 1900–1930*. Edited by Elizabeth Ives Hunter. Orleans, Mass.: Parnassus Imprints, 1986.

————. *Twilight of Painting: An Analysis of Recent Trends to Serve in a Period of Reconstruction*. New York: G. P. Putnam's Sons, 1946.

Gardner, Albert Ten Eyck. *History of Water Color Painting in America*. New York: Reinhold, 1966.

Gerdts, William H. *American Impressionism*. New York: Abbeville Press, 1984.

Goldman, Judith. *American Prints: Process and Proofs*. New York: Harper and Row, 1981.

Heintzelman, Arthur. *The Etchings and Drypoints by Frank W. Benson.* Boston: Houghton Mifflin, 1959.

Howe, M. A. DeWolfe. *A Partial (and Not Impartial) Semi-Centennial History of the Tavern Club, 1884–1934.* Boston: Privately printed, 1934.

Hitchcock, J. W. R. *Etching in America.* New York: White, Stokes and Allen, 1886.

Laver, James. *History of British and American Etching.* London: E. Benn, 1929.

Morgan, Charles Lemon. *American Etchers: Frank W. Benson, N.A.* New York: Crafton Collection, 1931.

Ordeman, John T. *Frank W. Benson: Master of the Sporting Print.* Brooklandville, Md., 1983.

Paff, Adam E. M. *The Etchings and Drypoints by Frank W. Benson.* Boston: Houghton Mifflin, 1917–29.

Pierce, H. Winthrop. *The History of the School of the Museum of Fine Arts, Boston, 1877–1927.* Boston: Museum of Fine Arts, 1930.

Reese, Albert. *American Prize Prints of the Twentieth Century.* New York: American Artists Group, 1949.

Sachs, Paul J. *Modern Prints and Drawings.* New York: Alfred A. Knopf, 1954.

Salaman, Malcolm M. *Modern Masters of Etching: Frank W. Benson.* London: The Studio, 1925.

————. *Modern Masters of Etching: Sir Francis Seymour Haden.* London: The Studio, 1926.

Saint-Gaudens, Homer. *The American Artist and His Time.* New York: Dodd, Mead, 1941.

Short, Frank. *On the Making of Etchings.* London: Robert Dunthorne, 1898.

Simmons, Edward. *From Seven to Seventy.* New York: Harper, 1922.

Troyen, Carol. *The Boston Tradition: American Paintings from the Museum of Fine Arts.* Boston: Museum of Fine Arts, 1980.

Weinburg, H. Barbara. *The Lure of Paris: Late Nineteenth-Century American Painters and Their French Training . . . in a New World: Masterpieces of American Painting, 1760–1910.* Boston: Museum of Fine Arts, 1983.

White, Nelson C. *Abbott H. Thayer: Painter and Naturalist.* Hartford, Conn.: Connecticut Printers, 1951.

Whitehill, Walter. *The East India Marine Society and the Peabody Museum of Salem: A Sesquicentennial History.* Portland, Maine: Anthoensen Press, 1949.

————. *Museum of Fine Arts, Boston: A Centennial History.* Cambridge, Mass.: Belknap Press, 1970.

Young, Dorothy Weir. *Life and Letters of J. Alden Weir.* New Haven: Yale University Press, 1940.

Exhibition Catalogues

Bartolo, Christine. *The Ten: Works on Paper.* Williamstown, Mass.: William Sterling and Francine Clark Art Institute, 1980.

Bedford, Faith Andrews, Bruce Chambers, and Susan Faxon. *Frank W. Benson: A Retrospective.* New York: Berry-Hill Galleries, 1989.

Dodge, Ernest S. *Exhibition of Paintings, Drawings and Prints by Frank W. Benson, 1862–1951.* Rockland, Maine: William A. Farnsworth Library and Art Museum, 1973.

Domit, Moussa M. *American Impressionist Painting.* Washington, D.C.: National Gallery of Art, 1973.

Dugan, Sheila, William H. Gerdts, and John Wilmerding. *Frank W. Benson: The Impressionist Years.* New York: Spanierman Gallery, 1988.

Dumas, F. G. *Exposition universelle de 1889. Catalogue illustré de beaux-arts, Paris.* Lille: L. Danel, 1889.

Fairbrother, Trevor, Theodore E. Stebbins Jr., and William L. Vance. *The Bostonians: Painters of an Elegant Age, 1870–1930.* Boston: Museum of Fine Arts, 1986.

Gerdts, William, et al. *Ten American Painters.* New York: Spanierman Gallery, 1990.

Heintzelman, Arthur. *Memorial Exhibition: Frank W. Benson, 1862–1951.* Boston: Albert H. Wiggin Gallery, Boston Public Library, 1952.

Hills, Patricia. *Turn-of-the-Century America: Paintings, Graphics, Photographs, 1890–1910.* New York: Whitney Museum of American Art, 1977.

Olney, Susan Faxon. *A Circle of Friends: Art Colonies of Cornish and Dublin.* Durham, N.H.: University Art Galleries, University of New Hampshire, 1985.

———. *Two American Impressionists: Frank W. Benson and Edmund C. Tarbell.* Durham, N.H.: University Art Galleries, University of New Hampshire, 1979.

Price, Lucien. *Frank W. Benson, 1862–1951: A Retrospective Exhibition.* Salem, Mass.: Essex Institute and Peabody Museum, 1956.

———. *Memorial Exhibition of Paintings and Water Colors by Frank W. Benson, 1862–1951.* Boston: Guild of Boston Artists and the Print Department of the Boston Public Library, 1953.

Price, Lucien, and Frederick W. Coburn. *Frank W. Benson, Edmund C. Tarbell: Exhibition of Paintings, Drawings and Prints.* Boston: Museum of Fine Arts, 1938.

Rathbone, Perry T. *The Boston Painters.* Boston: Museum of Fine Arts, 1971.

Sellin, David. *Americans in Brittany and Normandy: 1860–1910.* Phoenix: Phoenix Art Museum, 1982.

Stahl, Elizabeth. *Beatrice Whitney Van Ness, 1888–1981: The Privilege of Learning to Paint.* Boston: Childs Gallery, 1987.

Worthen, Amy. *The Prints of J. N. Darling.* Ames, Iowa: Brunnier Gallery and Museum, 1984.

Peabody Essex Museum

"I am still working at it and learning, and that is all I care about. I don't care about the pictures I have painted. I may become fond of one and say 'that's a good one,' but all I really care about is working at this thing, and it is still so far ahead of me that I shall never reach it, and have only just begun to know anything about it."

FRANK W. BENSON

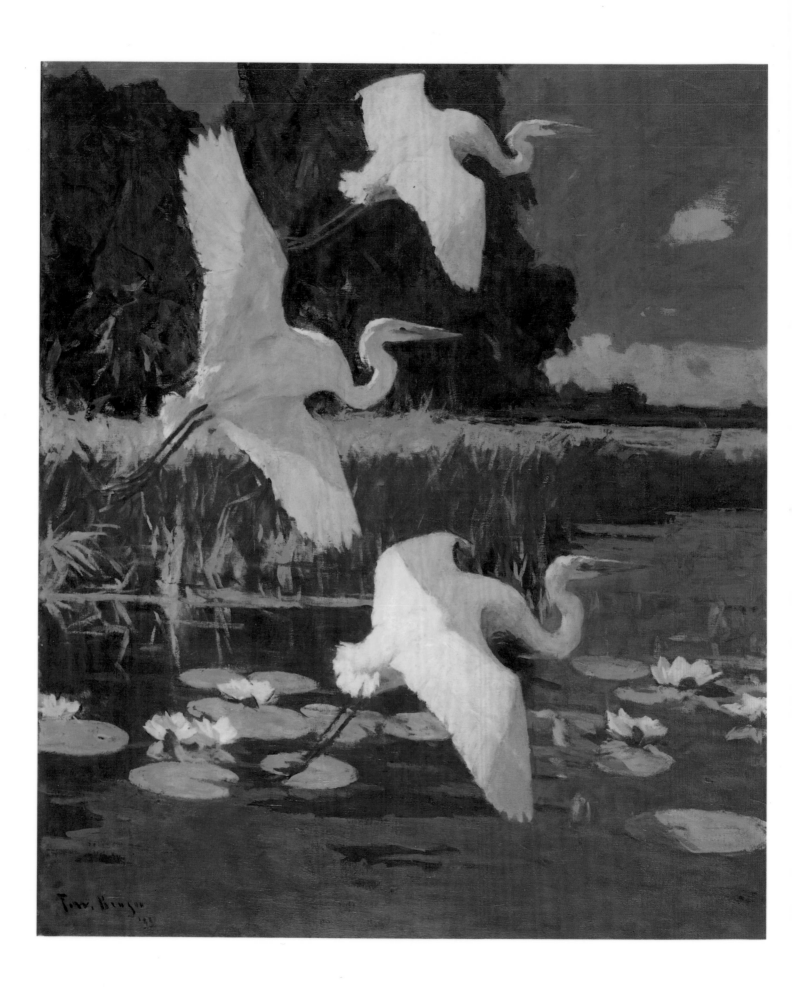